the style of

·LOISH·

finding an artistic voice

3DTOTAL PUBLISHING

Correspondence: publishing@3dtotal.com
Website: www.3dtotal.com

First published in the United Kingdom, 2022, by 3dtotal Publishing.

3dtotal.com Ltd, 29 Foregate Street, Worcester WR1 1DS, United Kingdom.

Hard cover ISBN: 978-1-912843-43-5
Printing and binding: Leo Paper Products Ltd. www.leo.com.hk

Visit **www.3dtotalpublishing.com** for a complete list of available book titles.

Managing Director: Tom Greenway
Studio Manager: Simon Morse
Lead Designer: Fiona Tarbet
Lead Editor: Jenny Fox-Proverbs
Editorial Project Manager: Sophie Symes

One tree planted for every book sold

OUR PLEDGE

From 2020, 3dtotal Publishing has pledged to plant one tree for every book sold by partnering with and donating the appropriate amounts to re-foresting charities. This is one of the first steps in our ambition to become a carbon-neutral company with carbon-neutral publications, giving our customers the knowledge that by buying from 3dtotal Publishing, they are working with us to balance the environmental damage caused by the publishing, shipping, and retail industries.

· contents ·

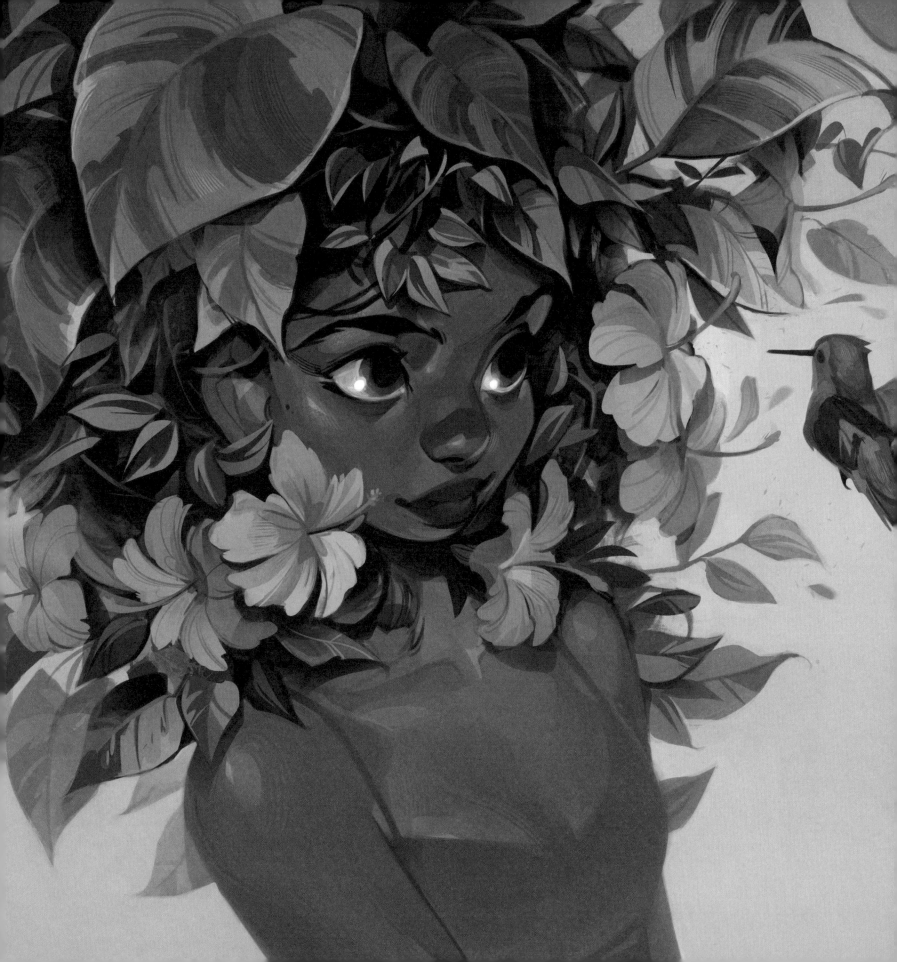

· introduction ·

When I created my first artbook, *The Art of Loish*, I knew that I wanted to make a series consisting of three books. I'm a huge fan of trilogies, so telling the story of my art in three installments felt like the natural thing to do. I also finished each book with the lingering sense that there was more I wanted to share, and I knew that I wanted the final book to go a level deeper than the previous ones. As an artist, I'm regularly generating new artwork, but underneath that artwork is a creative flow that runs like a river through everything I make. It feeds and nurtures my creative vision, and guides the path forward, giving me ideas and inspiration for future artwork. I wanted this book to be about that flow.

I brainstormed on this subject for many years, trying to narrow down the idea. Would it be about my workflow? My philosophy? My mindset? Each concept had potential, but felt too broad or too off-topic for an art book. After talking to numerous people who generously gave their honest feedback on my ideas, I stumbled upon something that finally "clicked": my style.

This idea instantly appealed to me because I felt it encapsulated that deeper level. It is the common factor that unites all of the art that I've created, and it informs my creative decisions and goals. I was also drawn to it because the topic of artistic style is a very big one in the art community. Especially in today's age of social media, artists are under a lot of pressure to stand out from the crowd with an identifiable brand. Many of them start searching for their style very early in their creative journeys or worry that their style is not distinct enough.

I created this book because I want to tell the story of my art, but also because I want to create a resource for artists that are searching for their own artistic voice. If there's anything I'd like to show you, it's that artistic style is not just about surface-level things, like how your art looks. It's actually the opposite: it's something that flows forth from some of the deepest parts of who you are, from your personality to your experiences and vision of the world. Many things that define an artists' style come into existence before they ever even realize they have a style of their own.

I hope you'll enjoy this deeper dive into my art, but most importantly, I hope it inspires you to better understand those foundational layers of your own creative work, and the factors that come together to give shape to your art and creative vision!

· finding my style ·

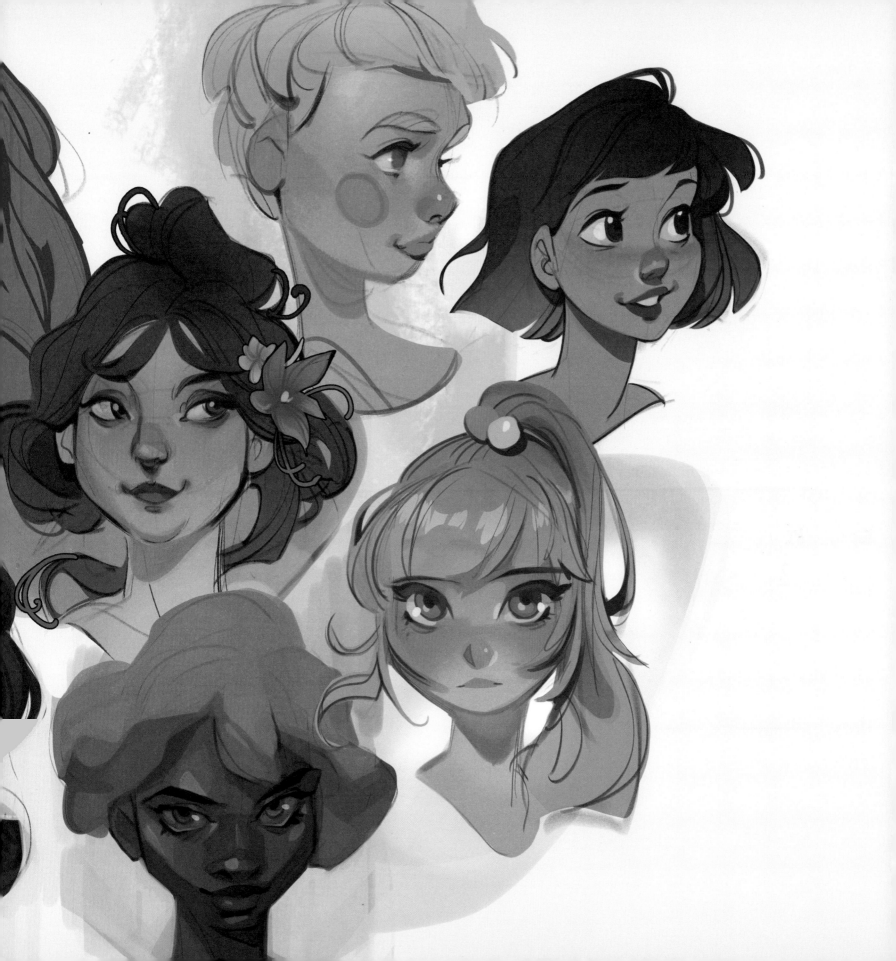

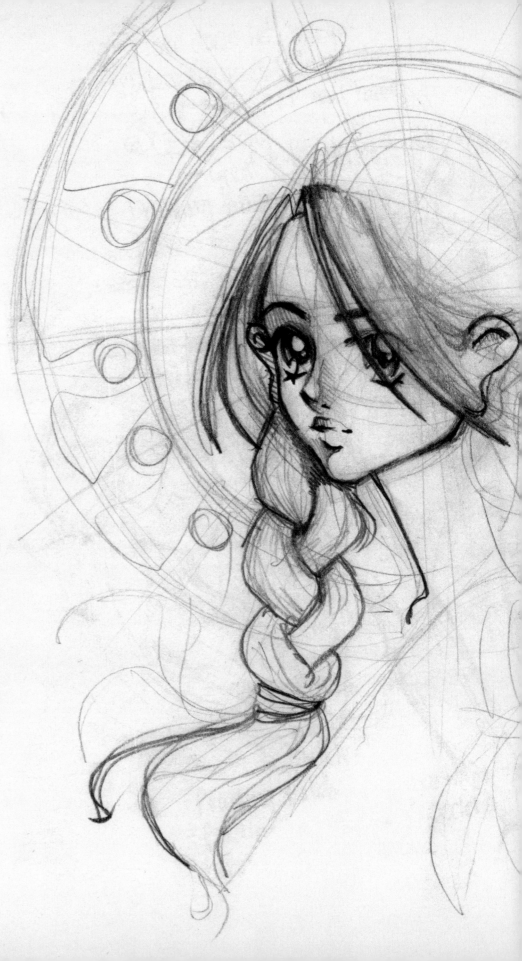

I vividly remember the first moment that I was made aware of the existence of my own "style." I was sixteen years old, and drawing every day (or to be more precise, every night, after finishing my homework). I would post the results of my numerous digital sketching sessions onto a small online drawing community, where other teenagers also shared their drawings. I was mixing and matching my various inspirations at the time, without much concern for whether these combinations were tasteful. I created *Star Wars*-themed Powerpuff Girls, and Roy Lichtenstein-inspired anime characters. In my mind, I was just a vessel for channeling the styles of others.

Suddenly I spotted a comment on my newest drawing of an elf girl with ringlet curls: "I love your style!" I wasn't sure what that meant. Did I even have a style? I continued to get similar comments from the people around me. There's a saying that you don't find your style, it finds you — and this was definitely true in my case.

This page: An early sketch from 2003, in which I explored a mixture of anime style with art nouveau elements

Opposite page: Some early digital style experiments, in which I mixed art nouveau, anime, and *The Powerpuff Girls* influences. The bottom right image is the first that was identified as being in my style

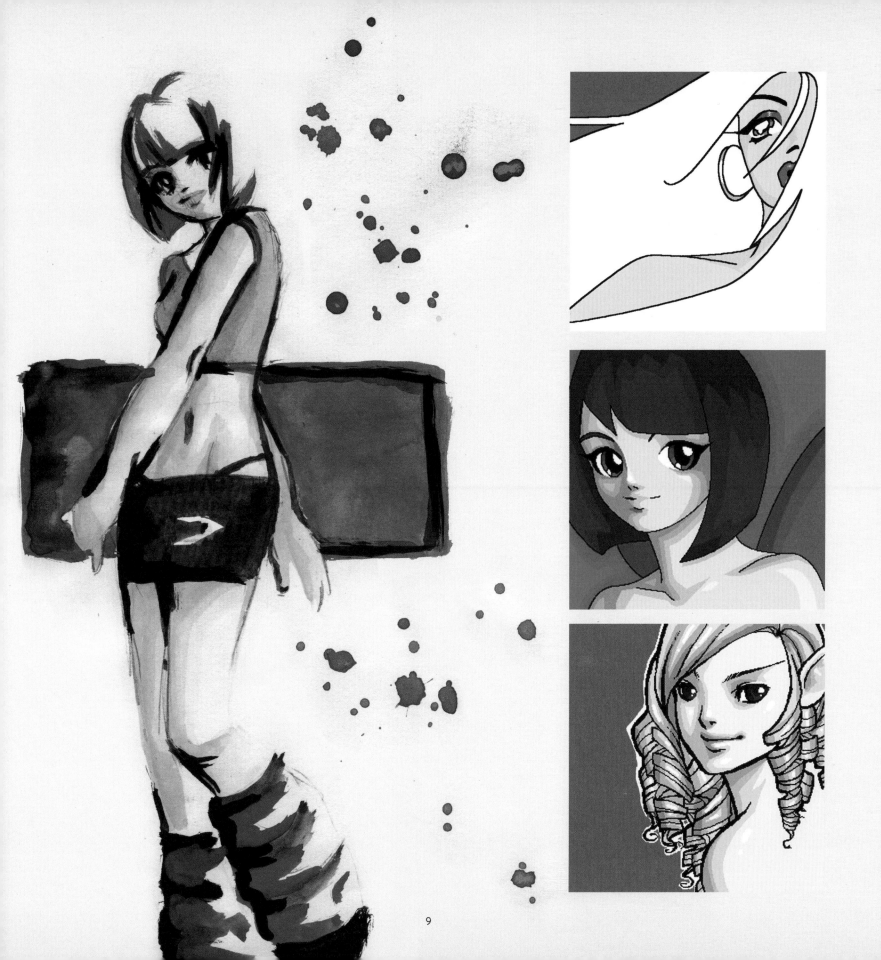

Over time, I discovered another valuable tool to help me understand my art: the power of hindsight. When I look back, I can see the turning points and developments that brought me to where I am now, and I can use my older artwork as a point of comparison. I've found that these are the two most important ingredients needed to understand one's own style: feedback from others, and the ability to map out your own artistic growth and history. If you are one of the many artists who struggles to identify their own style, gather your old sketchbooks and ask people around you for their thoughts. Some crucial insights might emerge from there!

This page: Remake of a digital painting from 2009

Opposite page: Sketchbook page from 2003

"When I look back, I can see the turning points and developments that brought me to where I am now"

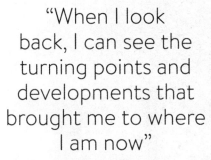

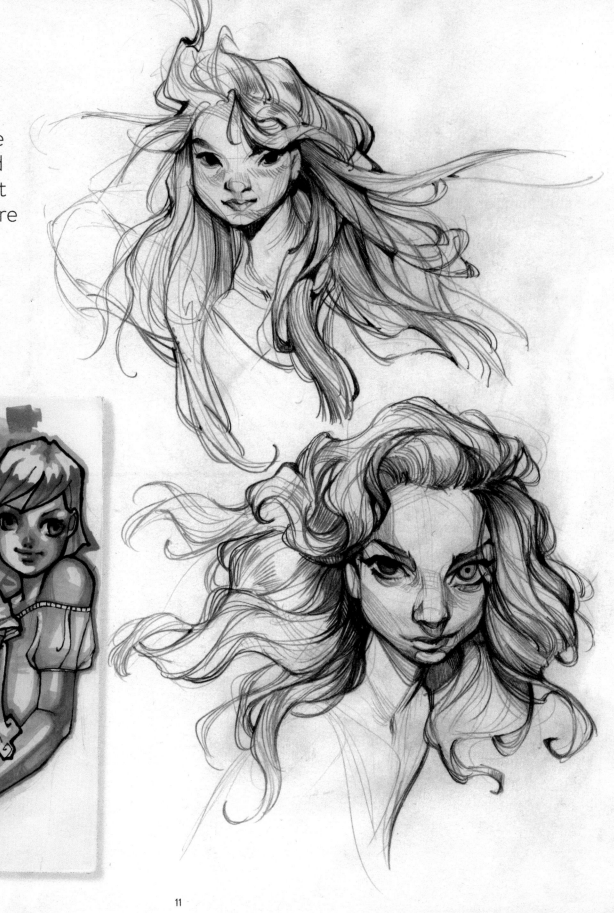

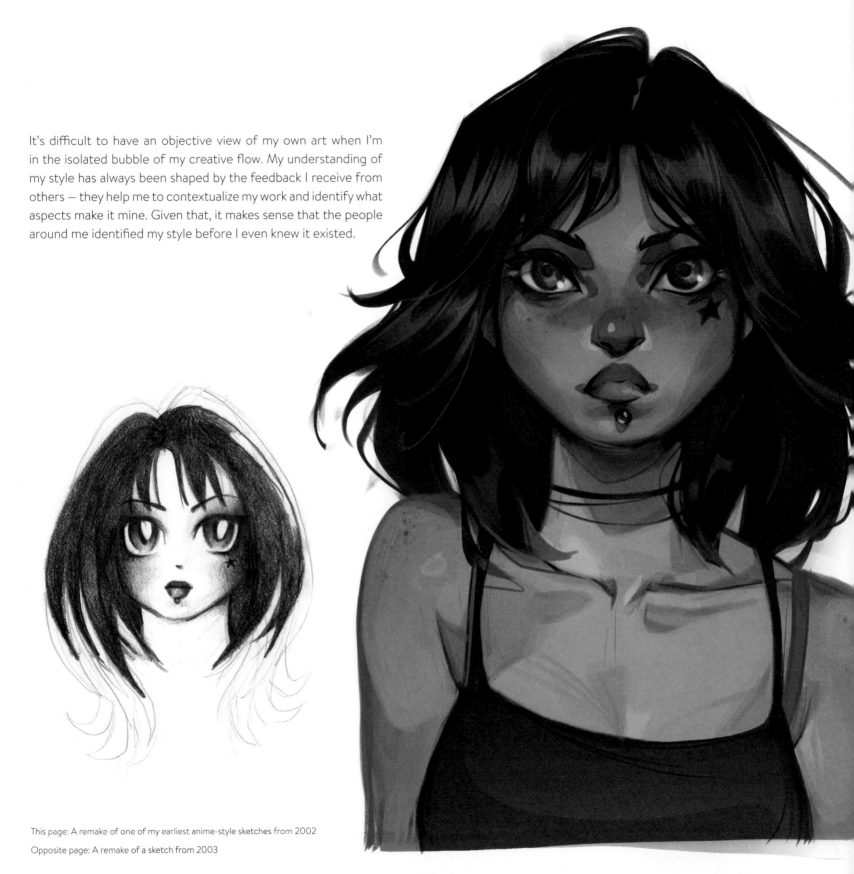

It's difficult to have an objective view of my own art when I'm in the isolated bubble of my creative flow. My understanding of my style has always been shaped by the feedback I receive from others — they help me to contextualize my work and identify what aspects make it mine. Given that, it makes sense that the people around me identified my style before I even knew it existed.

This page: A remake of one of my earliest anime-style sketches from 2002

Opposite page: A remake of a sketch from 2003

"My understanding of my style has always been shaped by the feedback I receive from others"

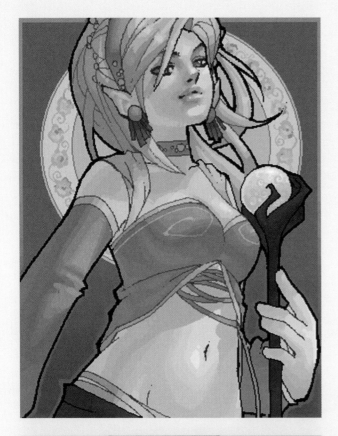

When I look back on my creative journey, what stands out most are a few moments where something just "clicked" for me. I never saw them coming, and they happened seemingly out of the blue, such as the moment that I first laid eyes on Alphonse Mucha's art. I was mesmerized and deeply moved. I saw a completely unique mixture of the real and the imaginary, with stylistic elements that set it in some kind of other world beyond our own. What captivated me the most was the stylization: the way that Mucha depicted his subject matter in a non-realistic way. I felt a powerful urge to achieve the same in my art. That was the moment that I changed from a hobbyist who occasionally drew things from reference to an aspiring artist in search of her artistic voice.

Alphonse Mucha's beautiful flowing artwork was one of the many things that I was naturally drawn to. This feeling was not limited to artistic inspirations, but also extended toward specific techniques and ways of working. As someone who has a strong dislike of committing to a specific decision, I was fascinated by digital drawing software, which gave me endless opportunities to change my art at any point in the drawing process.

Whenever I find myself drawn to something, I pursue my interest in it and incorporate it into my creative routine. Over time, these choices fused together and became the foundation for what is now my artistic style.

This page: Early digital art pieces that lean heavily into the art nouveau style that inspired me at the time

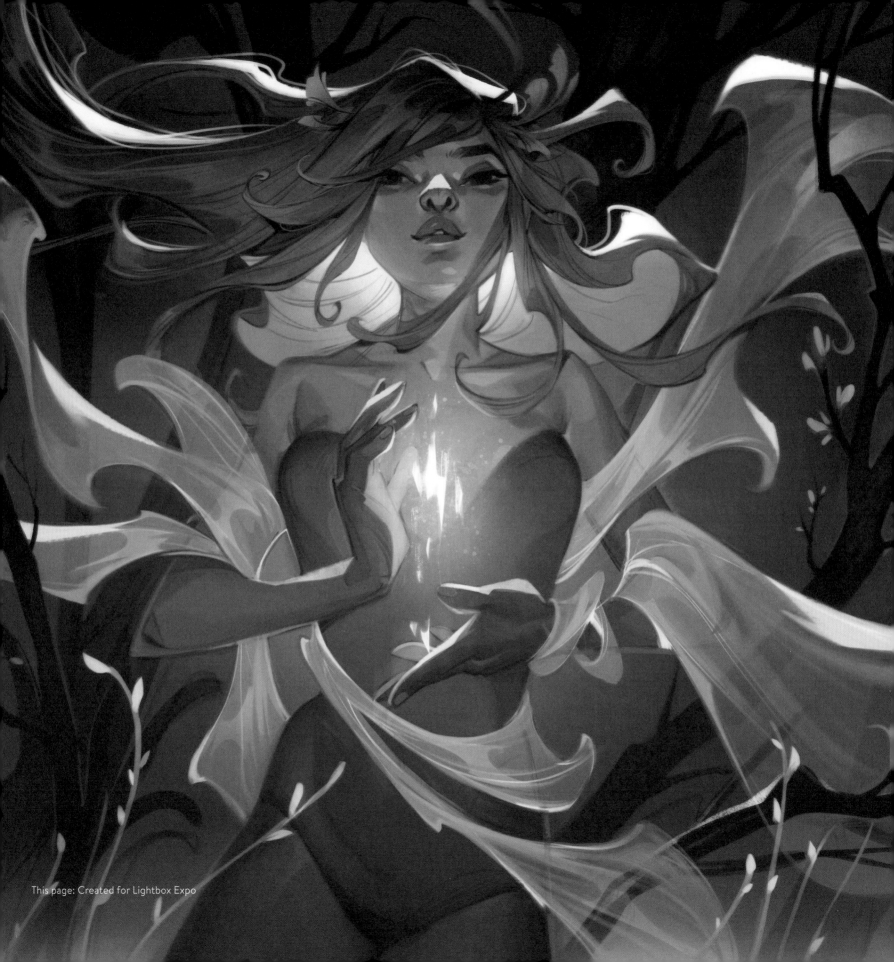

This page: Created for Lightbox Expo

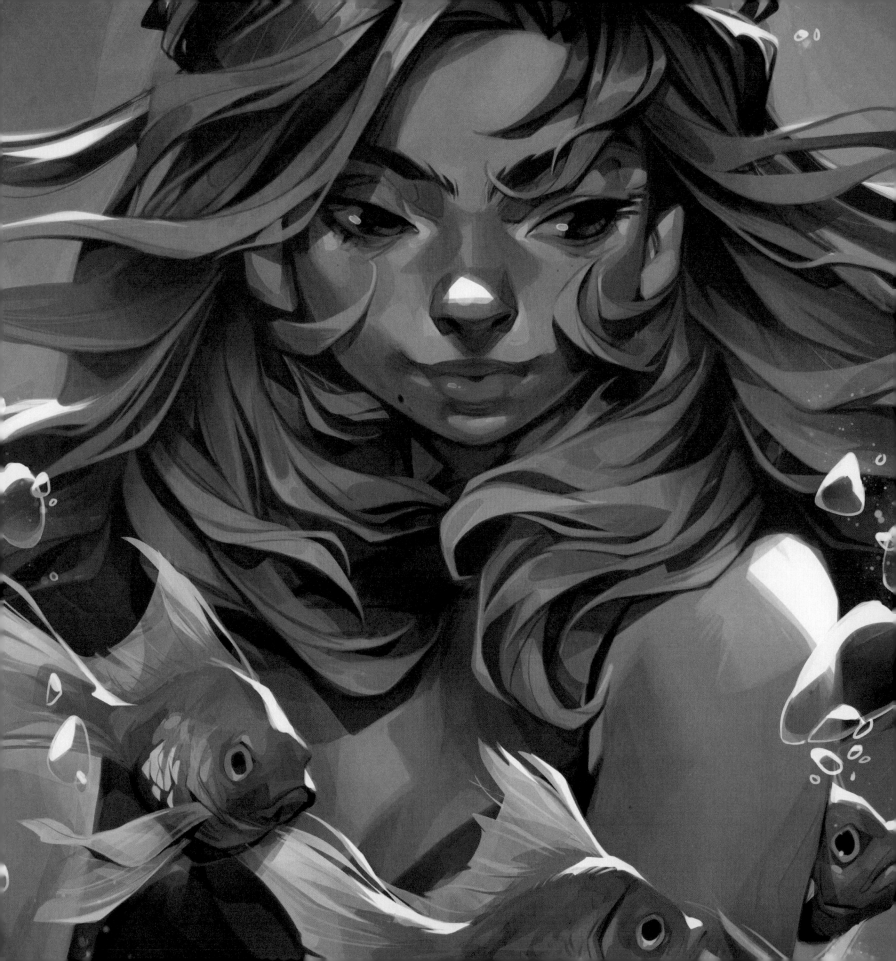

· turning points ·

During that time in my creative journey, I had no idea that what I was experiencing was in any way significant, but looking back, I can see that there were moments that hugely influenced the cultivation of my personal style. Here are a few of them:

Watching *The Little Mermaid*
I got my hands on a VHS tape of *The Little Mermaid* when I was four years old, and was instantly obsessed with Ariel's beauty, confidence, and approachable quirkiness. From this point forward, most of my art featured princesses, mermaids, and girls in pretty dresses. The desire to capture femininity and cuteness in my characters has yet to fade.

My introduction to anime and manga
When I was fifteen, I met a friend who was a huge fan of manga. Her bookshelves were filled with comics and she had posters all over the walls of her bedroom. She introduced me to the style and encouraged me to try it out for myself. To this day, the construction technique I use for all of my characters comes from a "how to draw an anime head" tutorial that I found online.

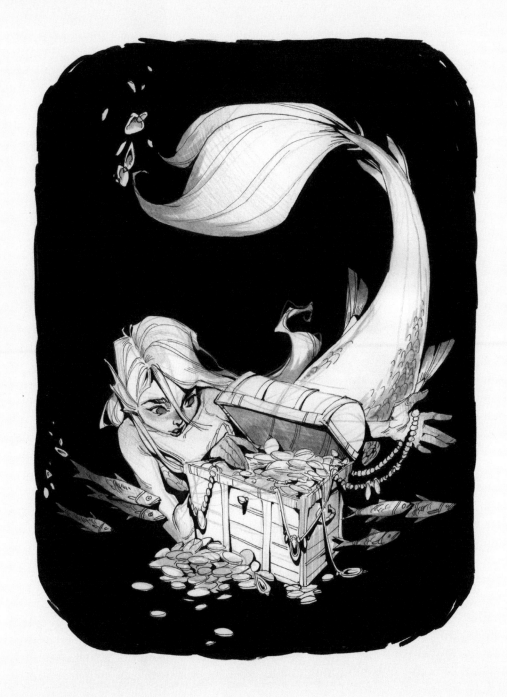

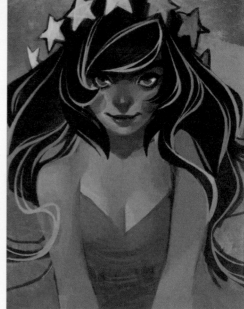

A dark-to-light painting tutorial

As an eighteen-year-old, I stumbled across a tutorial that explained how to paint lighter tones on top of a darker base color. This concept fundamentally changed my entire mindset while drawing. I went from filling in linework to sculpting with color, imagining the volumes emerging from the canvas. Later, I would find myself skipping the linework phase entirely and diving straight into painting, which became a defining aspect of my style.

Early digital art communities

As a teenager, I discovered online communities called oekaki boards. On these message boards, I could draw in a really simple browser app and post the results onto a type of forum, where others could do the same, forming a small community of beginner artists. The app was ideal for quick sketches and doodles, which resulted in an ingrained habit of creating rough work on a regular basis. I also learned that an uncomplicated workflow with minimal tools is ideal for my attention span.

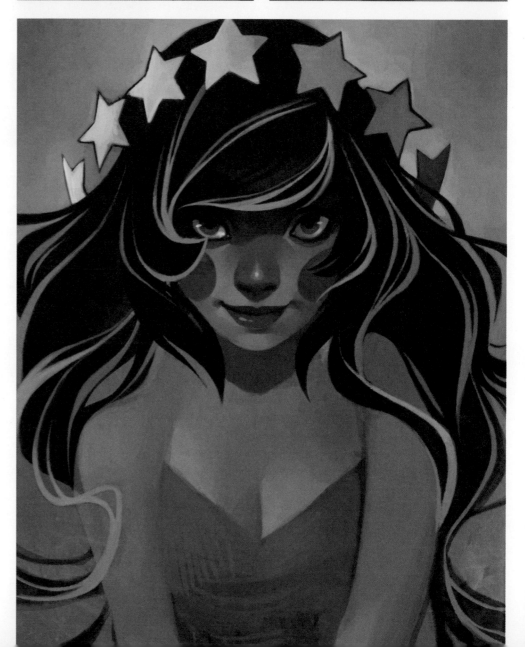

head

hair

chin

neck

waist

hands
skirt

feet

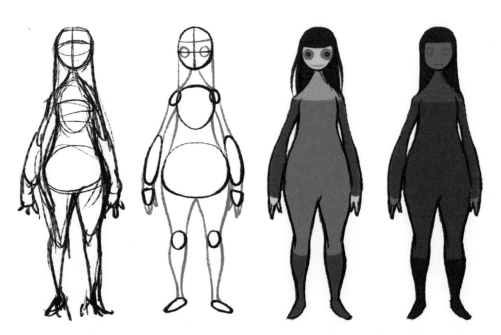

Studying animation

I decided to study animation because I believed it would provide me with a wide range of skills for my creative career. What I didn't know at the time of making that decision was how the fundamentals of animation would teach me to look beyond a two-dimensional image, and to think about art in terms of the three-dimensional shape and the movement. My drawings went from appearing chunky and blocky to being more streamlined, with more defined and readable volumes. Animation taught me a lot of useful techniques, but most of all, it taught me how to bring my art to life.

Looking back, I can see how important it was to allow myself a creative space in which I could explore, experiment, and play. By doing that, I increased the potential to stumble upon something that would fit with my vision and process, which catalyzed the creation of my own style. Of course, this only happened on rare occasions and wasn't something that could be forced. By regularly allowing myself the time and space to flip through books, visit museums, doodle mindlessly, and indulge in my artistic curiosity, I allowed myself to discover new things and, eventually, find my style — or let it find me.

For artists, this is much easier said than done. We want to get the most out of our drawing time and see consistent improvement, making sure every drawing we make is better than the last. The prevalence of gatekeeping in the art community doesn't help either, from art teachers who tell us that certain styles and interests are off-limits, to art communities that dictate what is acceptable and what isn't. Given these challenges, it can be really difficult to simply allow yourself to enjoy something that inspires you, or draw without the pressure to improve. Without realizing it, I navigated my way around those pressures by drawing purely on my own terms. At first it was because I didn't think I could pursue art as a career, and when I finally did take that step, I created my colorful, feminine paintings outside of school hours because my teachers disapproved of them. With hindsight, this "guilty pleasure" approach to drawing allowed me to have fun and discover new things at my own pace.

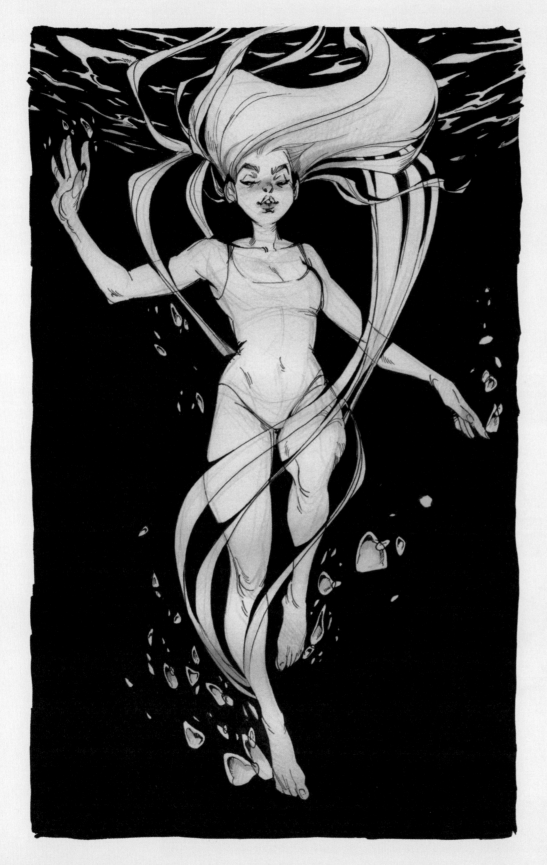

Having experienced the benefits that came from being able to explore freely and without too many external pressures, I now make a point of encouraging others to make that a priority in their creative routine. Doing so will yield something incredibly valuable: the opportunity to sense what you are naturally drawn towards, and what fits your vision and way of working. This is what will guide you in your journey toward finding an artistic voice that is uniquely yours.

What I've discovered over time is that an artistic style is something that grows forth from the choice to focus on some things and leave others behind. The things that interested me the most became central elements of my art, and the things that didn't interest me became less prominent. If you observe the work of any artist with a recognizable style, you'll notice which elements fascinate them and have become their area of expertise because they made them the central element of their art. In this sense, style transcends technique. It no longer becomes an issue of what is "right" or "wrong," but an individualistic reflection of who someone is as an artist. It's also something that will continue to change and evolve over time, as the artist changes and evolves as a person.

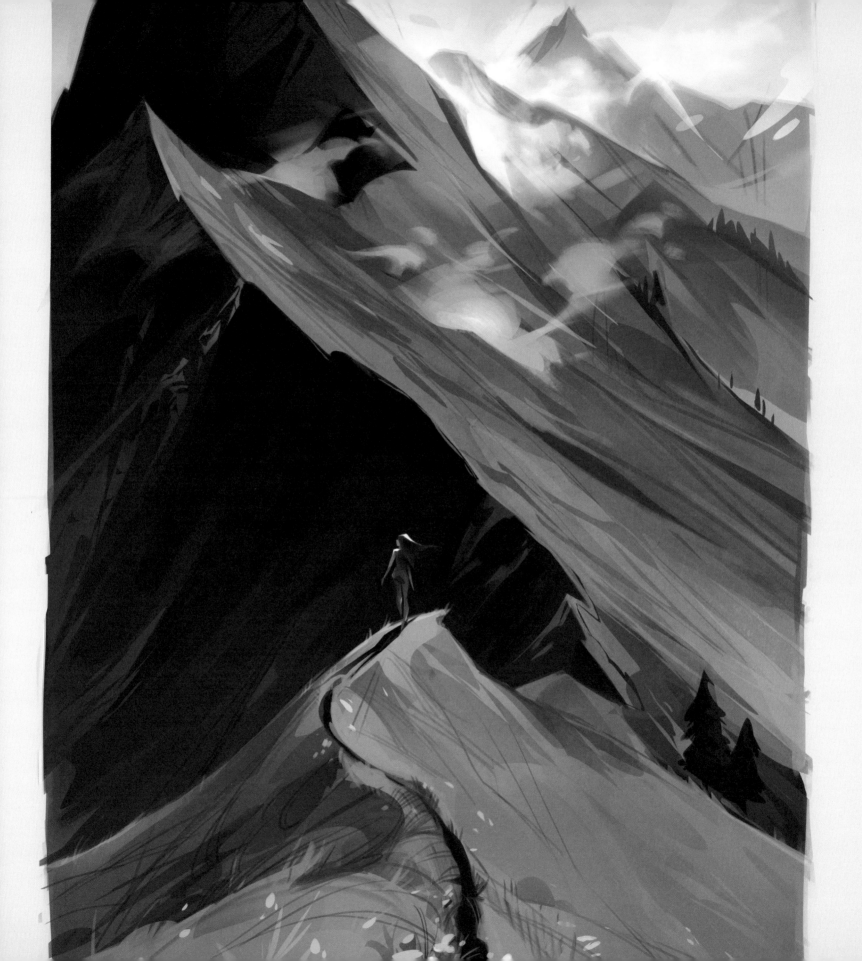

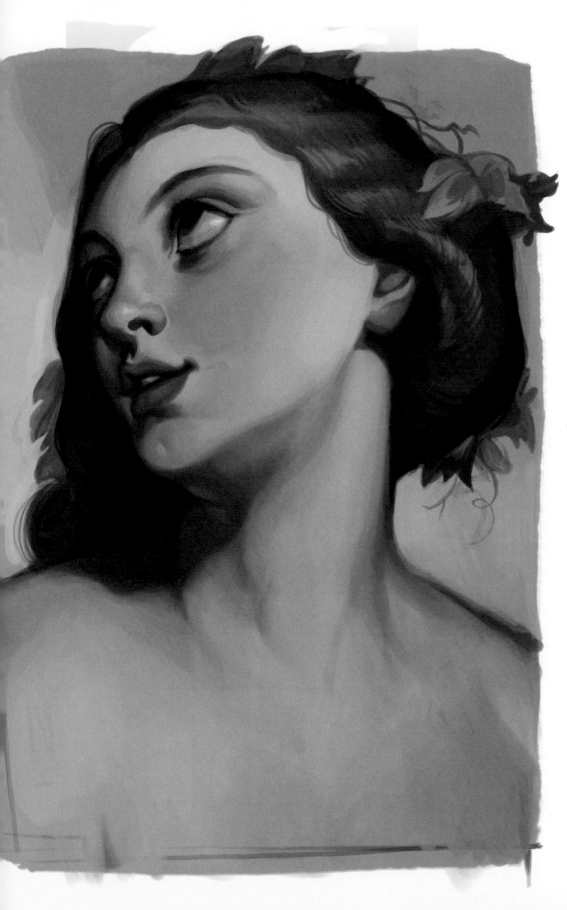

exercises //
artistic discovery

Specific creative activities were particularly helpful in allowing me to discover and cultivate my own style. If you are one of the many artists who is searching for a style of their own, these exercises might help you on your way!

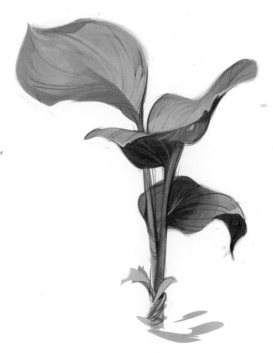

create studies

Sometimes I find a reference image of something really specific, such as a rock or a plant, and I make sketches of it. What I've discovered is that these drawing sessions train my brain to observe things in terms of what fascinates me most. The same happens when creating master studies of existing artwork. Creating studies boosts my drawing skills, but also trains my observational skills and allows my mind to search for which elements I find most interesting to capture.

Left: Study of the painting *De Hemelse en Aardse Liefde* by Ary Scheffer

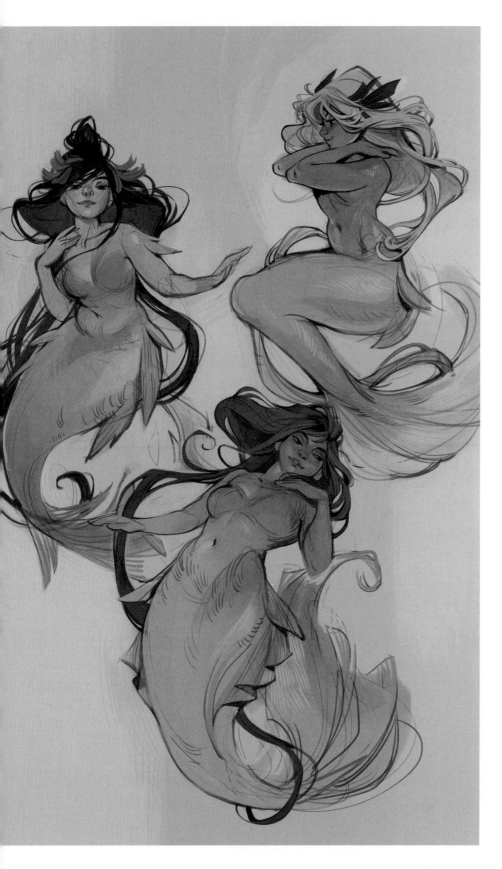

mix & match influences

Master studies (drawing or painting existing artwork) are a great way of studying an artist's style, but I tend to get lost in the activity of simply copying what I see. When I challenge myself to mix two influences, I am forced to filter the visual information that I see, and make more specific creative choices. This is an indulgent exercise that allows me to figure out what I love most about the art that inspires me.

Left: A mixture of mermaid and art nouveau influence

Above: An exercise where I applied J. C. Leyendecker's style to an existing reference image

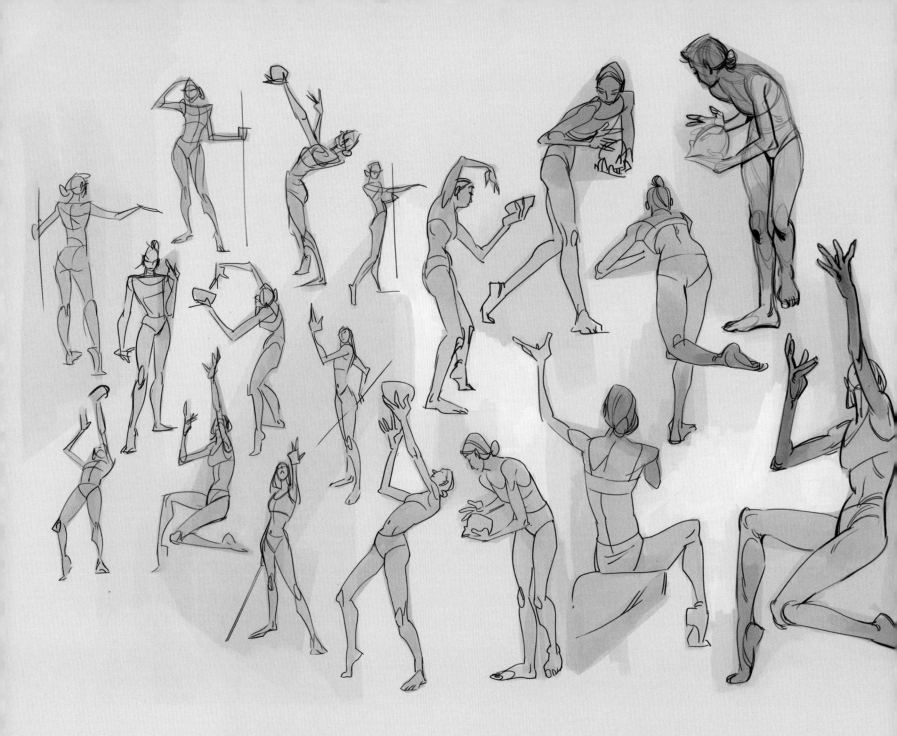

sketch with limited time

Speed sketching was something I was first exposed to in animation school. Initially, it felt pointless to hastily throw some lines on paper in just thirty seconds, but the more I did it, the more I learned that setting a time limit forces me to be more creative about what I choose to convey. There isn't enough time to draw all of the details, and so I shift my focus purely onto the gesture, shape language, or proportions. Drawing with limitations can be a pressure cooker that generates interesting results and forces you to fall back on deeper, more intuitive skills that you might not know you had.

26

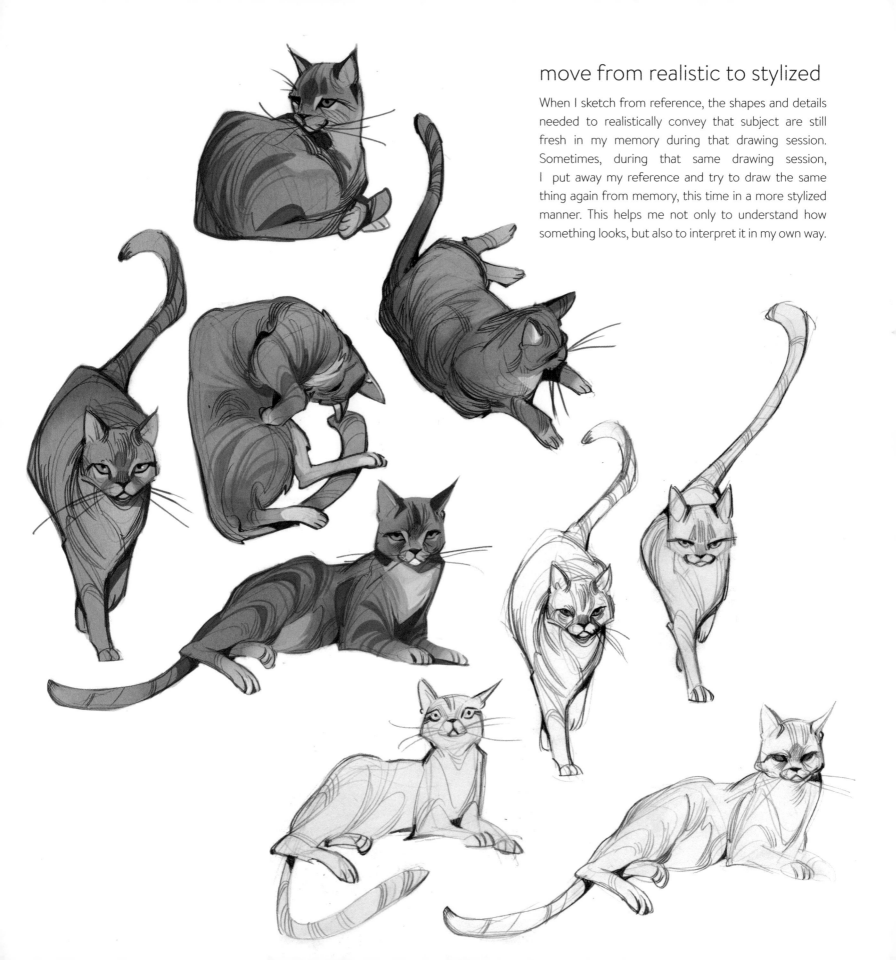

move from realistic to stylized

When I sketch from reference, the shapes and details needed to realistically convey that subject are still fresh in my memory during that drawing session. Sometimes, during that same drawing session, I put away my reference and try to draw the same thing again from memory, this time in a more stylized manner. This helps me not only to understand how something looks, but also to interpret it in my own way.

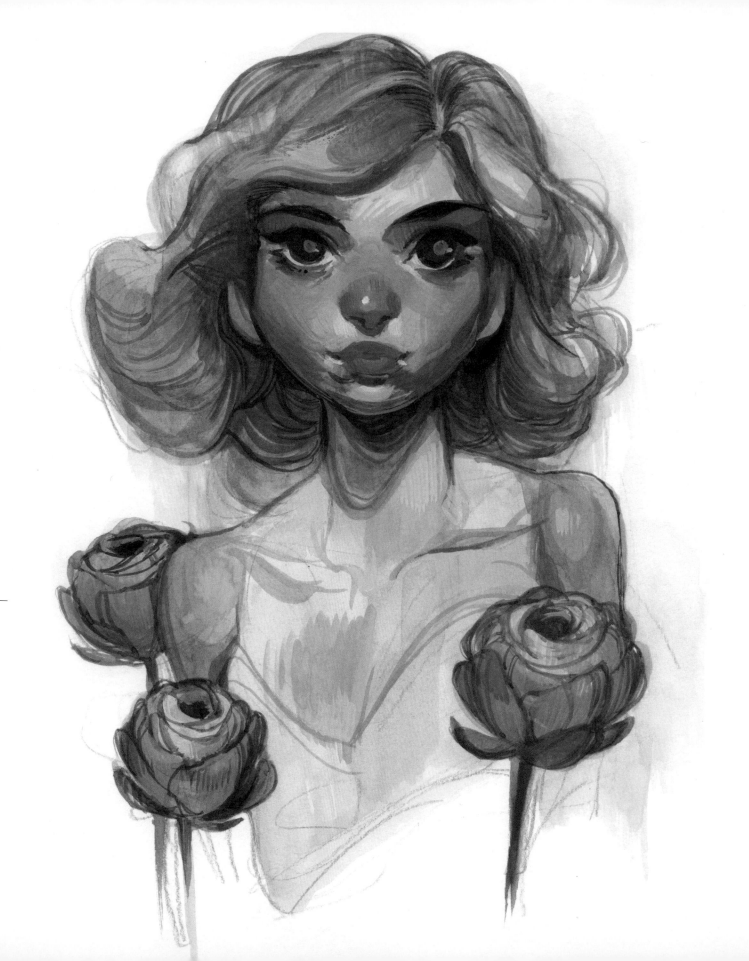

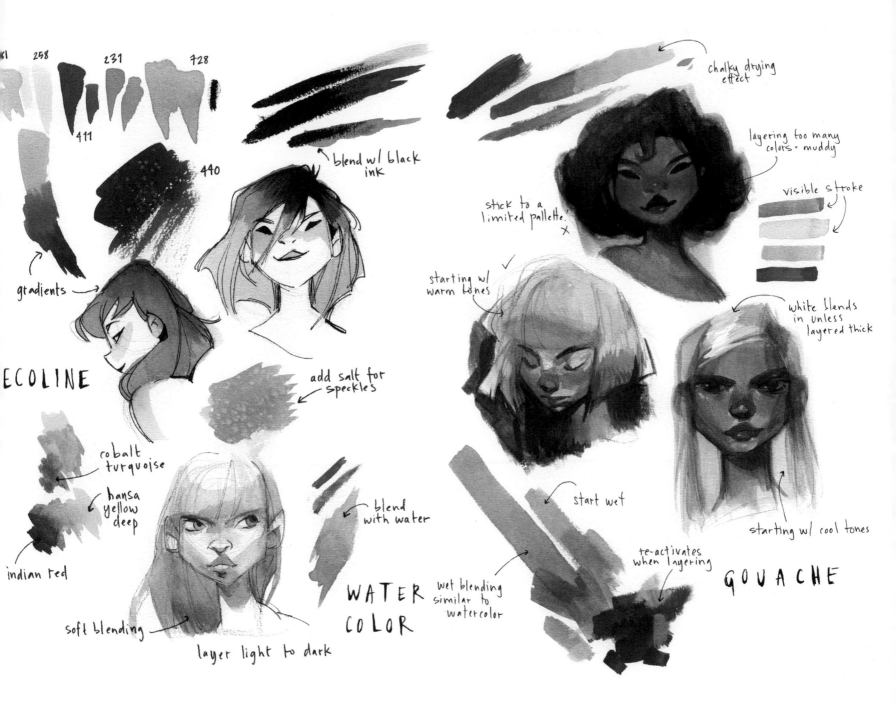

ECOLINE

gradients

cobalt turquoise

hansa yellow deep

indian red

blend w/ black ink

add salt for speckles

soft blending

layer light to dark

WATER COLOR

blend with water

stick to a limited pallette. x

starting w/ warm tones ✓

wet blending similar to watercolor

start wet

re-activates when layering

chalky drying effect

layering too many colors = muddy

visible stroke

white blends in unless layered thick

starting w/ cool tones

GOUACHE

try something new

As I developed my creative skills, I started using more and more techniques that I fell back on automatically whenever I drew. These deeply rooted approaches became invisible if I used them over and over again on the same subject matter. But whenever I tried something new, I not only expanded my skillset, but my automatic habits came into clear focus. Doing this helps me become more aware of which techniques feel natural to me, and gives me the opportunity to critically examine whether they are helpful in my creative practice.

· style characteristics ·

For this book, I analyzed my own art and tried to figure out what the defining aspects of my style are. I wanted to delve to a level deeper than simply listing the visual cues that make my art recognizable, so I focused on the motivations behind these choices: Why do I draw in this way? What powers these creative decisions? I broke them down into four core elements.

Volume with shapes

My art is stylized, but I've always wanted it to feel "real" in some way, as if you could reach out and touch it, or picture it in a three-dimensional space. It's something I gravitate towards because I want to balance the imaginary elements of my work with something tactile and believable. Because of this, I'm always striving to create a sense of volume with the shapes I draw.

Vibrant & emotive colors

Colors have a strong emotional effect on me. They can bring powerful feelings of nostalgia, radiate emotional intensity, or evoke pure aesthetic joy. My digital workflow allows me to use my intuition to choose the colors, tweaking and adjusting them until they evoke an emotion. My color choices are fundamentally emotive because my emotions are a guide when I choose the colors for my art.

Visual flow

I never quite got over *The Little Mermaid* and the flowing forms that captured my imagination when I was a child. The elegant movements made Ariel feel alive, dynamic, and exciting. From watching it, I learned that flowing forms are a way to bring a drawing to life and elevate it beyond a static image. This aesthetic motivates much of my art, and is the source of many of the techniques I use for conveying movement.

Emotional subjects

When I recall a story or event in my life, I tend to think of it in terms of the emotions I felt. Details and facts fade to the background, but moods and feelings are prominent in my memory. It's my way of making sense of the world, and it feels natural to make creative choices that are organized around conveying a mood first and foremost. Much of my work is focused around characters, because they form an ideal reference point for these emotional themes.

In the following chapters, I will elaborate on each core element of my style, exploring how they manifest in my work and what motivates the creative decisions behind them. I'll also suggest some exercises that might help you discover and develop your own style and artistic voice.

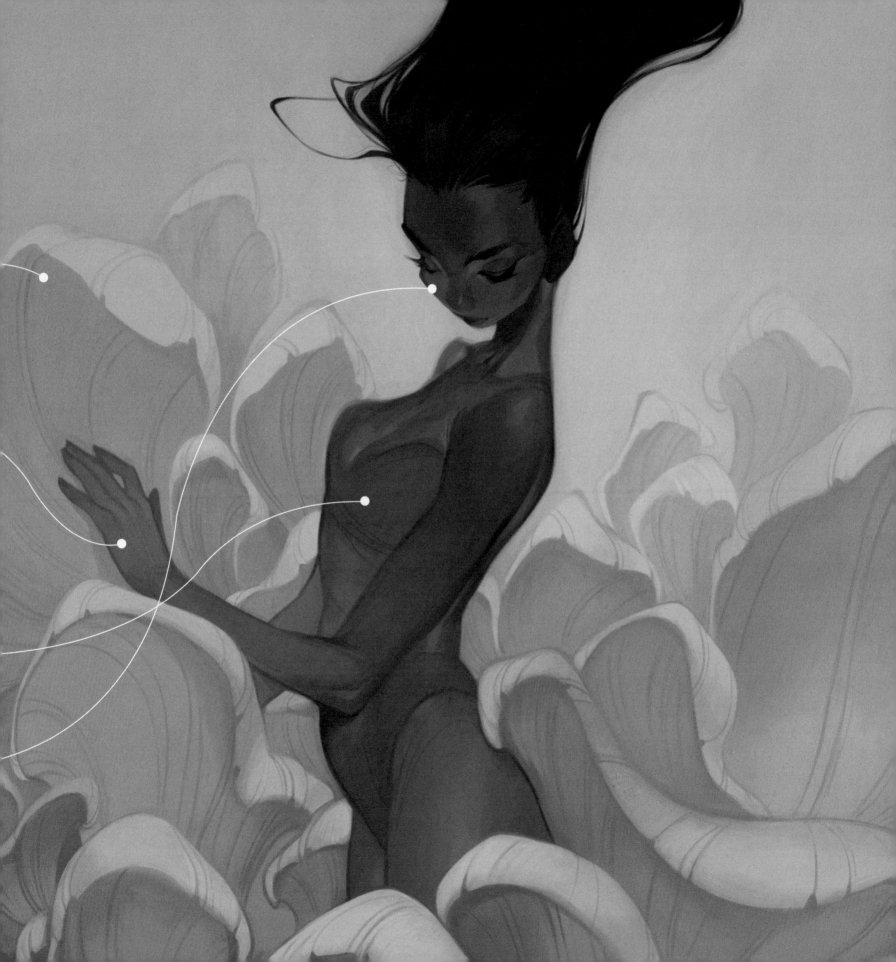

· creating volume through shape ·

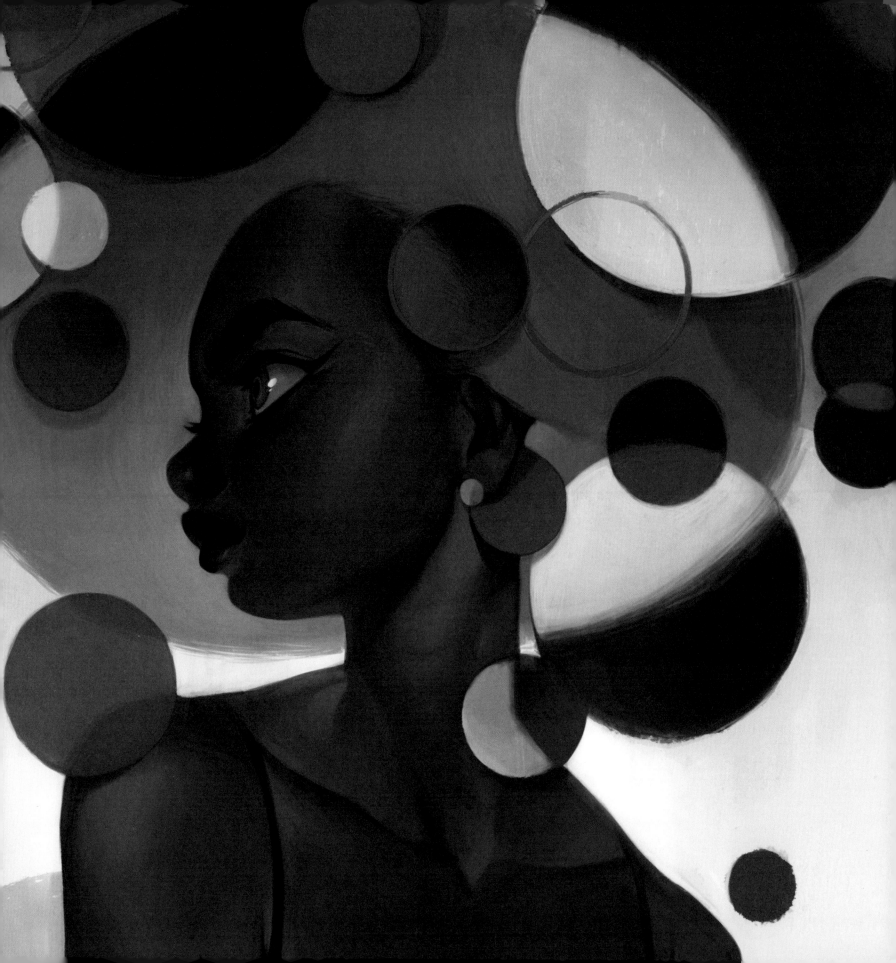

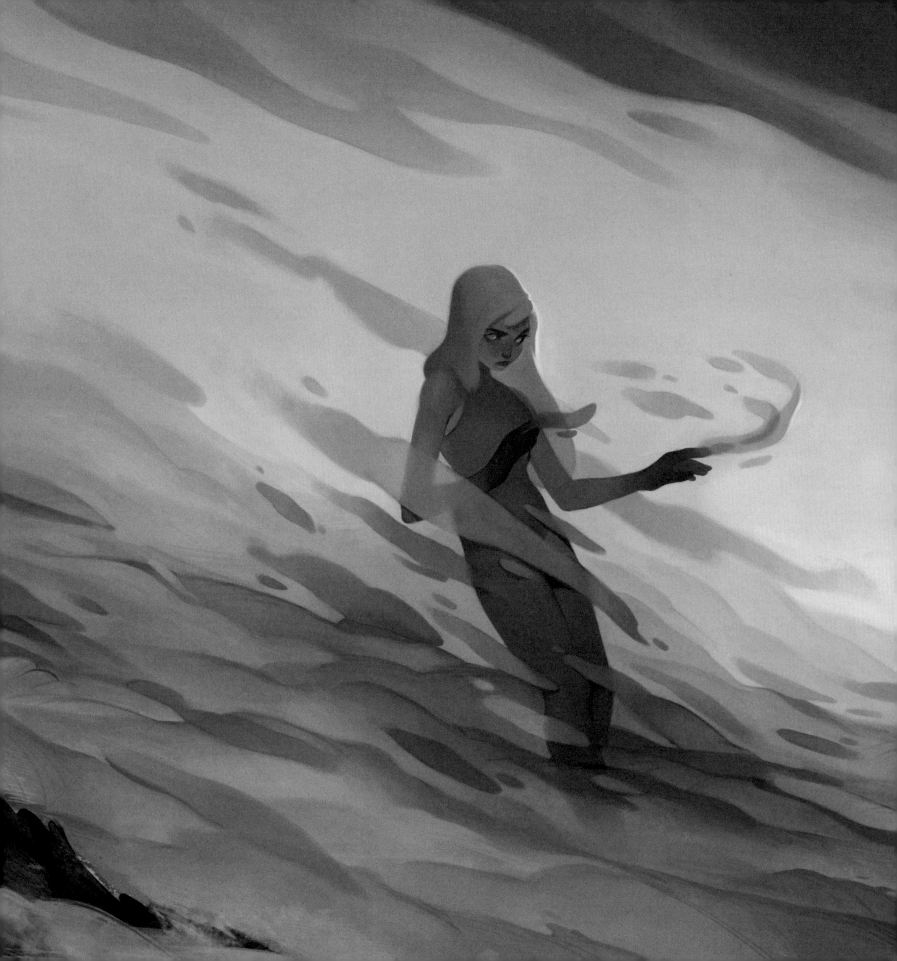

At the age of fifteen, I made a conscious decision to switch from relying heavily on reference, to drawing from the imagination. This required a huge change in mindset. I had to visualize the subject in my head before putting pencil to paper to capture the visualization accurately. I struggled with it at first, and my lines were often wobbly and full of hesitation. My art was missing something, but I couldn't put my finger on what. I compared my beginner sketches to those of my great inspirations, trying to figure out where I had gone wrong. Finally, I saw it: my drawings were missing a believable three-dimensional form. Instead of capturing something with a clear volume, I didn't know where to set my first lines, and the details were floating helplessly on the page with nothing to anchor them.

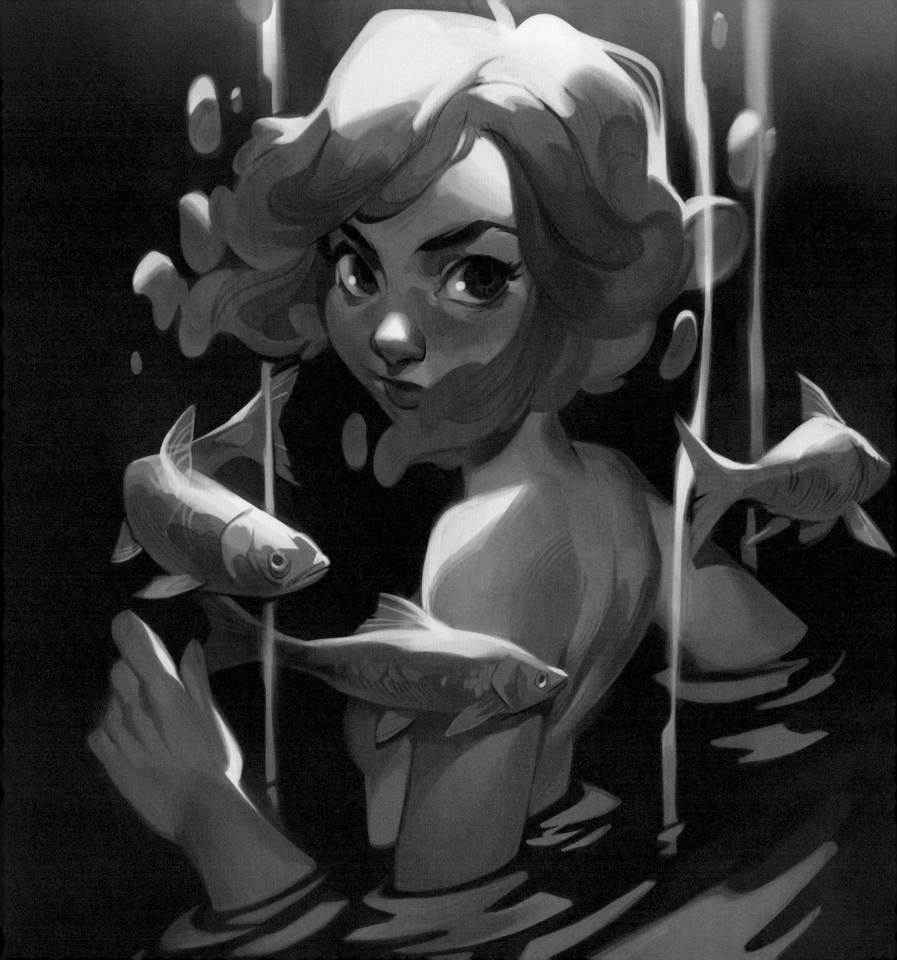

As I continued to practice, I learned that a drawing comes to life when it conveys volume and form. This gives the artwork a tactile quality that sparks the imagination and makes you want to reach out and touch it. This is especially potent when it is combined with visual elements that are stylized and contain elements of magic or fantasy, because it brings these fantastical elements into the realm of believability. From that point forward, I made it my goal to create volume through shapes in my artwork. I see this as an essential ingredient in maintaining the balance between stylization and realism in my work.

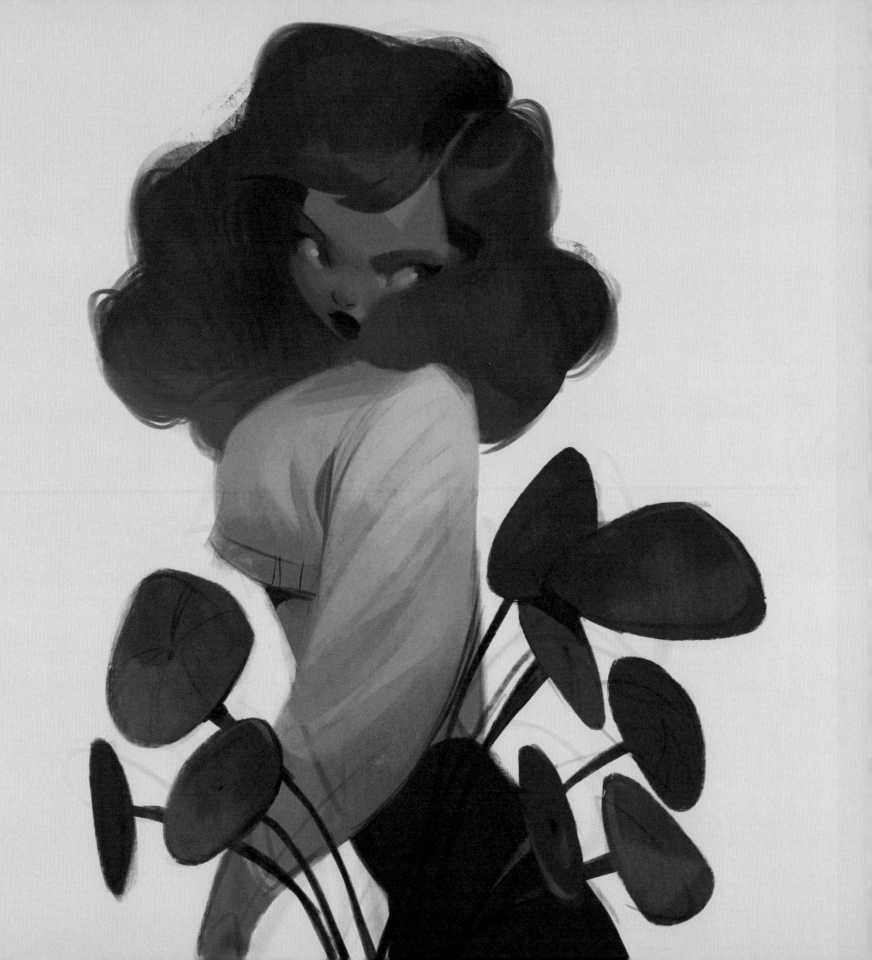

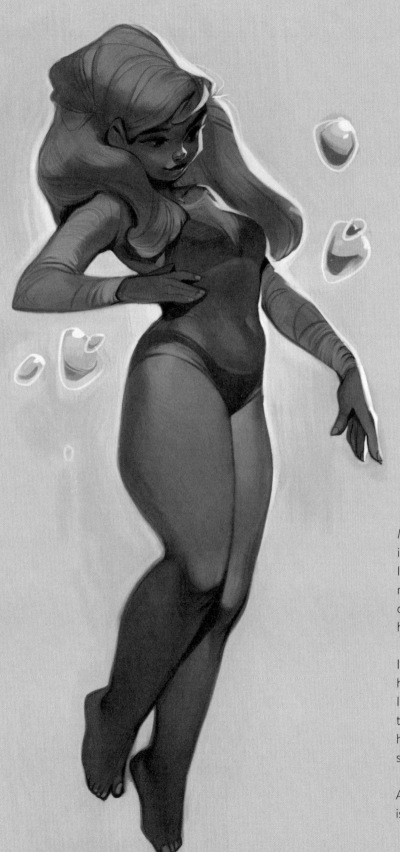

· semi-realism ·

My style has often been described as semi-realistic, which means that it has elements of both realism and stylization. This was something I didn't realize until other people pointed it out, since it was largely the result of intuitive design choices. I then began analyzing my own art to decipher how semi-realism manifested in my work, and realized that it had a lot to do with the first steps in my creative process.

I usually start with a cartoony character construction, featuring a larger head, big eyes, and exaggerated proportions. Later in the process, I move past this cartoony simplification and apply detail and lighting that feels more realistic. The result is similar to a traditional caricature: it has visual cues based on realism, but also exaggerated proportions and shapes that make it stylized.

As such, the construction of shapes in the early stages of my process is a defining aspect of this semi-realistic visual style.

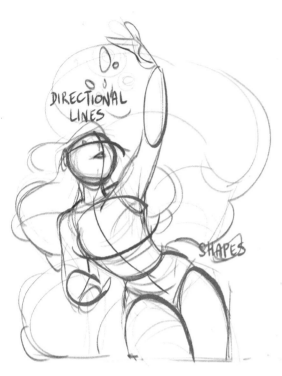

DIRECTIONAL LINES

SHAPES

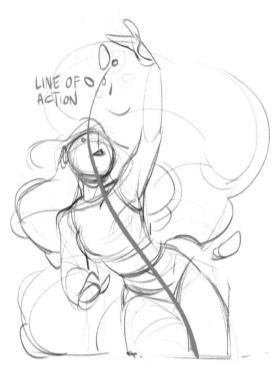

LINE OF ACTION

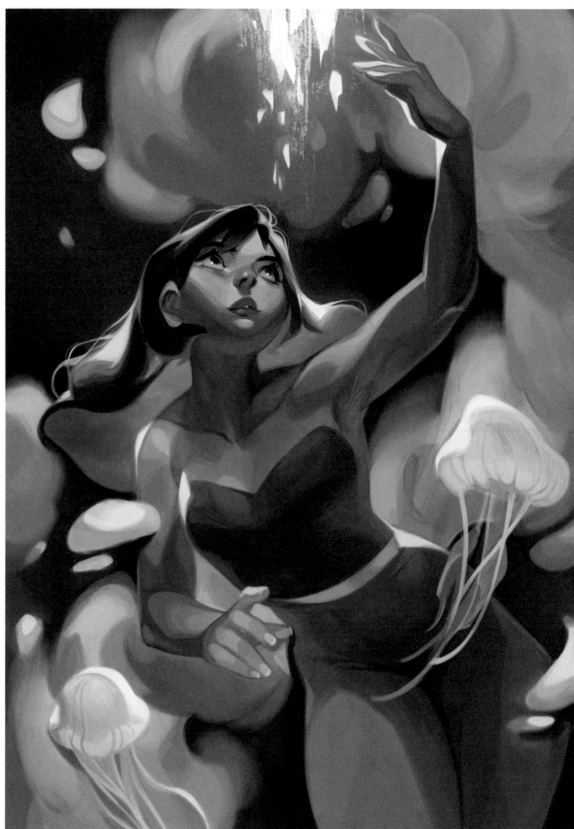

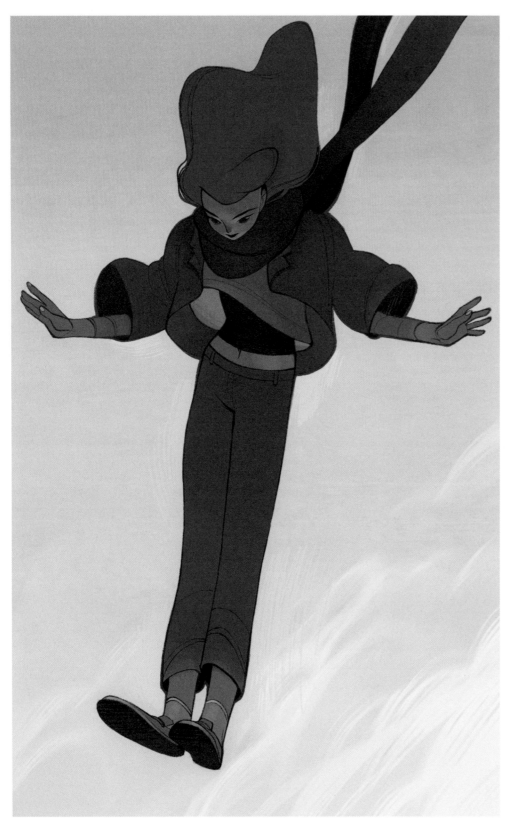

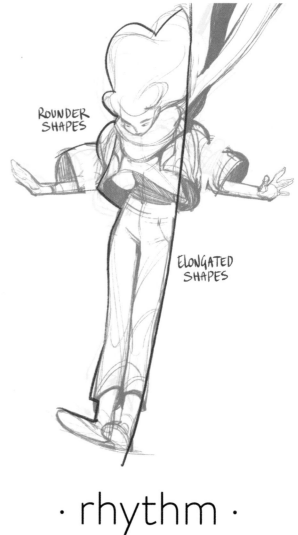

ROUNDER
SHAPES

ELONGATED
SHAPES

· rhythm ·

Conveying mass and movement in the individual shapes
is not the only way to create energy in the volumes.
It can also be created through *rhythm*, which happens
when different types of shapes, edges, and lines are
combined. When there's enough variety between
them, your eye will bounce from one shape to the
next, which enhances the sensation of movement in
the artwork. Creating an appealing sense of rhythm is
easier said than done. Does a drawing have too many
straight shapes, or too many round shapes? You only
really know when you see it. Because of this, I use a
trial-and-error approach, usually exploring different
options in my early sketches until I like what I see.

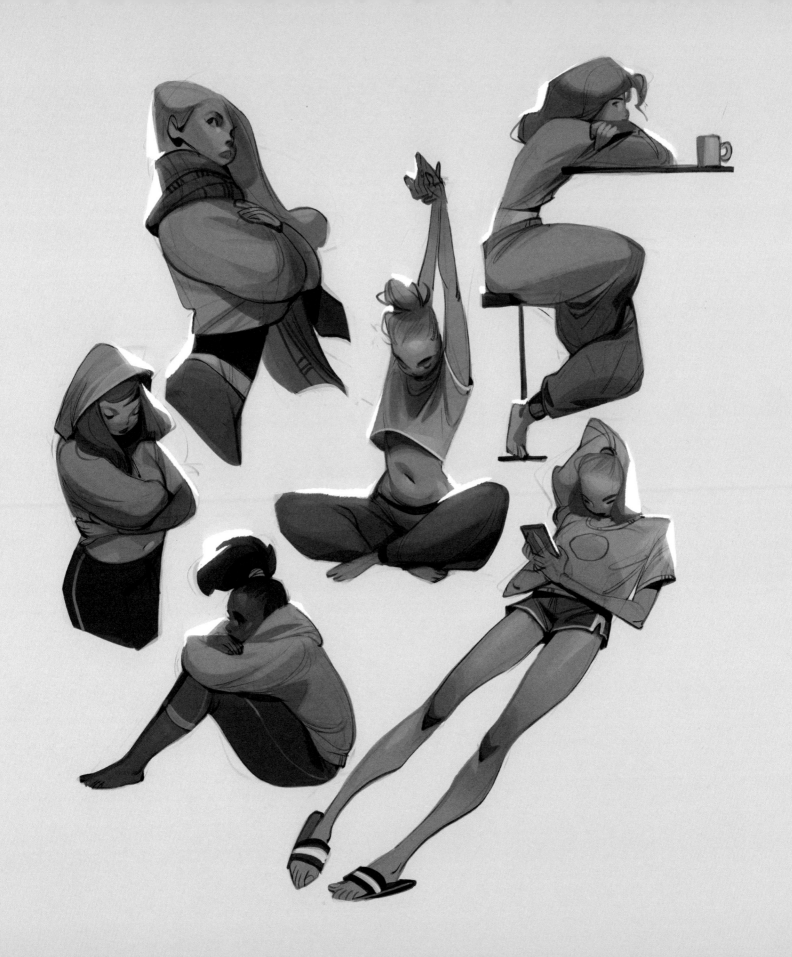

· energetic shapes ·

I've found that the more detail I add to my work, the more I lose the energy of my initial sketch. I try to offset this by ensuring that the shapes I draw in my initial sketch have a sense of energy and life.

Giving energy to a shape sounds like an abstract concept, but it's something that animators specialize in. One of the first assignments given to animation students is to animate a pillow or sack to appear as if it is walking or jumping. By giving a shape a stretchy quality and emphasizing its weight, any form can look like it has a will and a life force. I often keep these principles in mind when creating a rough sketch. The shapes are drawn with some degree of squishiness that can be found in character animation, and perspective lines and a line of action suggest weight and direction.

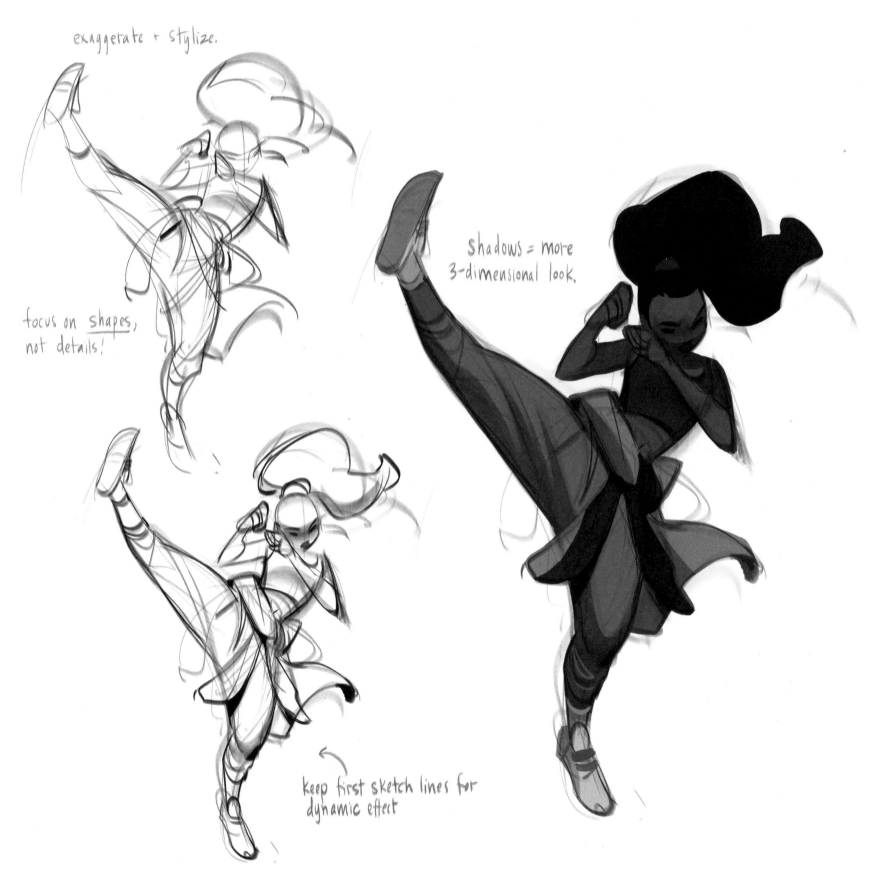

exaggerate + stylize.

focus on shapes,
not details!

shadows = more
3-dimensional look.

keep first sketch lines for
dynamic effect

45

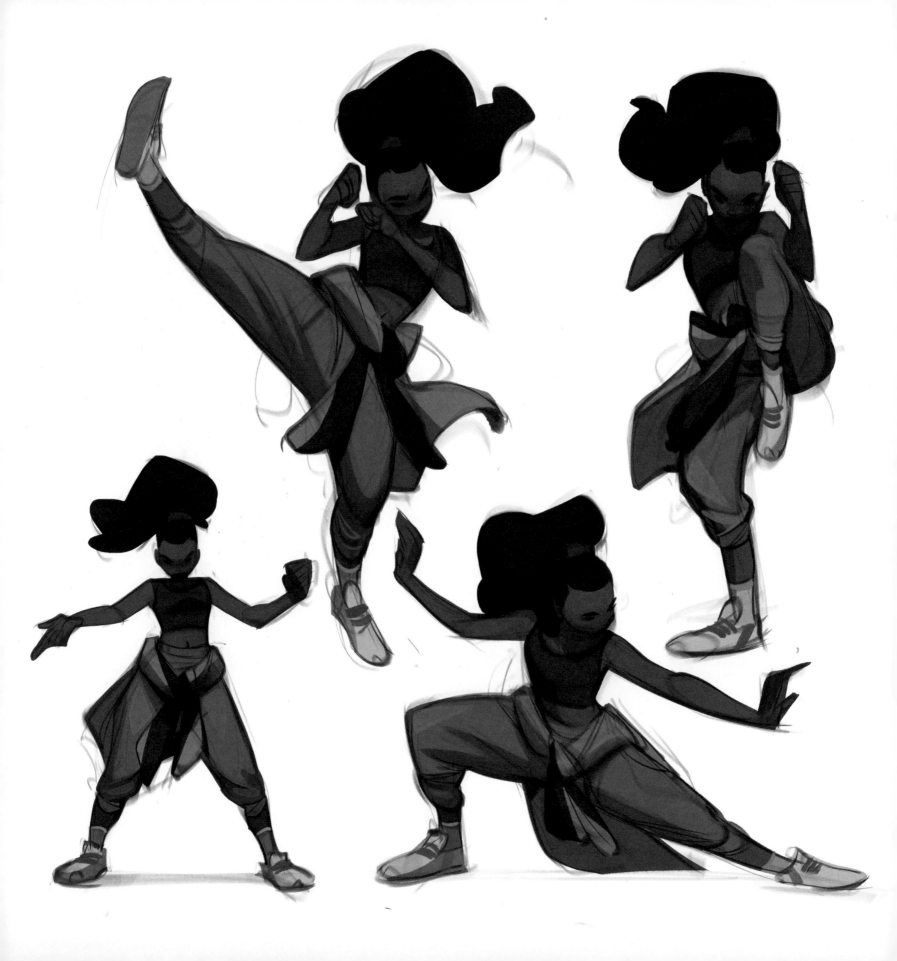

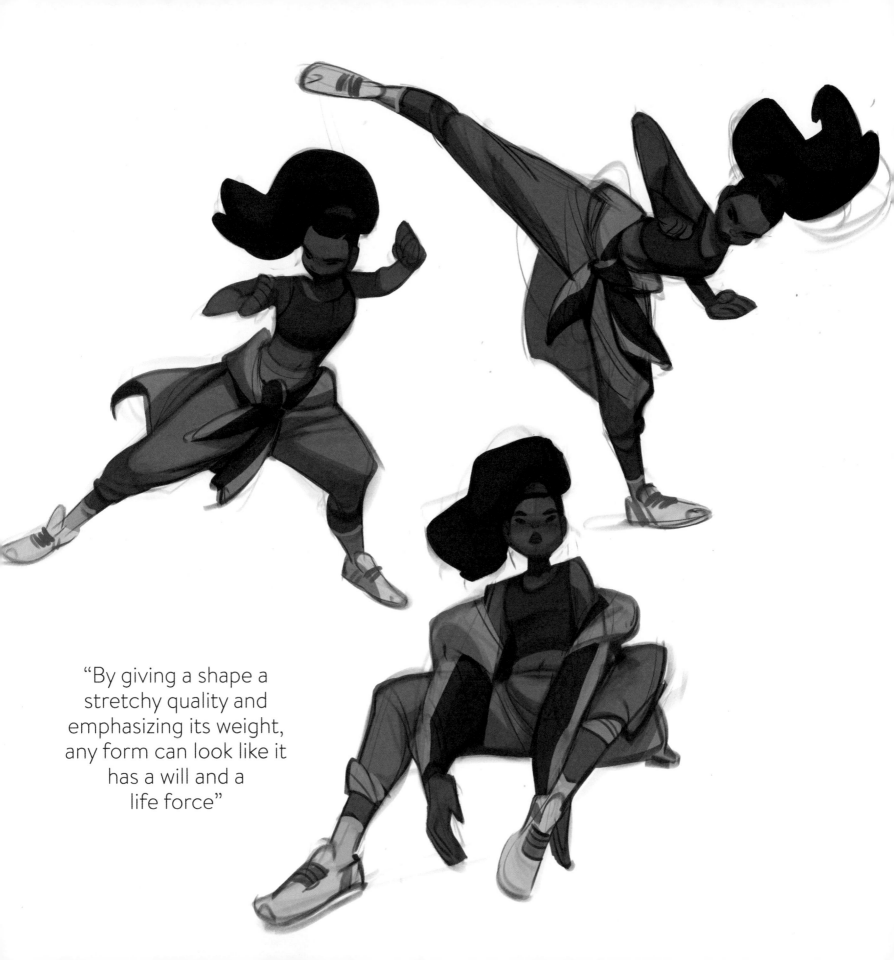

"By giving a shape a stretchy quality and emphasizing its weight, any form can look like it has a will and a life force"

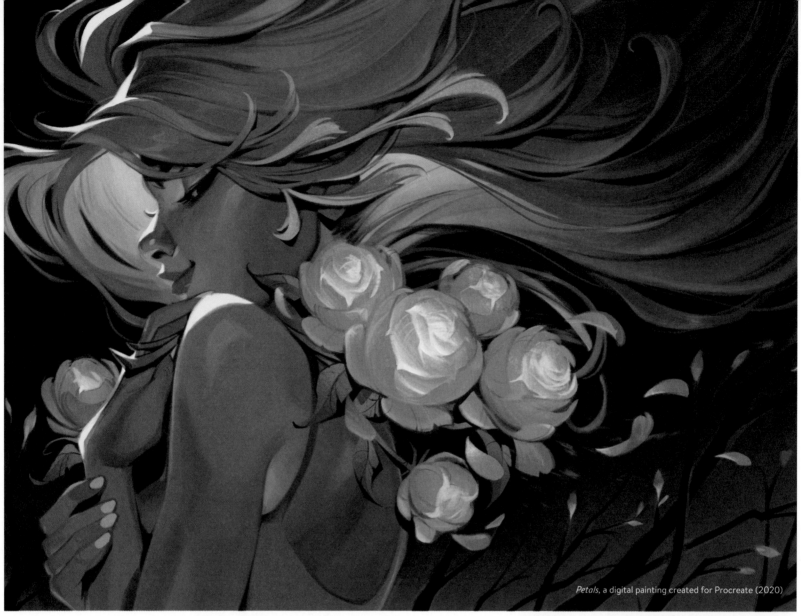

Petals, a digital painting created for Procreate (2020)

· painting shapes ·

In my painting process, I establish the basic shapes primarily in the initial sketching stages. When I move into the detailing and rendering stages, it's important that the volume and expressiveness of the shapes is not lost under a layer of detail. My creative choices surrounding color, highlights, and shadows tend to focus on maintaining, or even pushing, the three-dimensional shapes. As I continue to learn new techniques, I'm always looking for new ways to cultivate this essential ingredient of my artistic style.

"chunky" approach to layering highlights and shadows

bright highlight

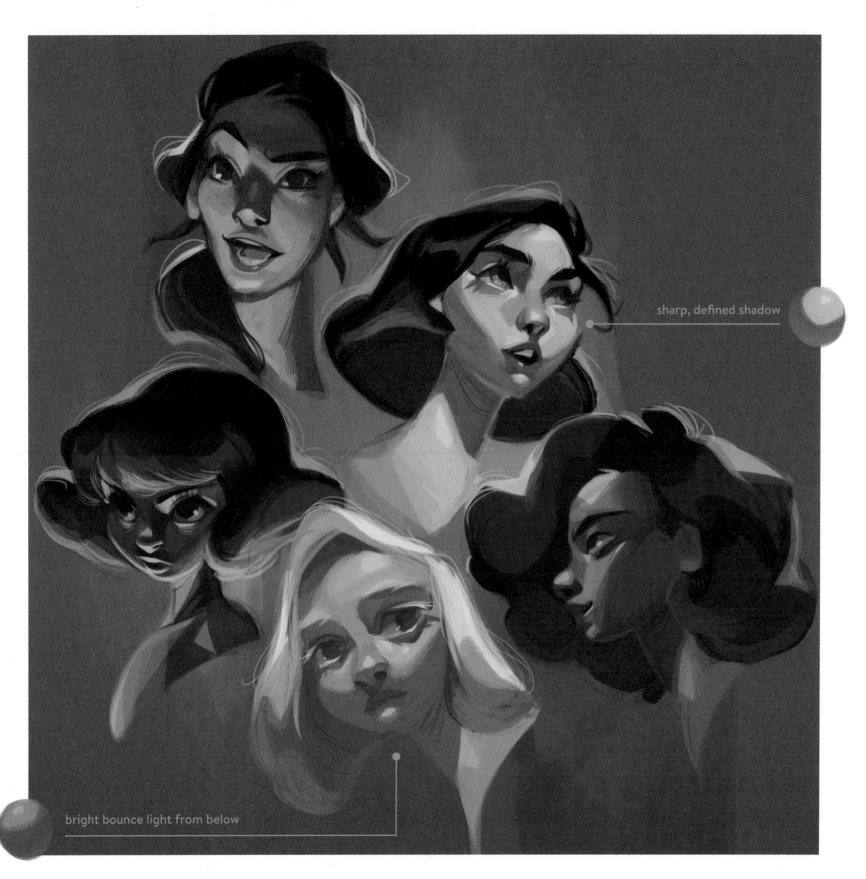

sharp, defined shadow

bright bounce light from below

49

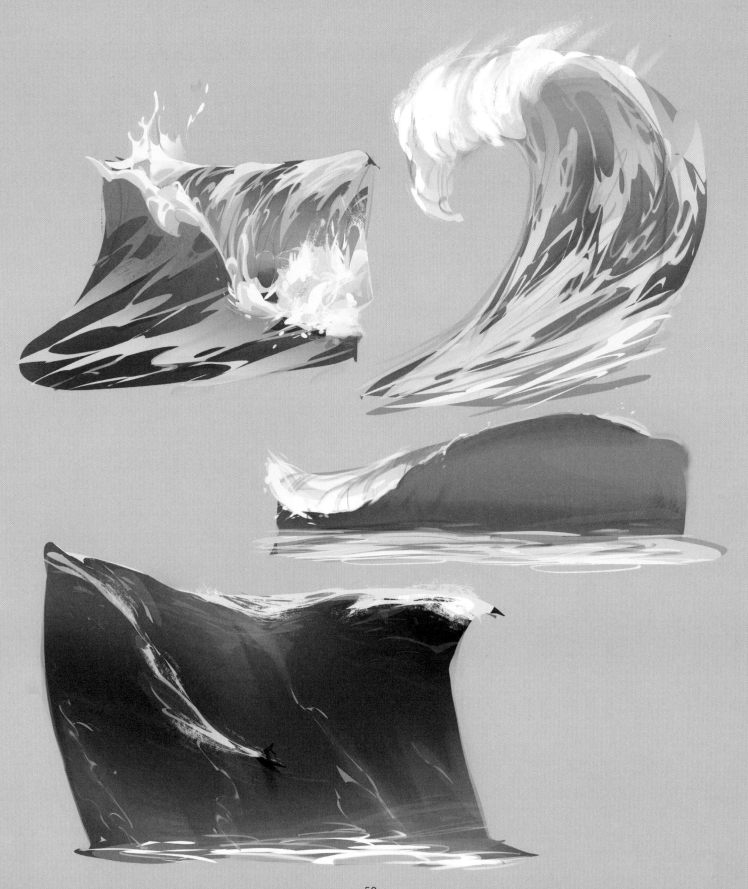

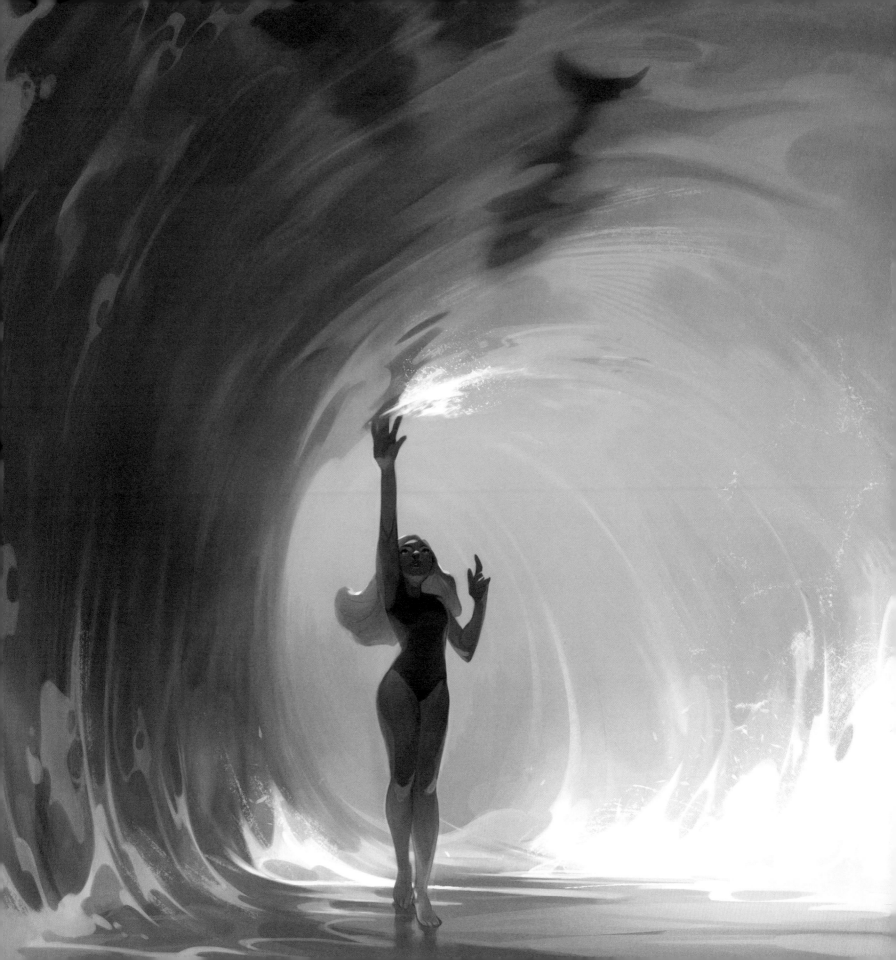

techniques //
conveying shapes

starting simple

I find that the more I can simplify the shapes in my initial sketch, the more effectively I can capture the movement and gesture I am aiming for. A basic construction consists of three main ingredients: shape, directional lines, and line of action. If you can convey these three things, you can create a simple character sketch. If you struggle with this, try limiting the time you spend on a sketch to just thirty seconds or less. The more you challenge yourself to draw quickly, the more you will improve at simplifying your character sketches.

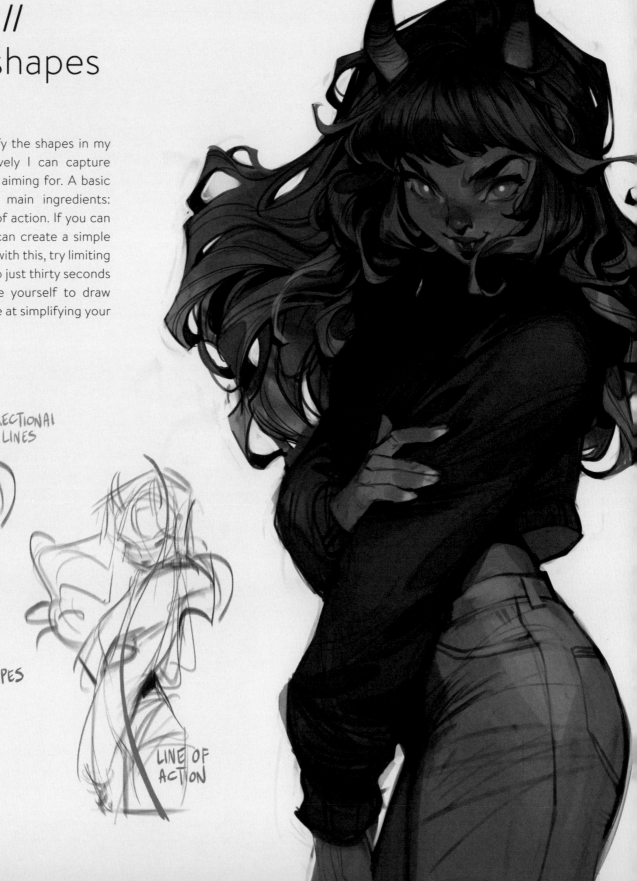

DIRECTIONAL LINES

SHAPES

LINE OF ACTION

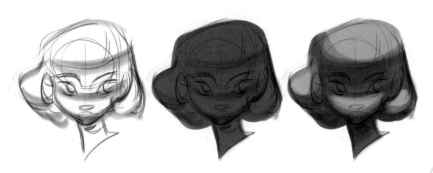

sculpting with color

This is a term that was once used to describe my art, and I have never forgotten it because it conveys the essence of my process so accurately. This technique involves using color to carve out the volumes of a drawing. It works best to start with one color, and then paint lighter and darker values on top of it. Block in the overall highlights and shadows first, and "sculpt" the details from these rougher forms.

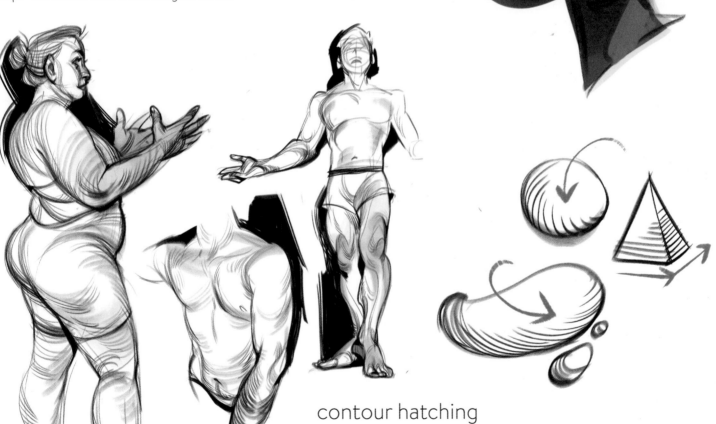

contour hatching

This is a hatching technique in which the lines follow the contours of the shape. The resulting lines look as if they are wrapped around the shape they are conveying. When I draw lines, I can easily fall into the trap of only thinking in terms of the outlines and, as a result, flattening the subject. Contour hatching keeps me focused on the volumes and three-dimensional qualities of my sketch.

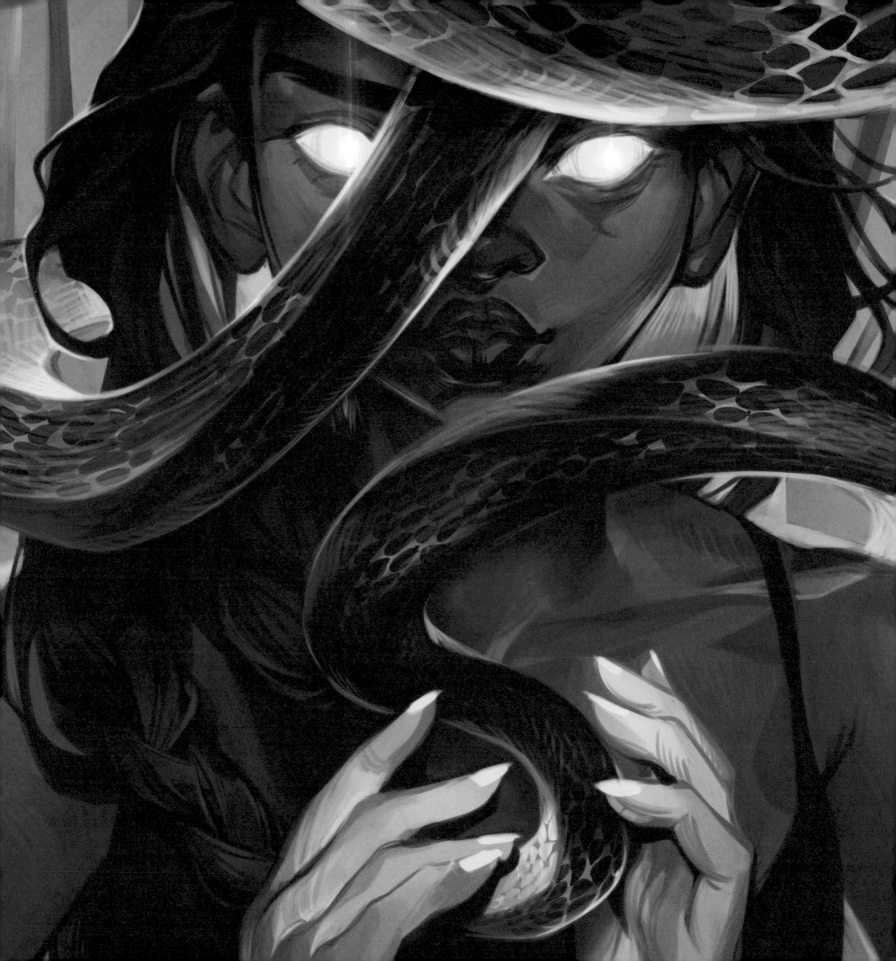

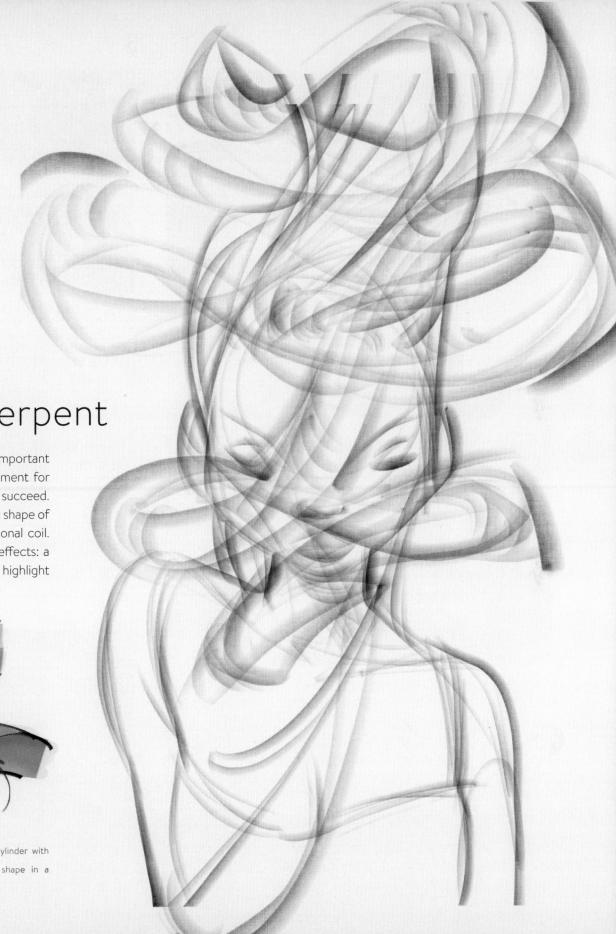

case study // serpent

Serpent is a painting where volume plays an important role. Effective dimensionality was a requirement for this painting to have a visual impact, and thus succeed. In the initial sketch, I aim to capture the basic shape of the snake, envisioning it as a twisted hexagonal coil. In order to add more depth, I add lighting effects: a bright yellow glow from below and a grayish highlight from above.

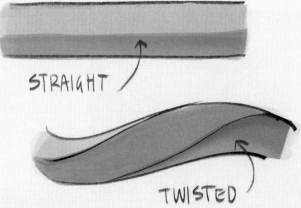

STRAIGHT

TWISTED

Drawing the shape of the snake as a straight form (a cylinder with flat edges), before twisting it, helps to envision the shape in a three-dimensional setting.

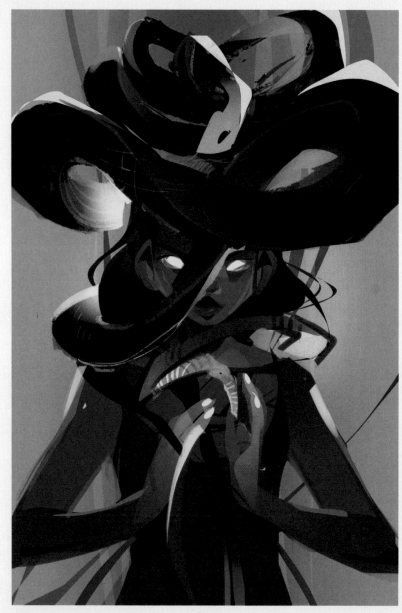

At this stage of the painting process, I focus on conveying the shape of the snake, before thinking about its surface texture.

Attempt 1: scribbles/cross-hatching.

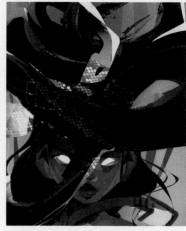

Attempt 2: copy and paste a texture.

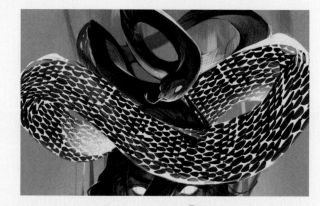

ARRANGE OVER SECTION OF SNAKE

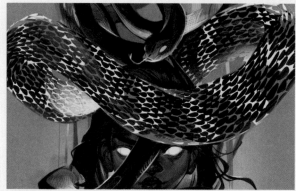

LOCK TRANSPARENCY + PAINT THE STRIPES

The biggest challenge was elevating this basic shape to a higher level of detail. I tried a few different techniques to add a believable snake texture, but they flattened the shape instead of emphasizing it. In the end, I ignored the texture and just focused on painting the basic shape. I then created my own snakeskin texture, which I wrapped around the shape using the Warp tool. The end result is somewhere between a real snake and a snake that could only exist in a fantasy world, which is a fundamental characteristic of the semi-realistic style that defines my art.

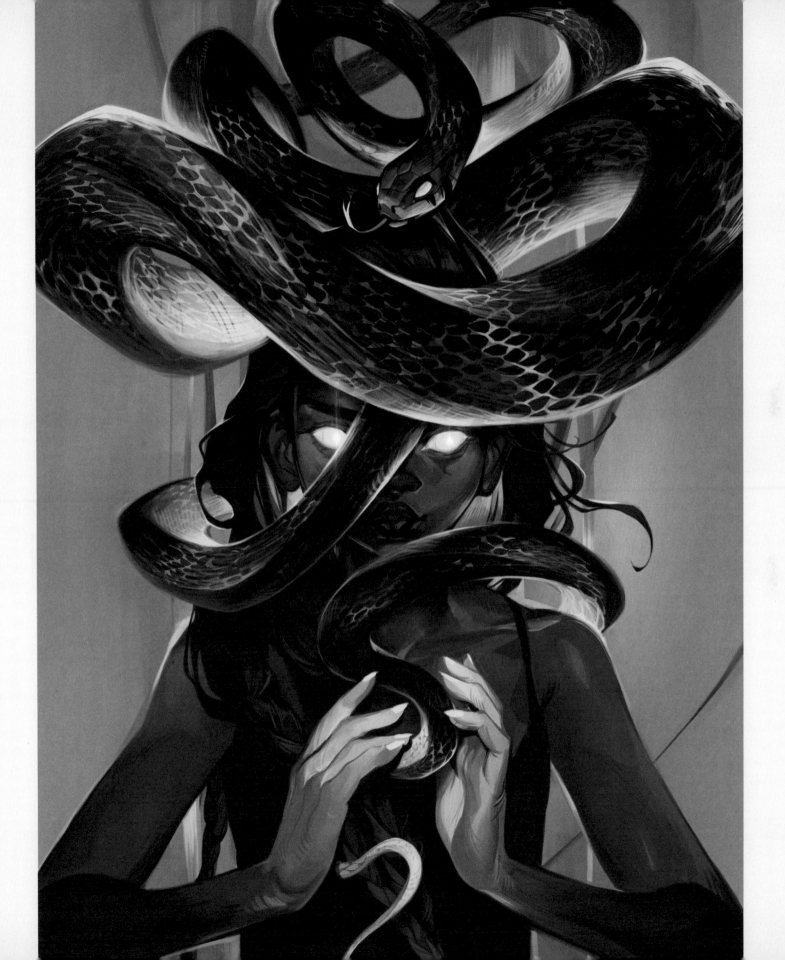

exercise // find your shape language

In the first chapter, I discussed how important it is to identify which visual elements you are naturally drawn towards. This exercise is intended as a way to explore different stylistic approaches, but more importantly, to discover which shapes intuitively capture your attention the most.

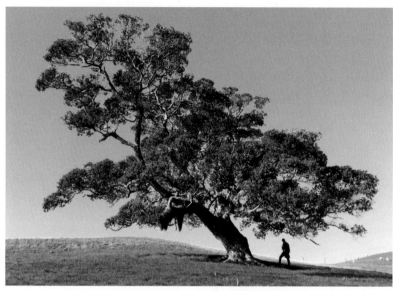

Begin by making a few quick sketches in which you simplify the basic shapes and forms of this tree in a few different ways. You can try the examples here, or try a few of your own ideas too.

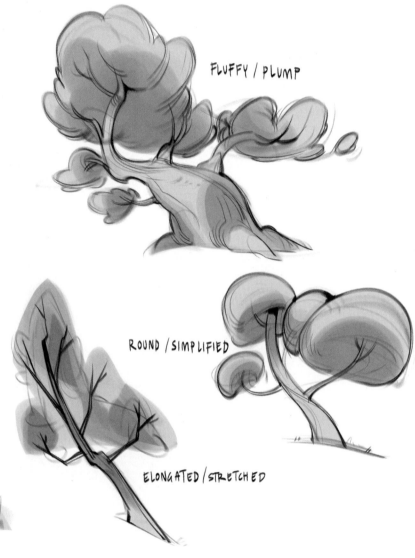

FLUFFY / PLUMP

ROUND / SIMPLIFIED

ELONGATED / STRETCHED

ANGULAR

TWISTY

Which way of simplifying the tree was the most interesting and enjoyable for you? Which shapes did you identify first and which did you find the most satisfying to capture in your sketch? The shapes you feel most drawn towards might tell you something about how you see the world, and by extension, how you can capture your unique vision in your art. Try this exercise on different subjects, and you will gradually start to see your own approach to shapes develop in your art.

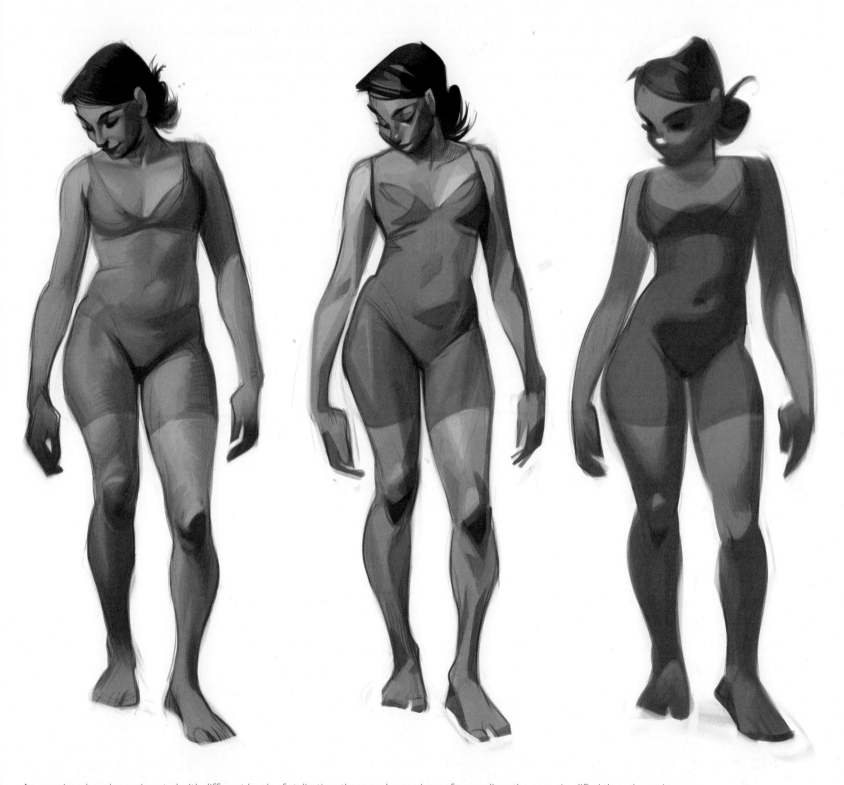

An exercise where I experimented with different levels of stylization; the more I moved away from realism, the more simplified the volumes became

· vibrant & emotive colors ·

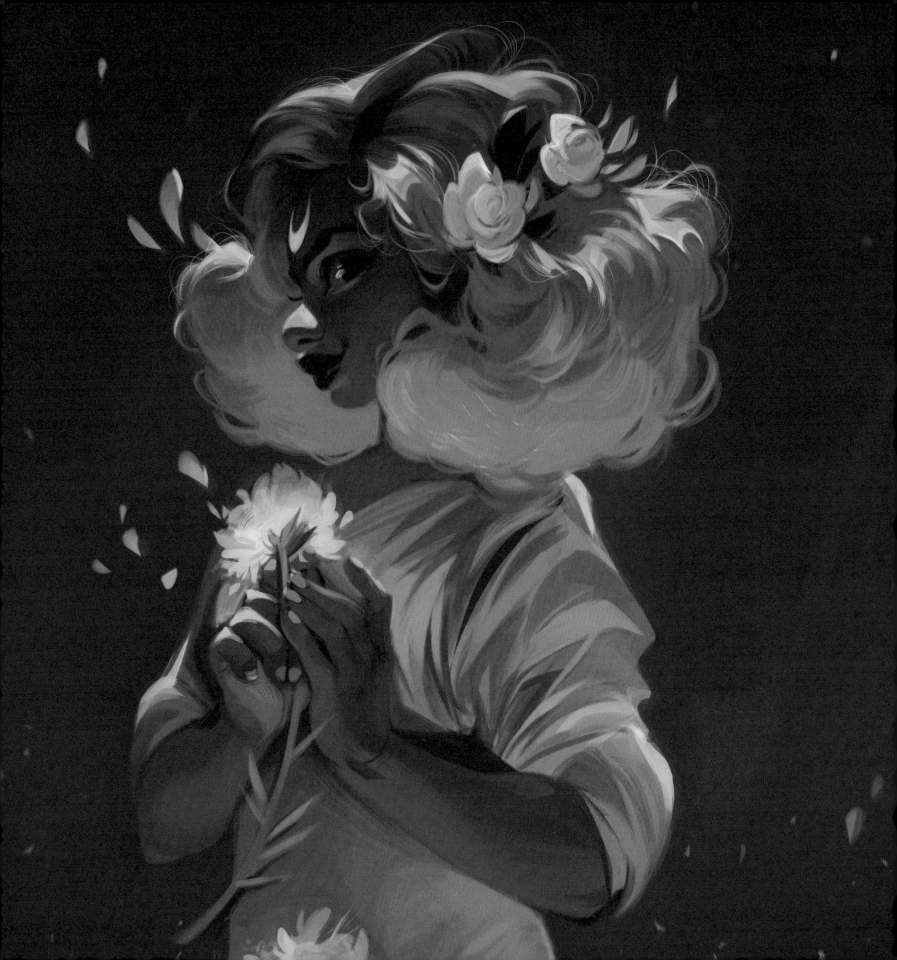

Ever since I first started developing my artistic style, I have received remarks about my use of color. Some found them too bright and intense, others experienced them as muted and soft. Regardless of how they were experienced, this feedback made it clear to me that my color use stood out as something distinctive, and as a result, was an important foundational aspect of my style. I have never studied color theory or taken a fact-based approach to understanding how colors interact. Instead, I have always relied on my instinctive, gut-feeling response to guide my creative decisions around color. As such, my relationship with color is rooted in my emotions that surround them.

One of the strongest emotions that dictates my relationship to color is nostalgia. I was the kind of kid who played with Barbies, My Little Ponies, and anything Disney. The sweet pastel hues, iridescent shimmers, and bright glitter surfaces of these 1990s toys captured my imagination. As a teenager, my view of the world changed and I started wearing only black, with a scowl as my default expression. My art, by contrast, became more colorful than ever. Art became a way for me to express a side of myself that craved the innocence and happiness of childhood, and my color choices flowed forth from the warm, nostalgic emotions that they stirred in me.

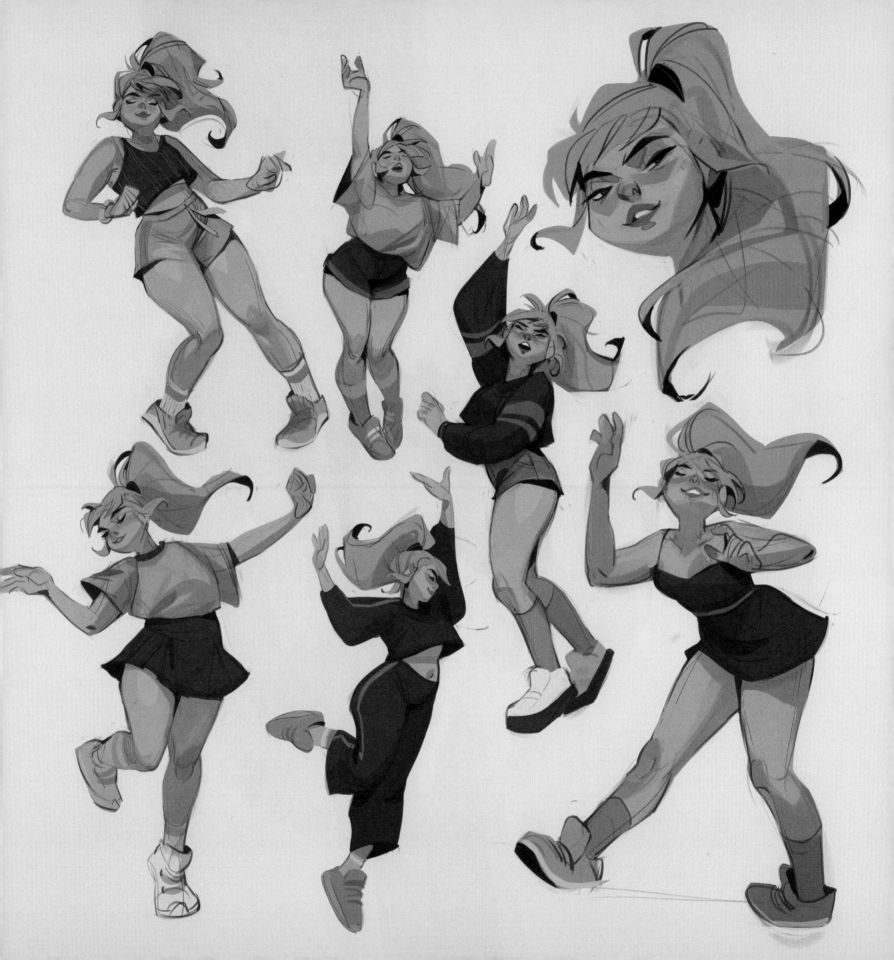

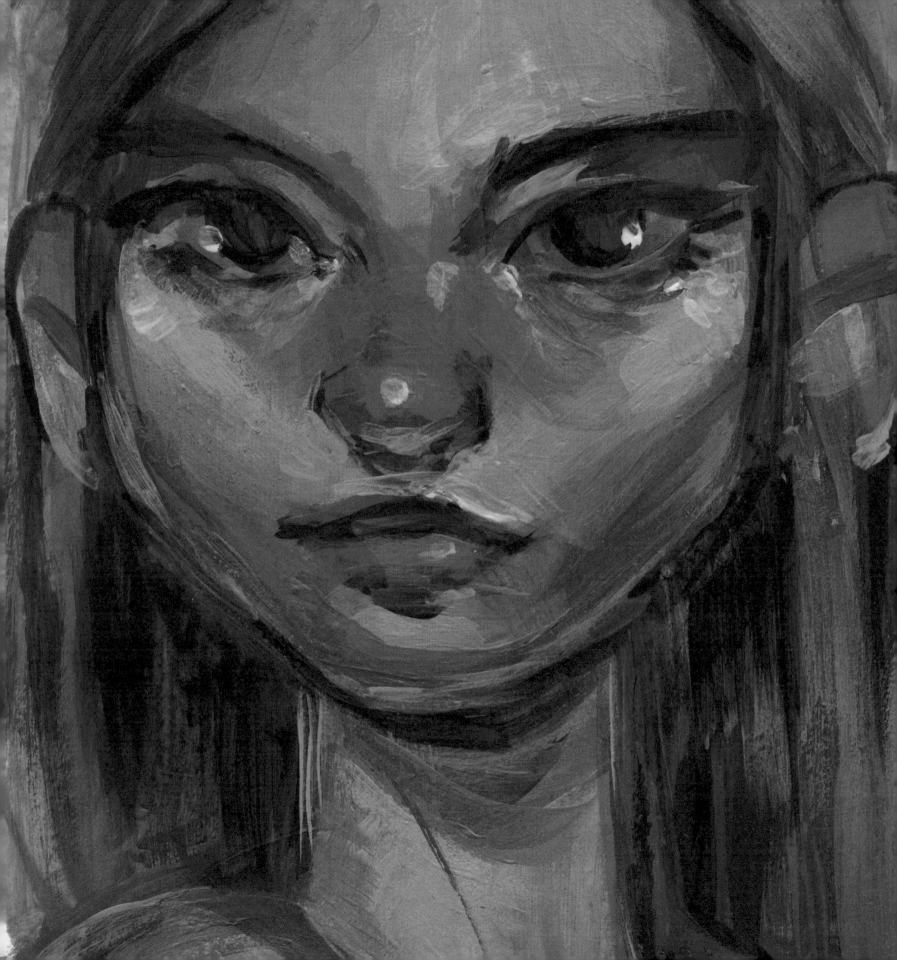

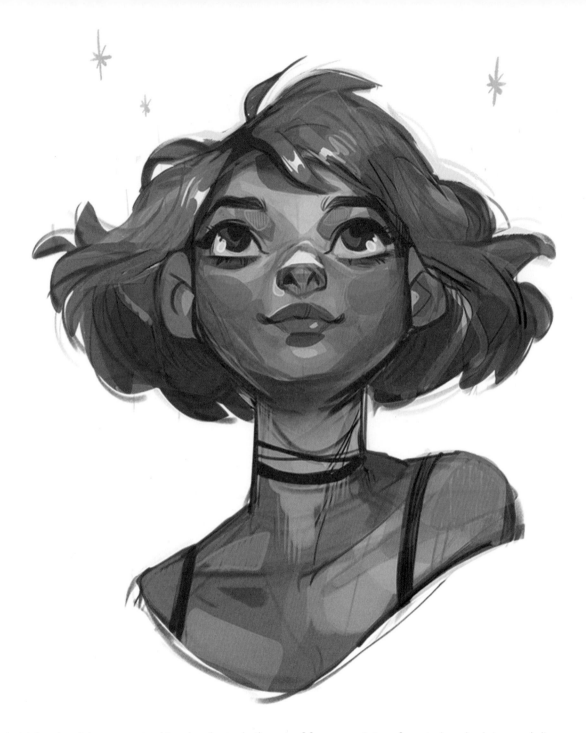

In high school, I was required to closely study the art of famous painters for art class. In doing so, I discovered the art of Lucian Freud and Gustav Klimt, who mixed blues, greens, purples, and other unexpected colors into the skin tones of their subjects. Somehow, these colors didn't clash with the rest of the painting at all. In fact, they made the portraits feel more alive and vibrant with warmth and energy. Later in my creative journey, I was introduced to the art of pop surrealists and was fascinated, especially with the work of James Jean. I saw bright candy colors mixed with dark and dreamlike imagery, and I learned that the soft pastel hues of my childhood could be reconciled with a more mature artistic style.

Opposite page: Acrylic portrait. I found that using neon colors helped to prevent mixing muddy colors while painting with this medium

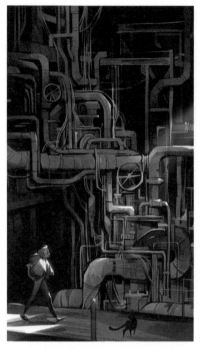
Desaturated variation

Saturated variation

· intuition ·

When asked how I choose my colors, I usually state that I do so intuitively. Many find that to be a vague answer, and rightfully so. What does that actually mean? In the purest sense, it means that I look at a color and ask myself whether I like it. If I don't like it, I will change it. If I do like it, I try to push it a little further to see if I can like it even more. Then I add another color, and ask myself: do these colors work together? What do I like about this? How can I modify these colors so that they feel more harmonious? I continue this process with every new color that I add. It's a trial-and-error process, gradually adjusting what's in front of me until it feels like the colors are singing in perfect harmony. Digital software was essential in allowing me to develop this approach, giving me the freedom to endlessly tweak and adjust colors at any point in the process.

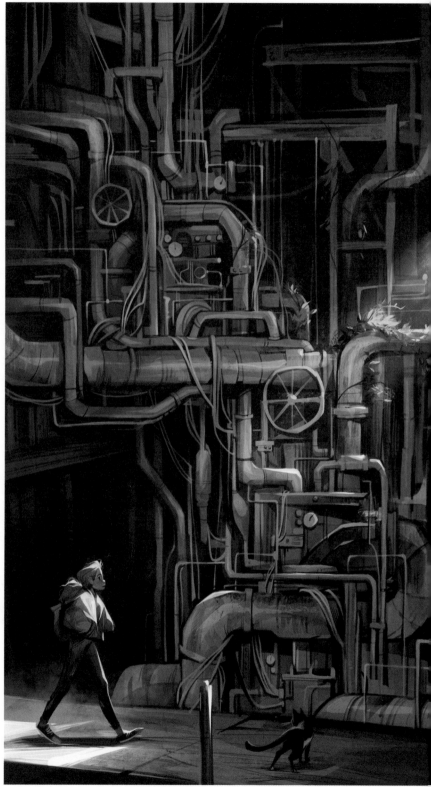
The final design

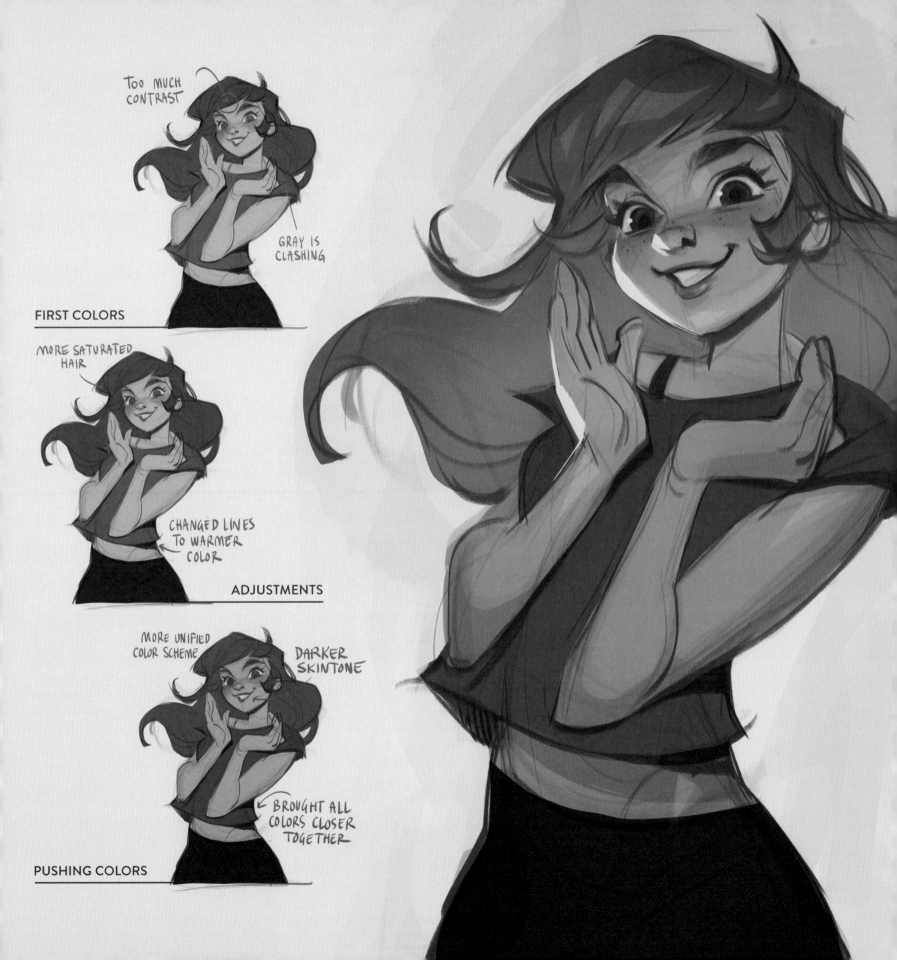

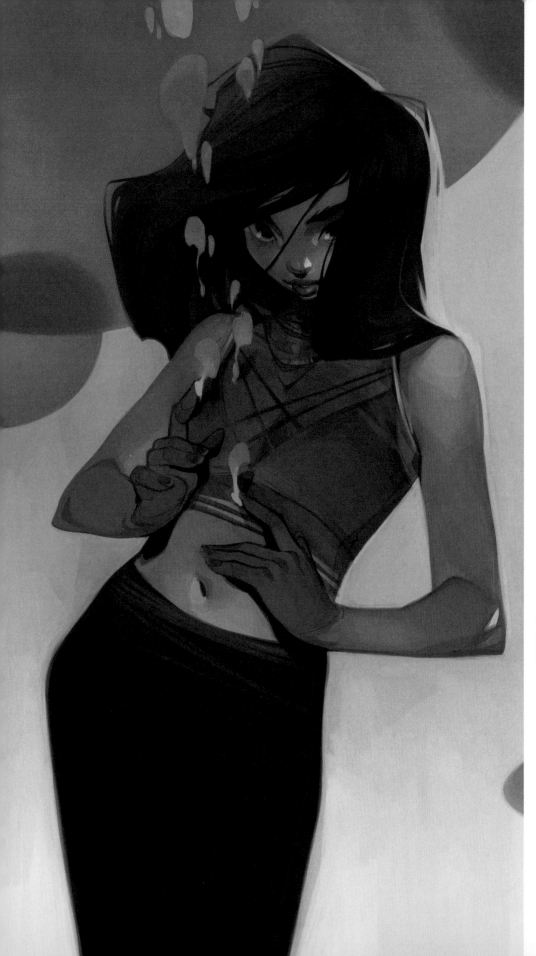

· color relationships ·

Through intuitive experimentation, I learned that color is in no way absolute. We give meaning to color based on its relationship with the other colors around it. For example, a color can appear gray when isolated, but look green when combined with a totally different color.

Letting go of the idea of absolute colors and instead thinking of them in terms of their relationships with other colors opens up a world of possibilities. It allows me to use bright, unconventional hues without breaking the believability of my paintings. This principle also extends to how the colors are distributed. A color combination can be reinvented in endless ways simply by changing the ratio of one color to the other.

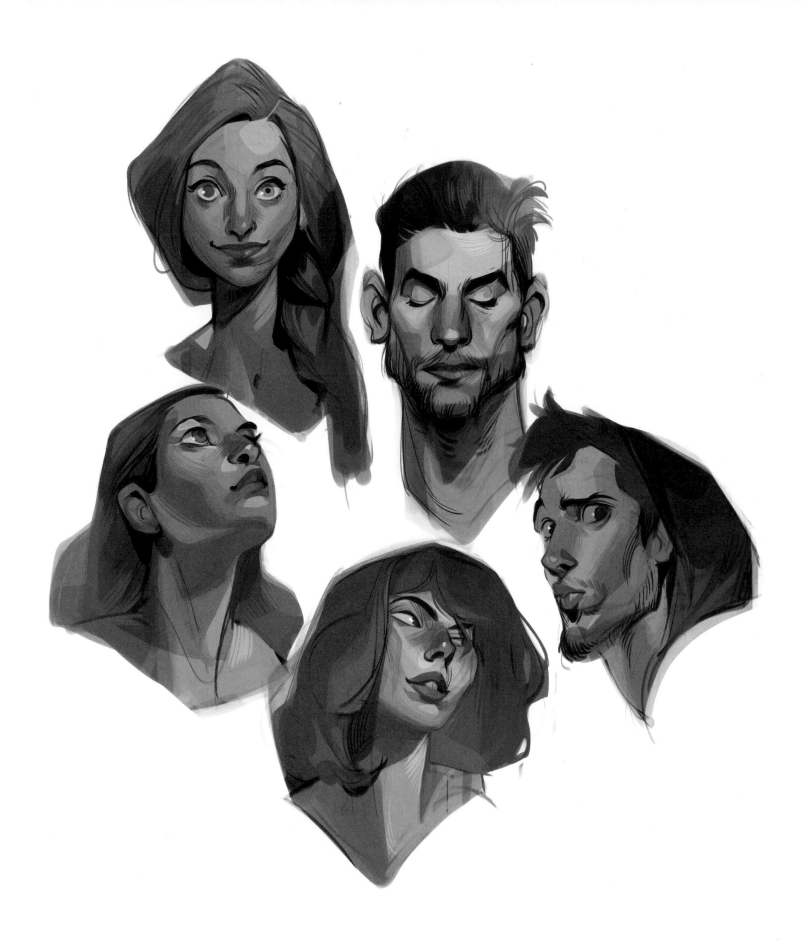

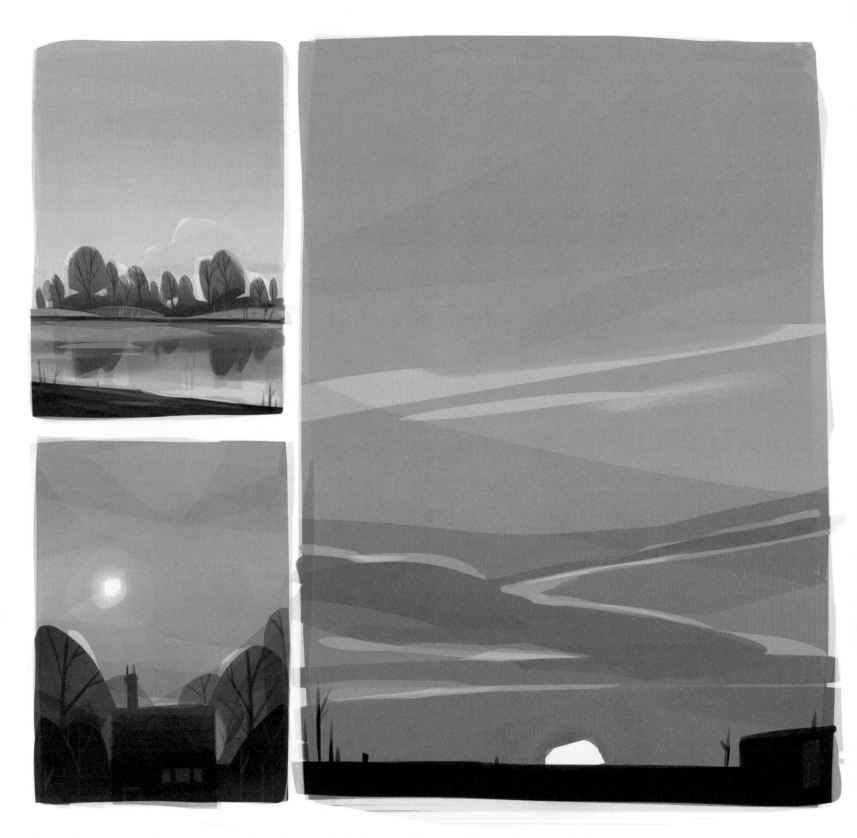

This page: Extreme colors can still make sense as long as they are in balance with the other colors in the image, which is something I explored in these landscape studies

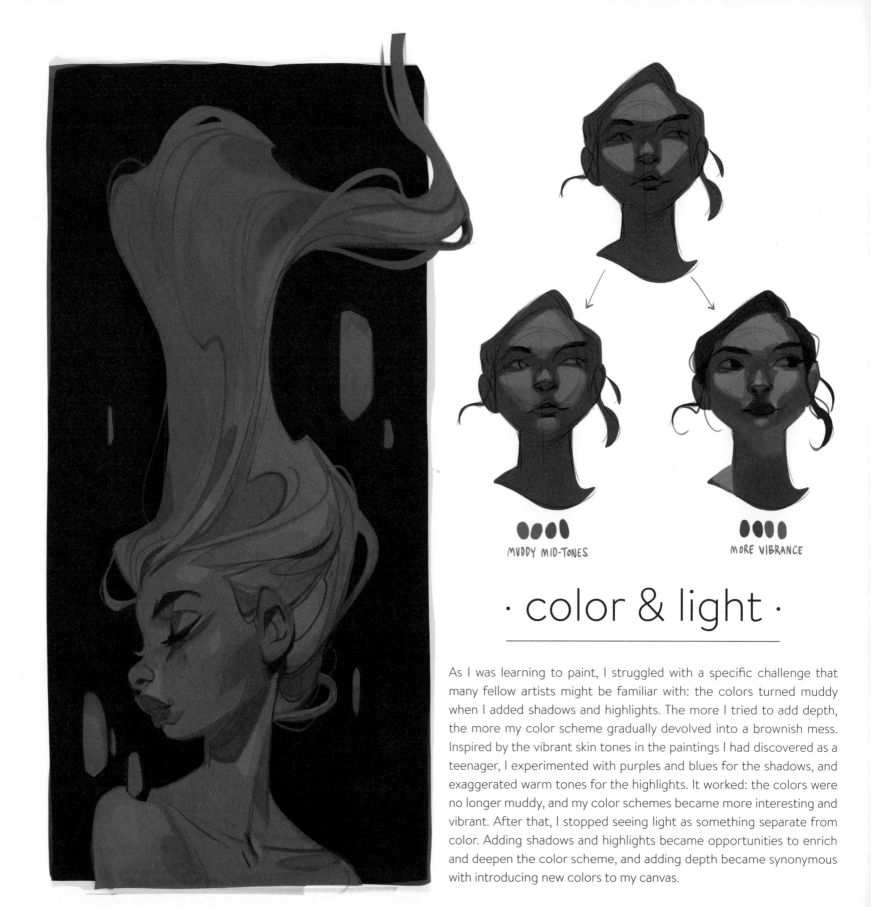

MUDDY MID-TONES

MORE VIBRANCE

· color & light ·

As I was learning to paint, I struggled with a specific challenge that many fellow artists might be familiar with: the colors turned muddy when I added shadows and highlights. The more I tried to add depth, the more my color scheme gradually devolved into a brownish mess. Inspired by the vibrant skin tones in the paintings I had discovered as a teenager, I experimented with purples and blues for the shadows, and exaggerated warm tones for the highlights. It worked: the colors were no longer muddy, and my color schemes became more interesting and vibrant. After that, I stopped seeing light as something separate from color. Adding shadows and highlights became opportunities to enrich and deepen the color scheme, and adding depth became synonymous with introducing new colors to my canvas.

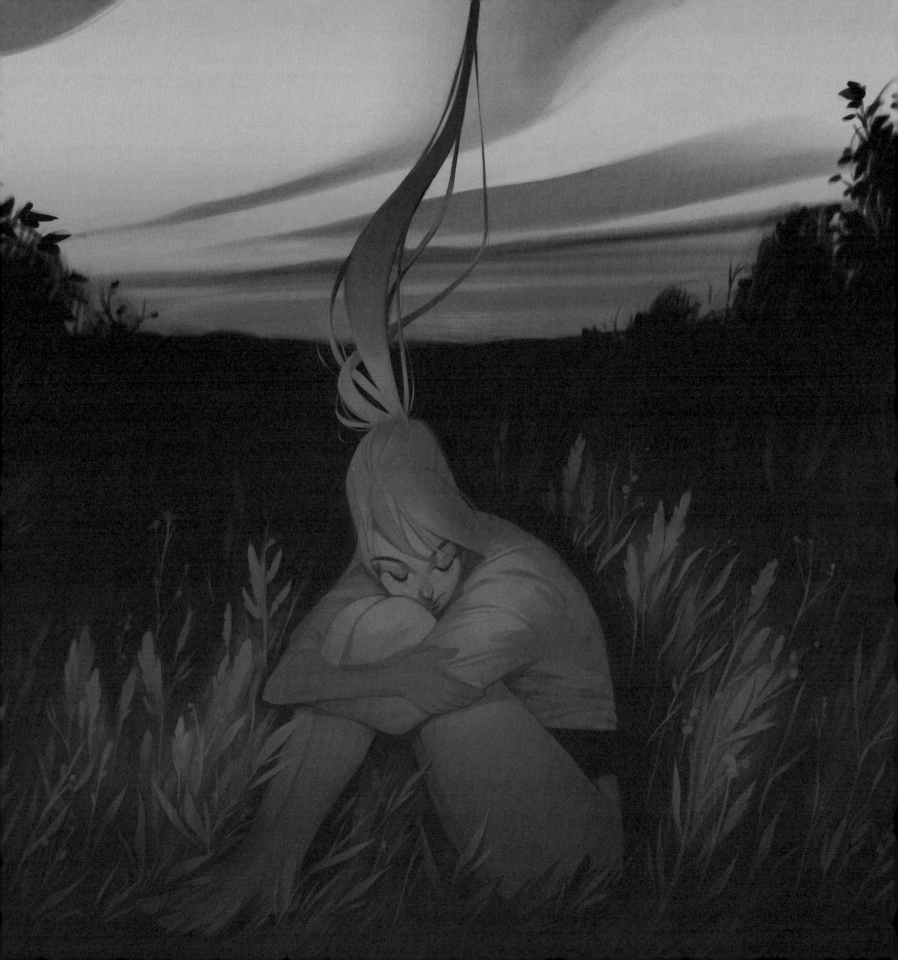

techniques //
intuitive color

changing the color of lines

I often sketch with a simple black brush. However, as soon as I add color, I find that the black lines don't do the color scheme any justice. My solution is to set the lines to Multiply, and then change the line color. By moving the Hue/Saturation slider, I can experiment and see for myself which color blends well with the base colors below. This is a simple technique that is crucial to all of my color choices because it helps unify the color scheme and bring vibrancy and interest to the lines.

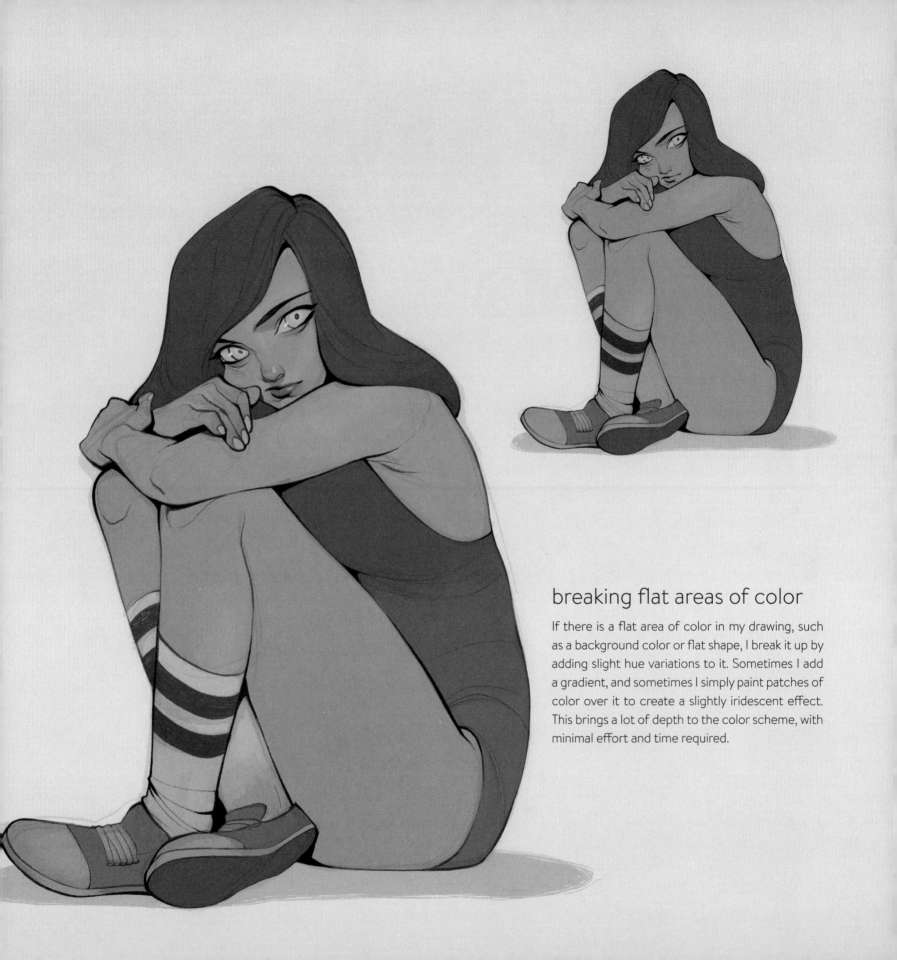

breaking flat areas of color

If there is a flat area of color in my drawing, such as a background color or flat shape, I break it up by adding slight hue variations to it. Sometimes I add a gradient, and sometimes I simply paint patches of color over it to create a slightly iridescent effect. This brings a lot of depth to the color scheme, with minimal effort and time required.

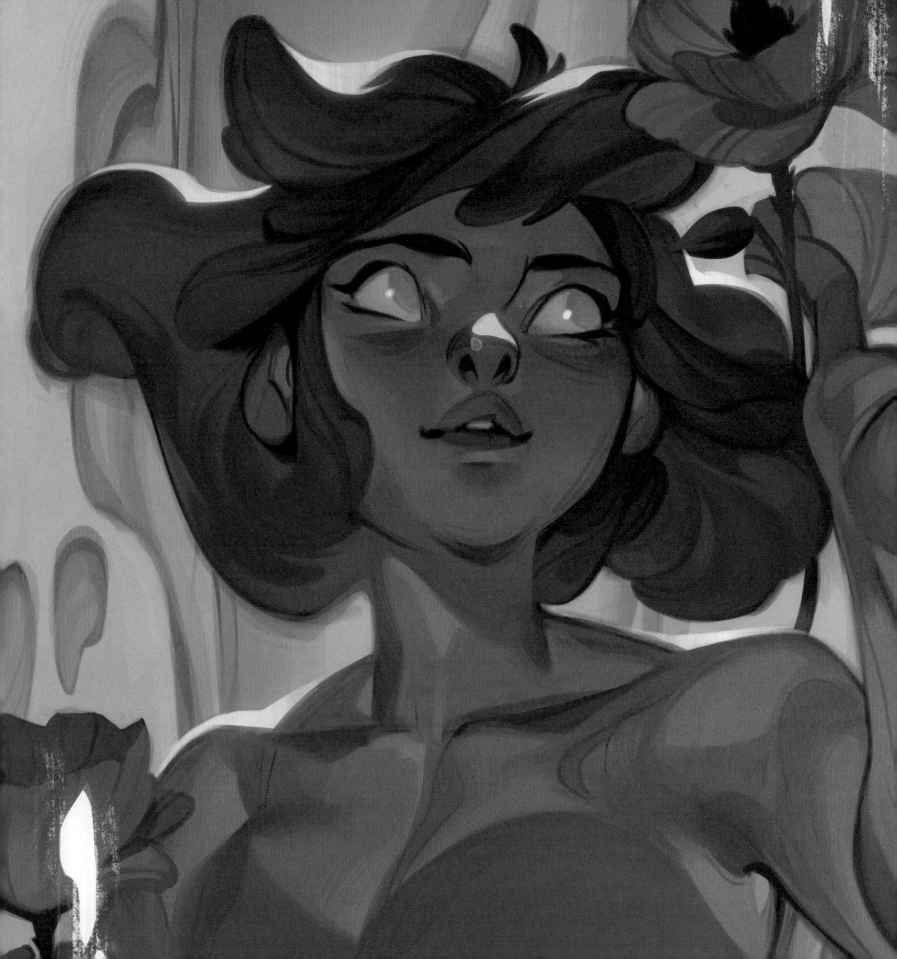

case study // poppies

For this painting, I wanted to capture the vibrant warmth of the poppy flowers, so their color became the starting point of my color scheme. From there, I gradually added colors that I felt worked well with this vibrant red, such as warm yellows and soft mauves. However, when I added a grayish hue to the background, the colors clashed. I made two variations to try and solve the issue.

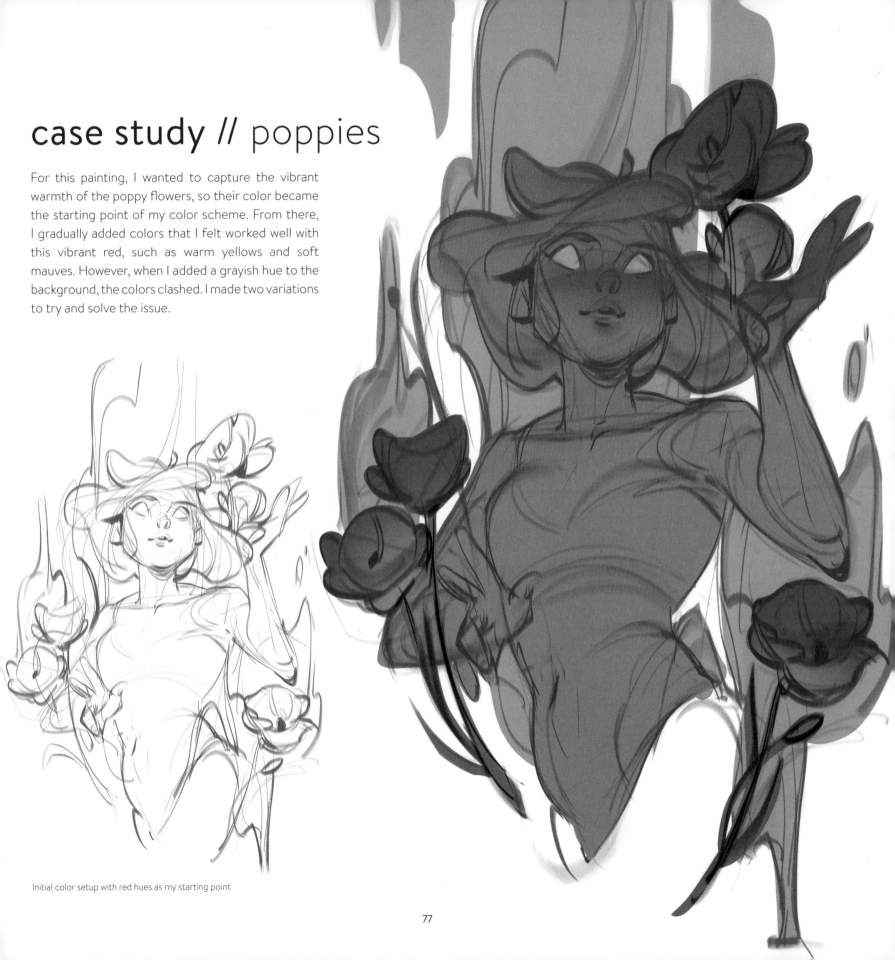

Initial color setup with red hues as my starting point

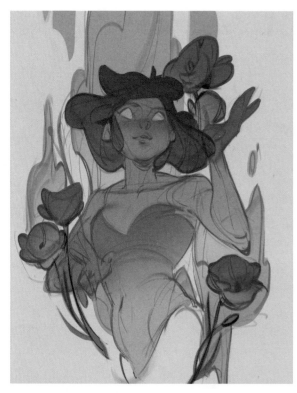

At this stage, the medium gray background is clashing with the warm foreground colors, so I need to explore some alternative options

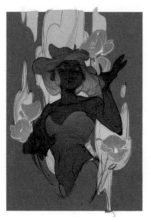
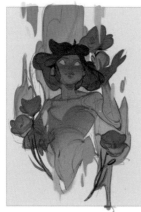

I decided to go for the lighter variation, and discovered that the red tones felt even warmer when I surrounded them with purple and soft violet. I also added some subtle color variation to the background to break the flatness. In the end, the warm colors set the tone for the entire piece, not only because of the red hues present in the painting but also because of their relationship with the cooler tones surrounding them.

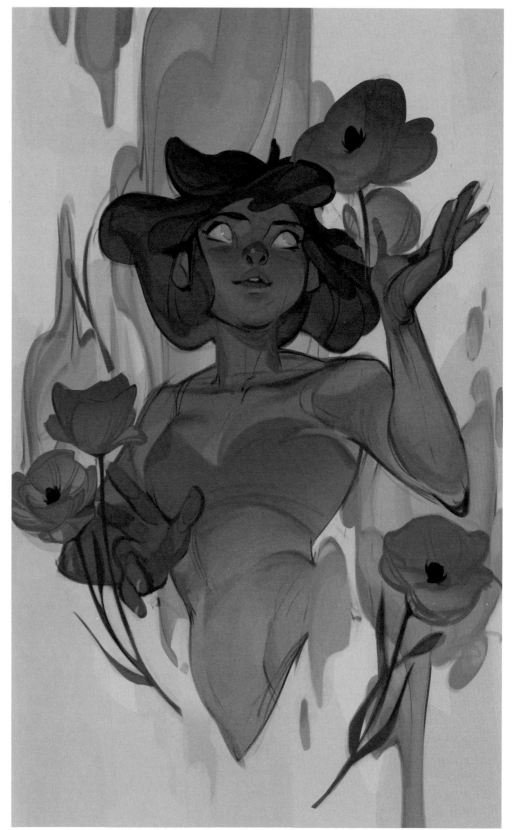

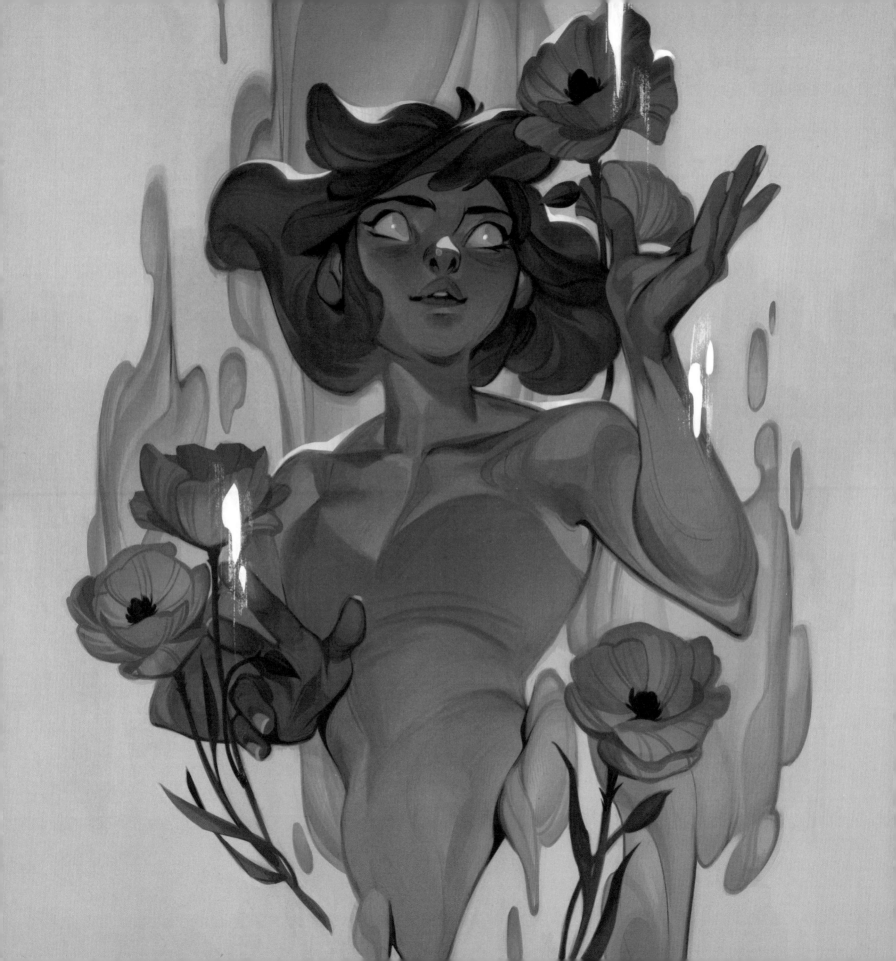

exercise // trying unconventional colors

Like many artists, you might struggle with the feeling that your color scheme needs to be "correct," which limits your creativity when choosing colors. Try this exercise to break out of predictable patterns in color selection and let go of the rules that hold you back. You can follow this exercise digitally or with an opaque paint such as gouache or acrylic.

First, make a simple shape and color it in with a base color similar to this one.

From there, add a shadow color, but make it something you wouldn't normally choose — be as creative as you like!

After that, add a highlight color that is similarly out of your comfort zone.

Repeat the exercise a few times, with different colors for the highlights and shadows each time.

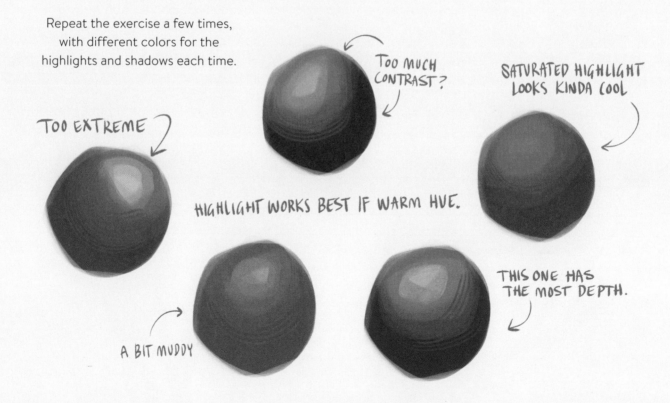

TOO MUCH CONTRAST?

SATURATED HIGHLIGHT LOOKS KINDA COOL

TOO EXTREME

HIGHLIGHT WORKS BEST IF WARM HUE.

A BIT MUDDY

THIS ONE HAS THE MOST DEPTH.

You can repeat the exercise with different base colors or different subject matter!

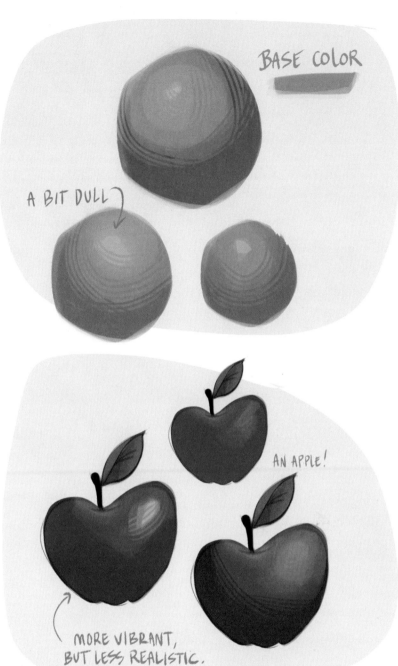

BASE COLOR

A BIT DULL

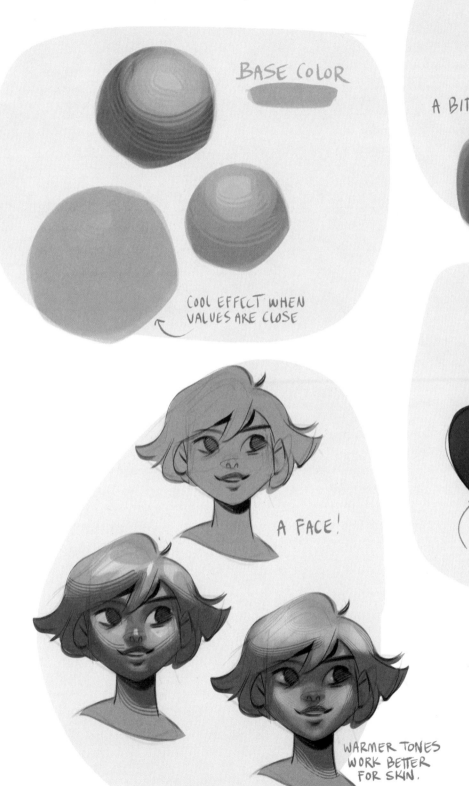

BASE COLOR

COOL EFFECT WHEN VALUES ARE CLOSE

AN APPLE!

MORE VIBRANT, BUT LESS REALISTIC.

A FACE!

WARMER TONES WORK BETTER FOR SKIN.

Reflect on the results. Which one do you like the most? Which one worked, and which one didn't? Try to trust your intuition when assessing what you like and don't like.

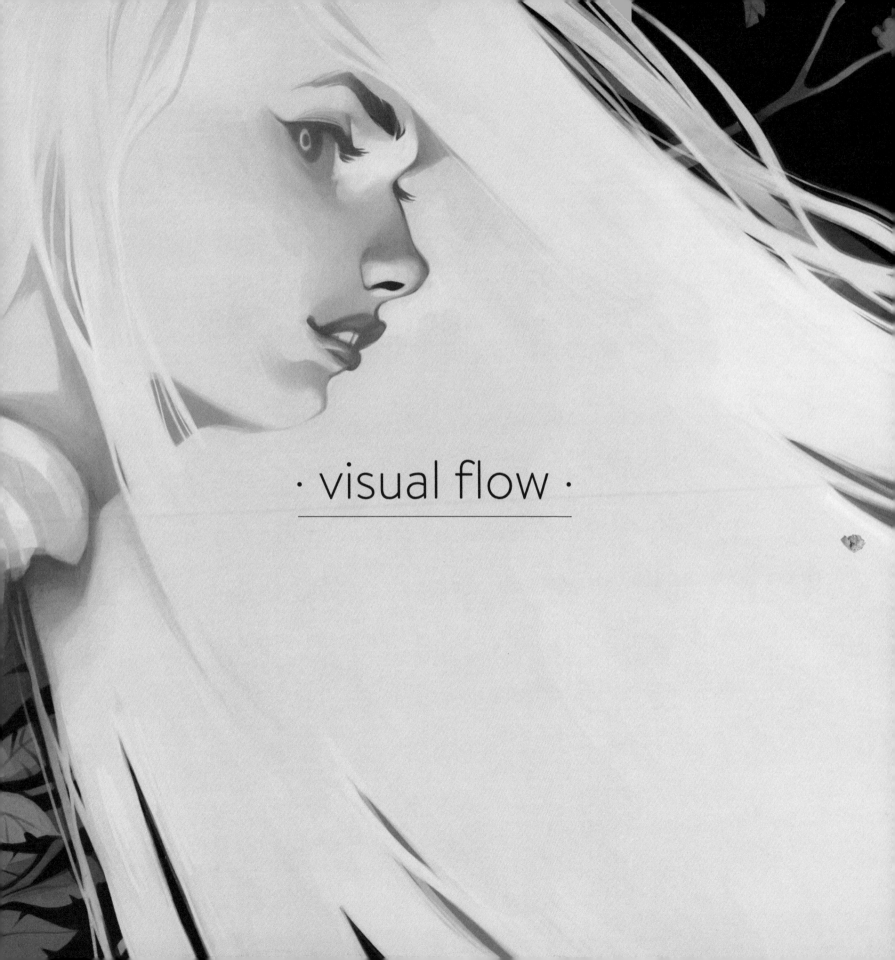

· visual flow ·

Many hours of my childhood were spent watching animated films. I watched the same movies over and over again, never growing bored of the plots I had seen unfold so many times before. What captivated me the most were the beautiful pastel dresses and long flowing hair of the princesses. I was obsessed with one princess in particular: The Little Mermaid, with beautiful green fins and voluminous red locks. My eight-year-old mind could barely conceive of the idea that she was not a real person. Her movement and energy suggested she was a living, breathing being, bursting with energy and life. These animated movies showed me that drawings could not only be beautiful: they could bring something, or someone, to life.

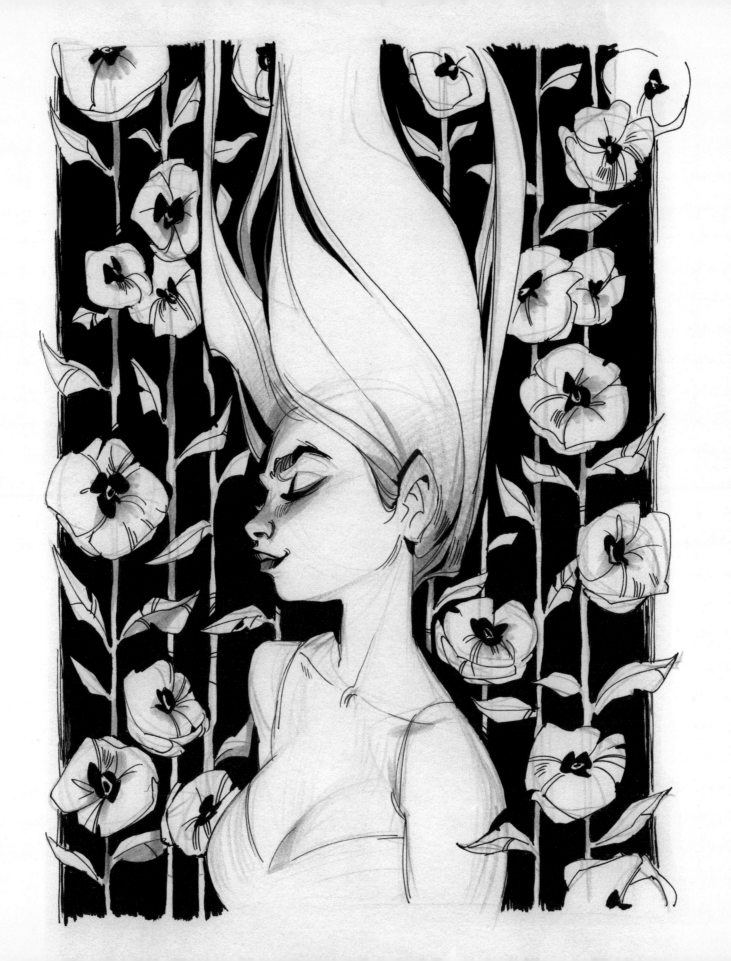

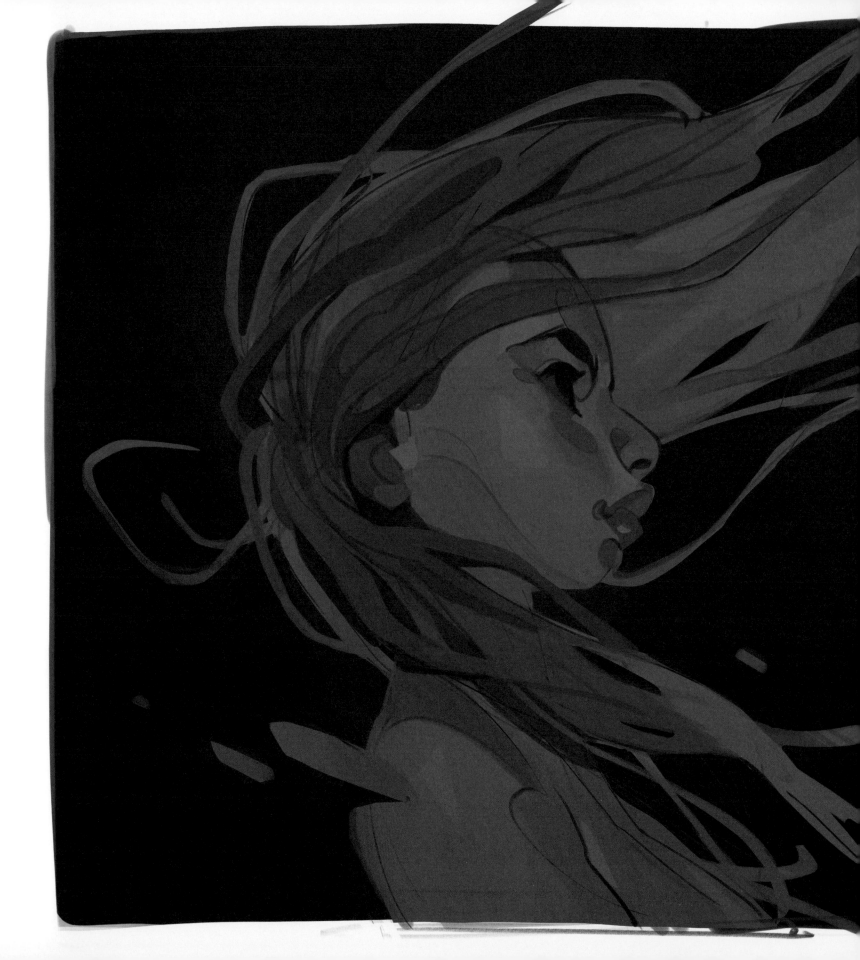

"... animated movies showed me that drawings could not only be beautiful: they could bring something, or someone, to life"

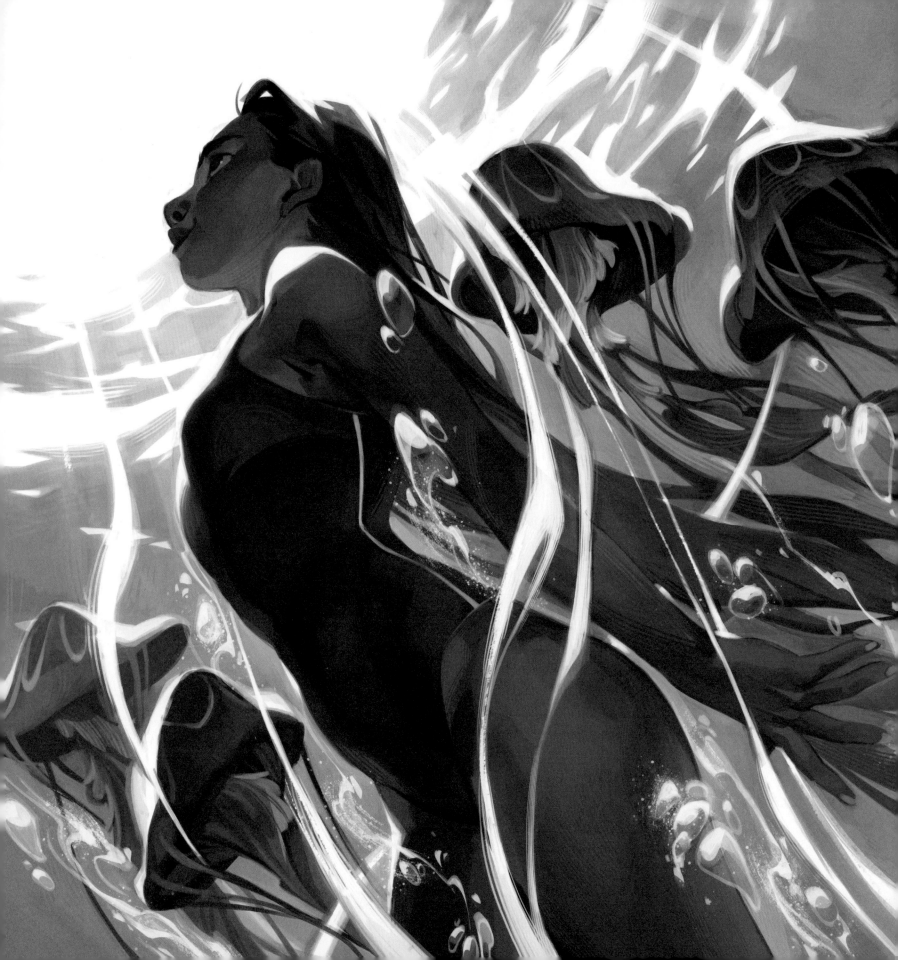

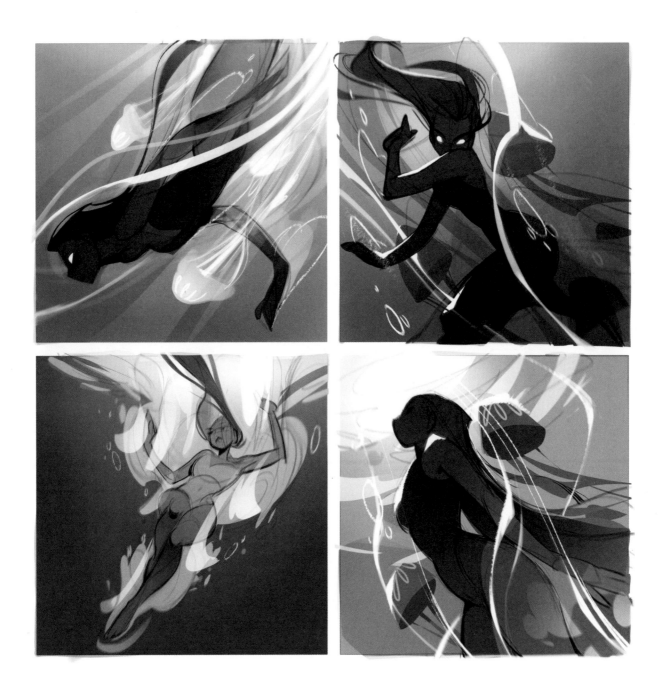

The same emotions were evoked when I discovered art nouveau, with its unique approach to curved lines and organic shapes. My own art was full of hesitation and awkwardness by comparison. I wanted to be able to capture that same sense of movement, but more specifically, I wanted to capture a sense of flow — a movement with a loose, weightless, free, and elegant quality to it. This desire influenced many different aspects of my workflow: my first lines, my choice of posing, which decorative elements I added, and most importantly, the compositions of my paintings. Once I had established flow as my goal, I focused on cultivating it in every level of my creative process.

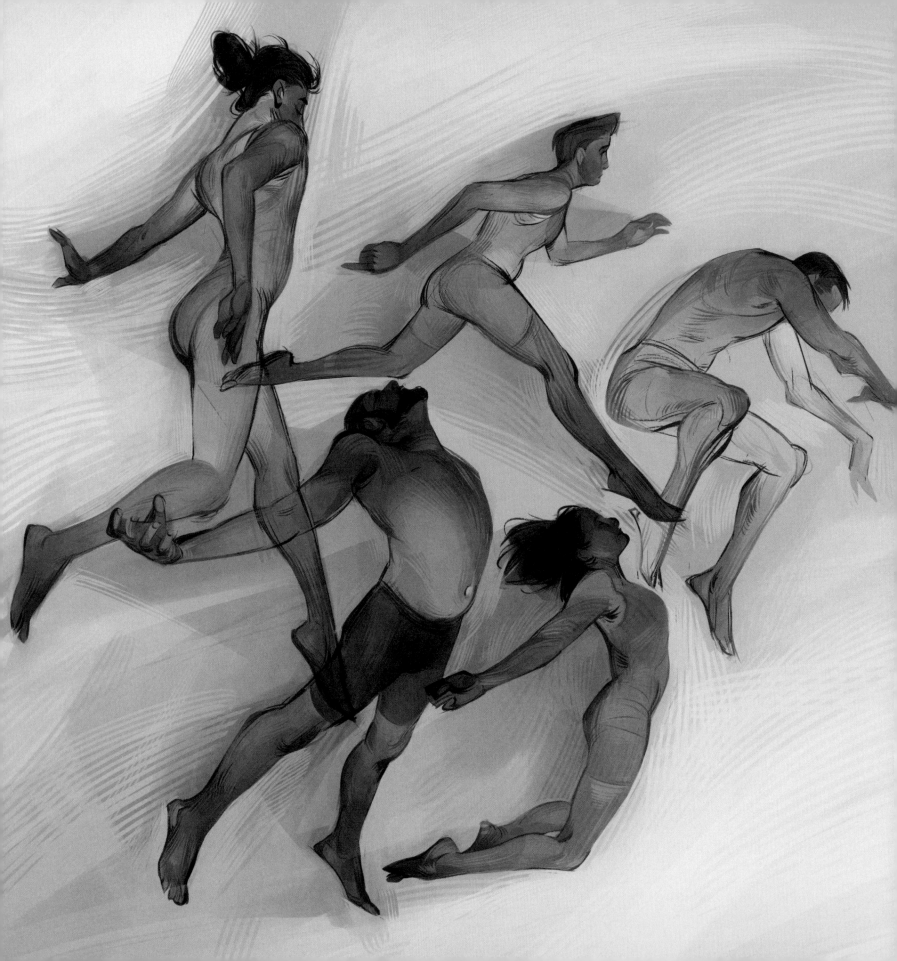

Depicting fluidity was not something that came naturally to me. As a teenager, I lacked confidence in my art and tried to cover up my mistakes with thick contours and heavy cross-hatching. My lines did not have the smooth, confident quality I wanted, so I overcompensated by leaning heavily into jagged and choppy lines, which were a lot easier to draw. This did not go over well in animation school, where I soon learned that in order to convincingly animate a character, my lines needed to be lighter, smoother, and more dynamic. Slowly, over the course of many years, my lines became more streamlined.

There was no "ah-ha" moment or turning point that sped up the process. For me, the only path towards more confident linework was through lots and lots of practice. The more I drew, the less I would overthink my process, and as I became more experienced, the more confident my lines and brushstrokes appeared. This is why, when artists ask me how to achieve more confident lines, my most honest answer is: through patience and practice.

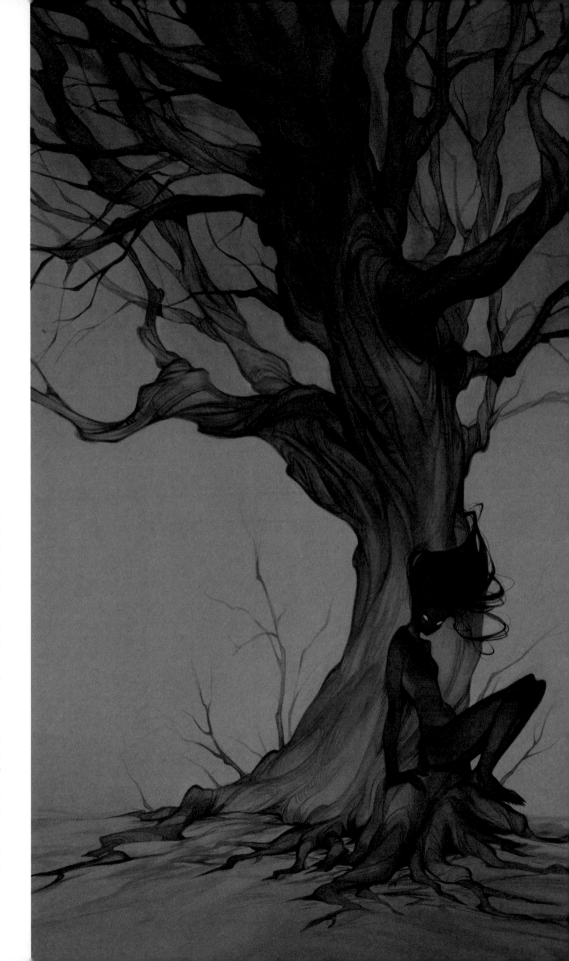

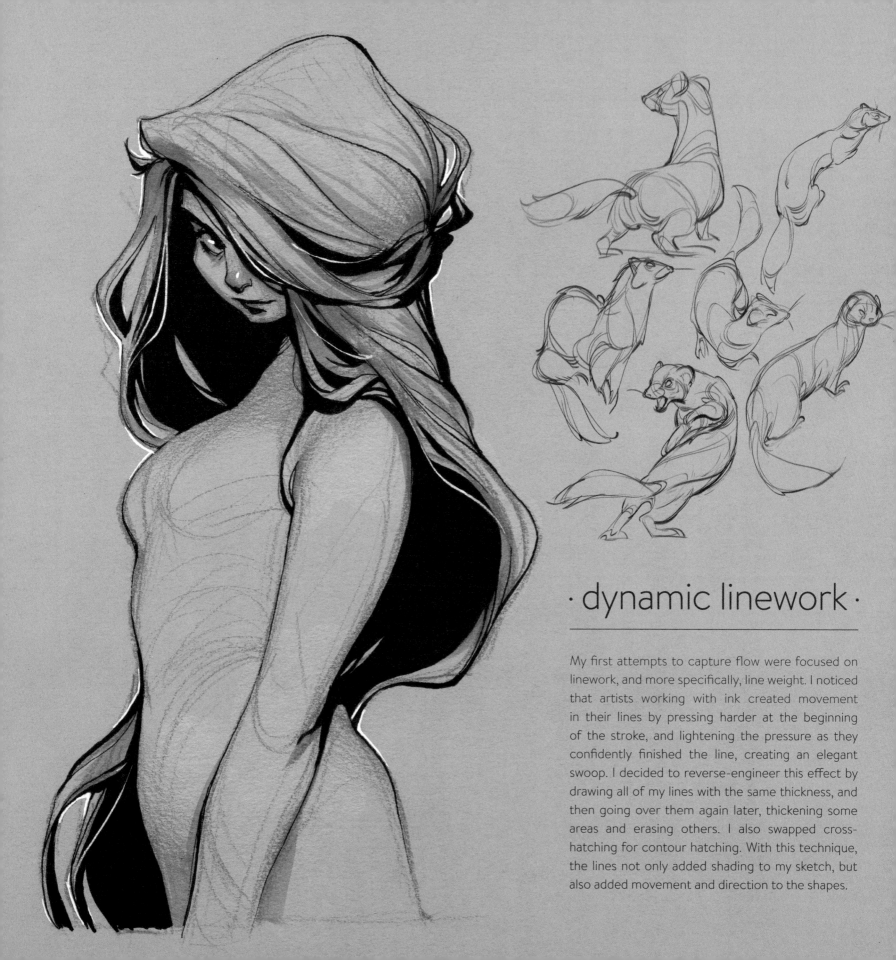

· dynamic linework ·

My first attempts to capture flow were focused on linework, and more specifically, line weight. I noticed that artists working with ink created movement in their lines by pressing harder at the beginning of the stroke, and lightening the pressure as they confidently finished the line, creating an elegant swoop. I decided to reverse-engineer this effect by drawing all of my lines with the same thickness, and then going over them again later, thickening some areas and erasing others. I also swapped cross-hatching for contour hatching. With this technique, the lines not only added shading to my sketch, but also added movement and direction to the shapes.

This page: Animal studies from reference

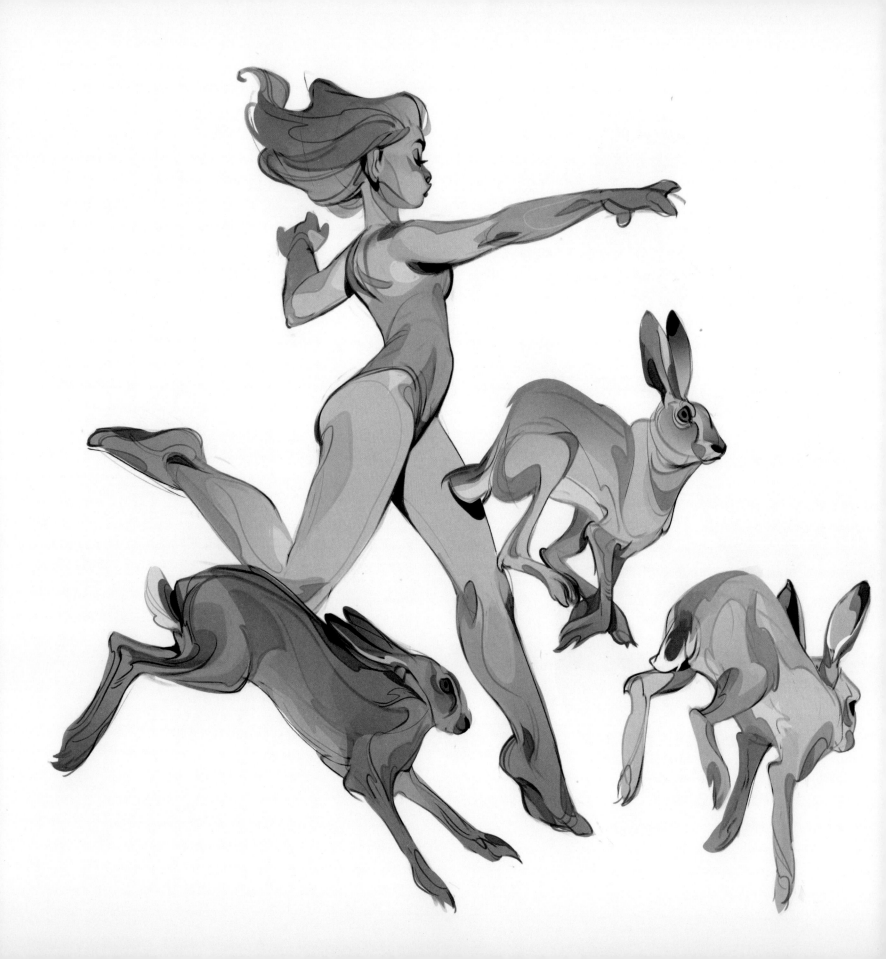

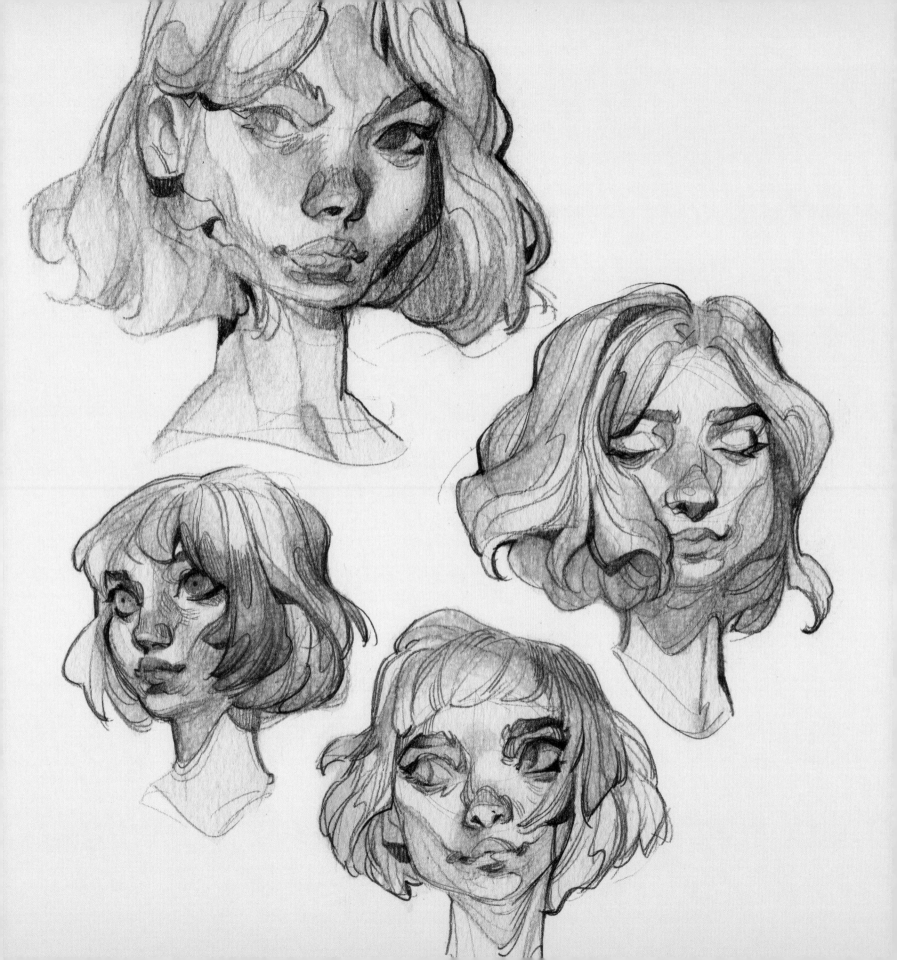

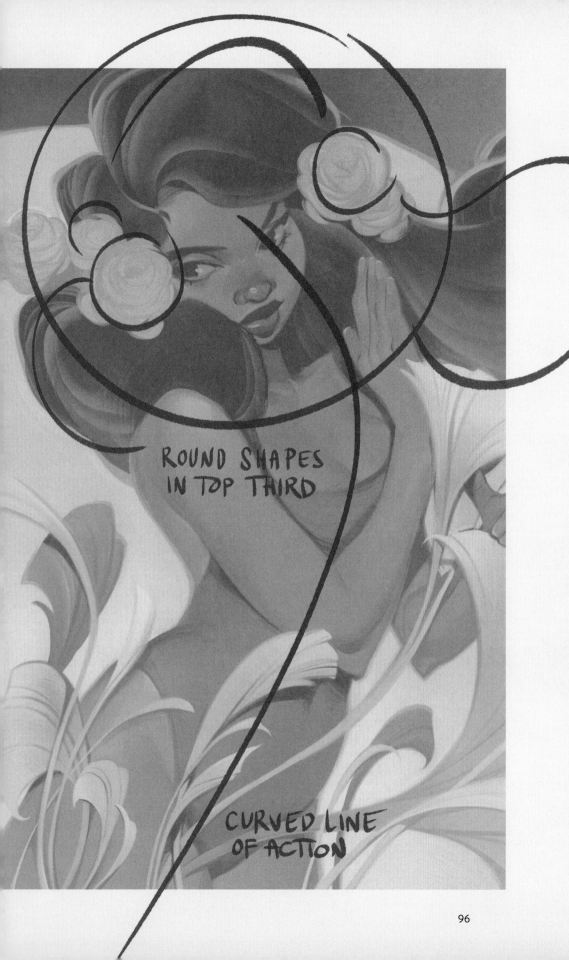

ROUND SHAPES
IN TOP THIRD

CURVED LINE
OF ACTION

· compositions ·

Alphonse Mucha's work mesmerized me because of his ability to balance so much detail and complexity with a clear and readable composition. Studying his work, I noticed that most of the detail was focused in the top third of the painting, where he placed round and welcoming shapes. From there, elegant, curved lines swooped downwards into the lower half of the image, where the detail gradually tapered off. Decorative elements were carefully distributed along this curved line of action, creating a sense of harmony, balance, and most importantly, flow. In my art, you will often find the same basic compositional arrangements, with the focal point in the top third of my image and curved lines of action expanding from there. I try to organize my creative decisions around this line of action, making sure that the pose, lighting, decorative elements, and overall framing all serve to enhance the sense of movement that it creates.

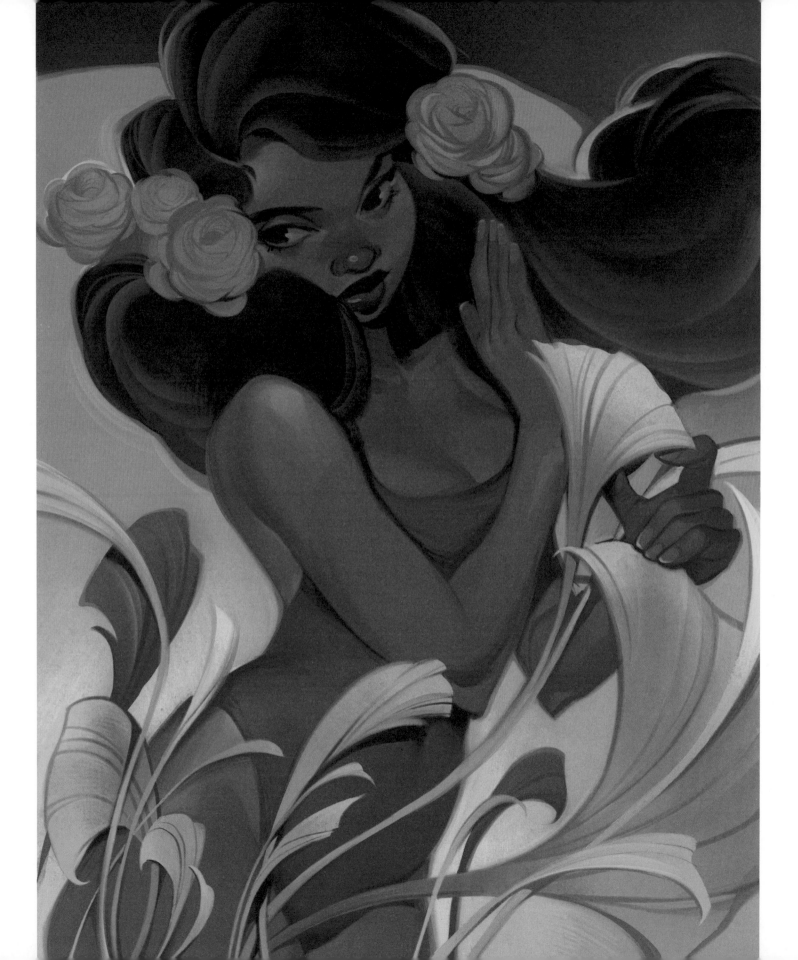

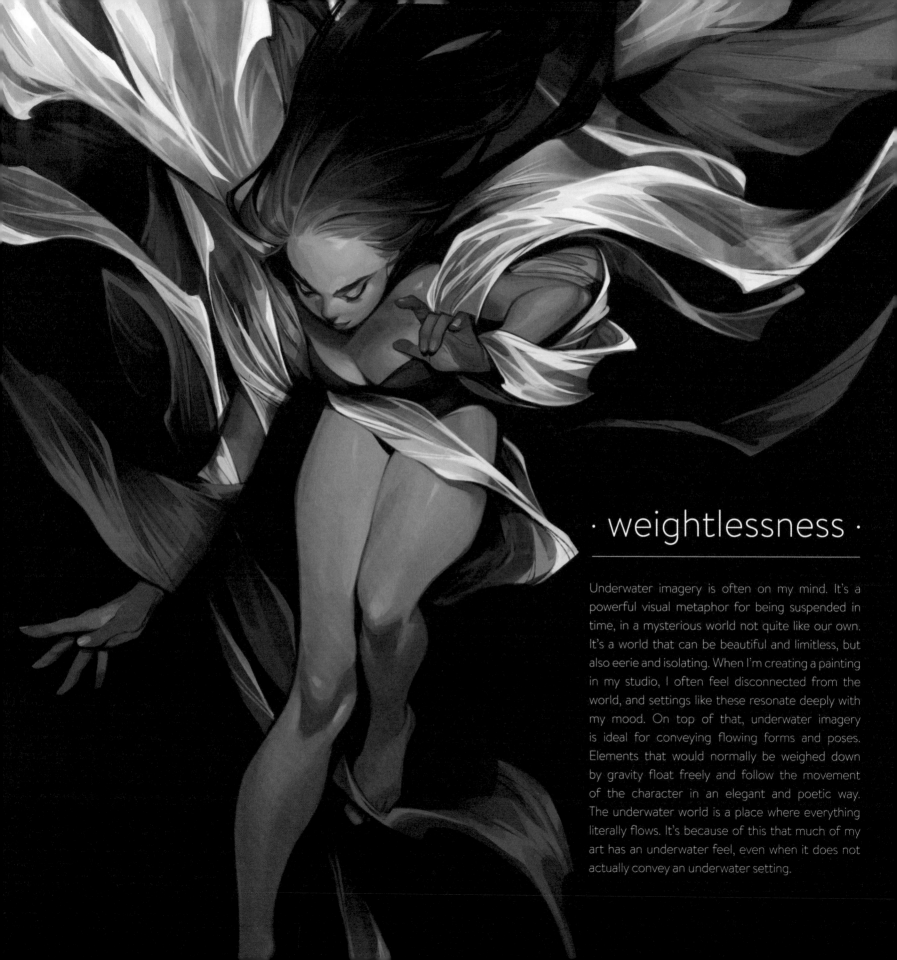

· weightlessness ·

Underwater imagery is often on my mind. It's a powerful visual metaphor for being suspended in time, in a mysterious world not quite like our own. It's a world that can be beautiful and limitless, but also eerie and isolating. When I'm creating a painting in my studio, I often feel disconnected from the world, and settings like these resonate deeply with my mood. On top of that, underwater imagery is ideal for conveying flowing forms and poses. Elements that would normally be weighed down by gravity float freely and follow the movement of the character in an elegant and poetic way. The underwater world is a place where everything literally flows. It's because of this that much of my art has an underwater feel, even when it does not actually convey an underwater setting.

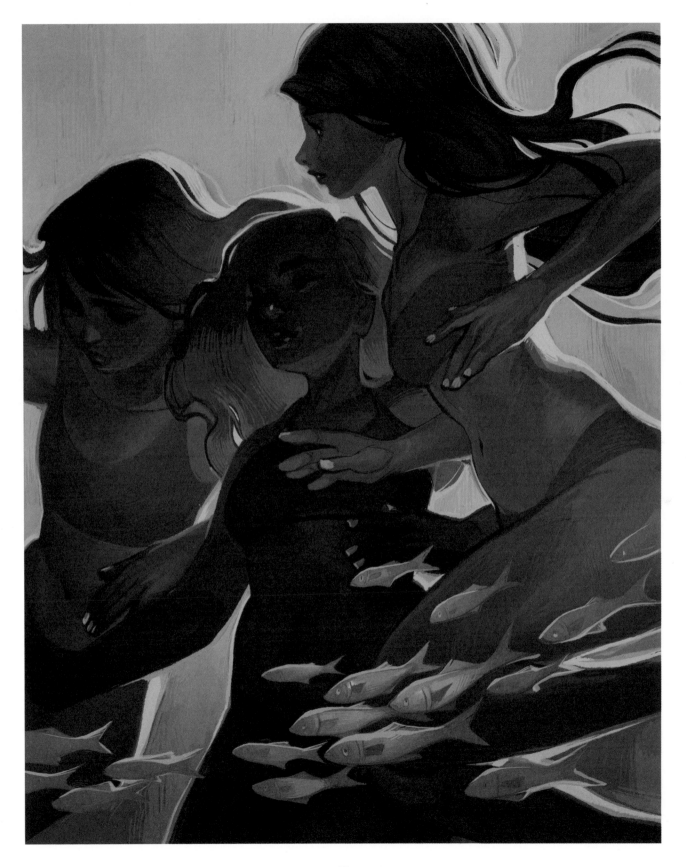

techniques //
conveying movement

starting with the pose

I find it difficult to create movement in a composition featuring many conflicting elements. By creating a dynamic pose first, and then arranging the additional elements carefully around it, it becomes a lot easier to clarify and support the line of action that is created by the pose. This is why I usually start with a pose, and move out from there, gradually adding decorative elements on a separate layer until I like what I see.

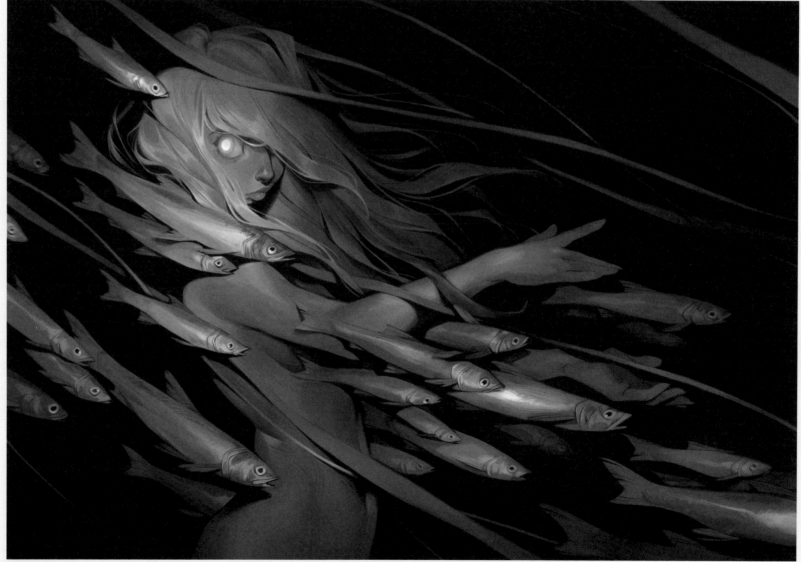

gradients

Gradients are soft transitions from light to dark, or from one color to another. They're great for blending colors and adding depth, but most importantly, they're an excellent tool for creating movement. Because the transition is gradual, the eye is naturally led from one color to another. When arranged in harmony with a line of action, gradients can help enhance the visual flow.

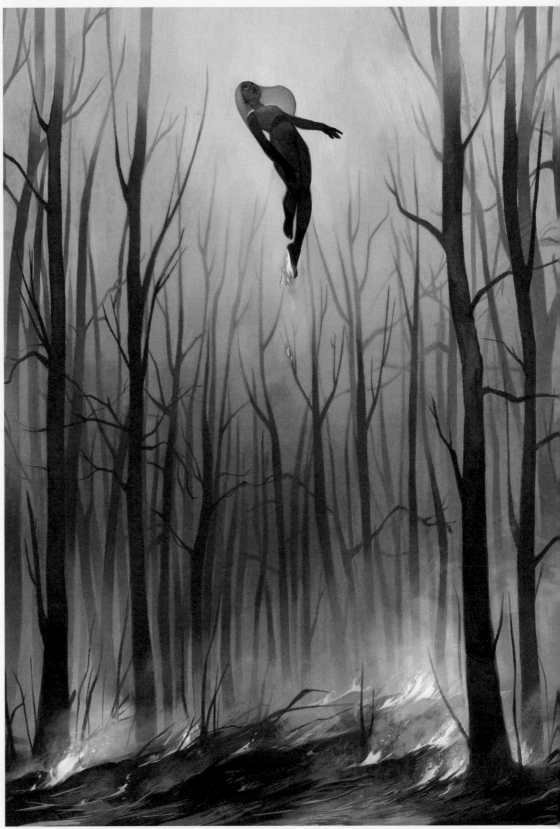

thumbnailing

I'm someone who loves to jump straight into the painting process, so at first it felt counter-intuitive to make small thumbnail sketches. However, I quickly learned that it is one of the best ways to explore different compositions. Because thumbnail sketches are small and low in detail, it is much easier to see whether a composition is working, which is why I like to start small and simple.

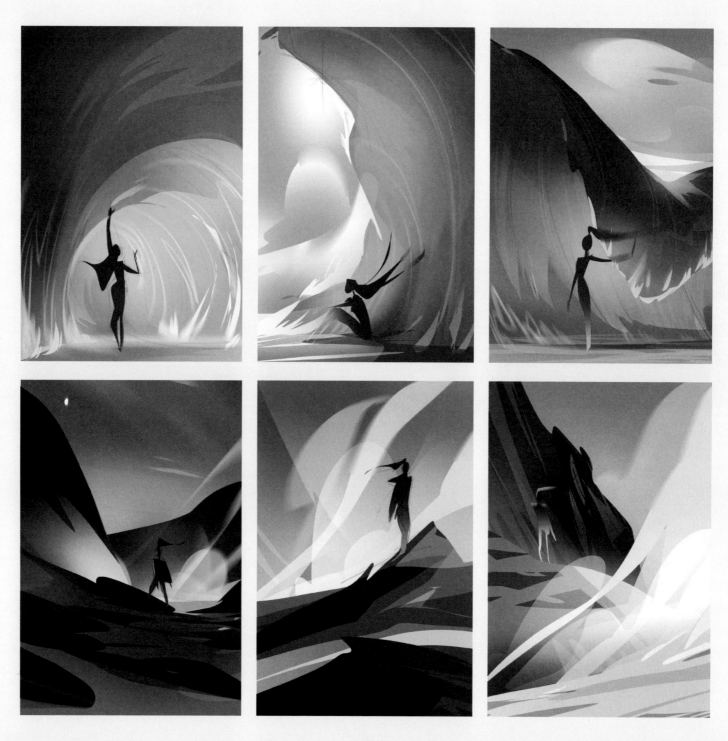

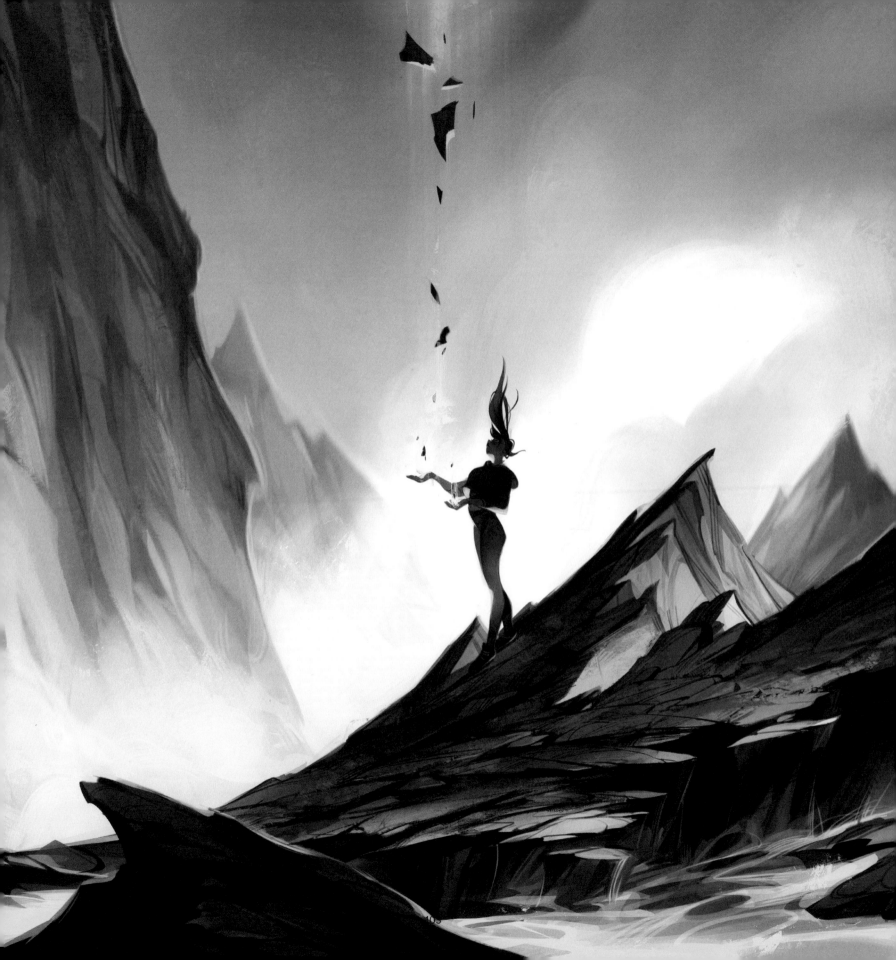

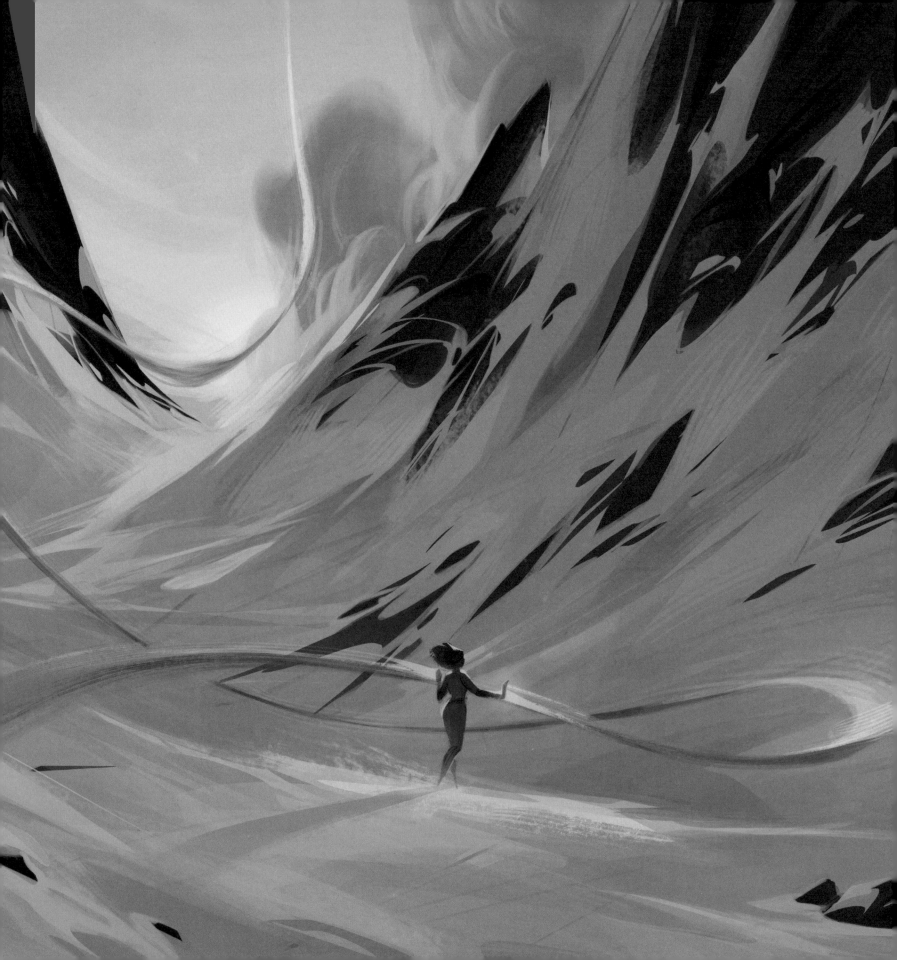

case study // peaks

My process for this painting was the opposite of my usual approach. Rather than starting with a character, I began with a speed-painted environment. I liked the movement created by this initial landscape sketch, but whenever I added a character, I felt it weighed down the dynamic lines created by the mountains and snow. I tried out a few different options for the character pose and placement, but the character didn't feel like it belonged in the environment around it. There simply wasn't a connection between this mountainscape and the tiny person walking through it.

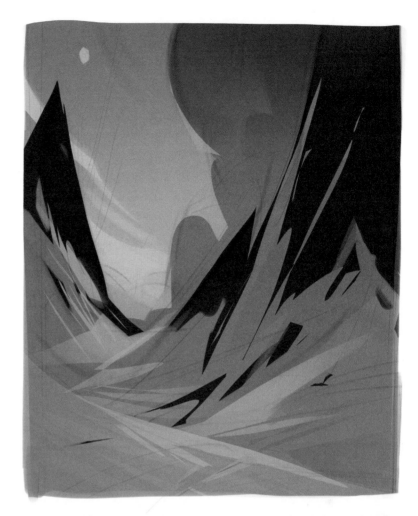

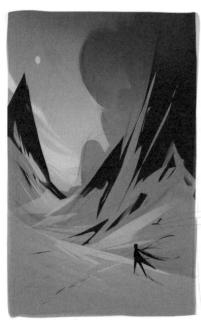 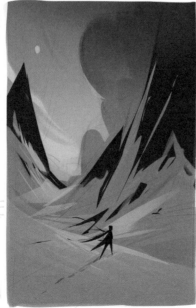 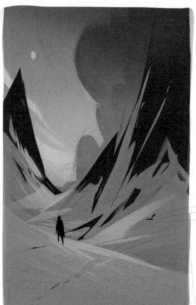 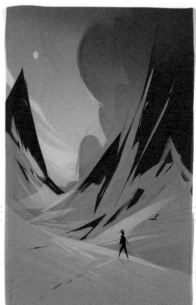

Variations with different positions for the character. None of these seemed to work

To solve this issue, I decided to create a deeper relationship between the setting and the character. I was reading a book at the time about people with magical, elemental powers, and so I was inspired to experiment with different ways to convey magic. I tried various options, from semi-translucent blobs to zig-zagging electricity. I settled on dynamic, flowing lines that extended from the character's hands. After that, I made sure that the rest of the elements — snow, peaks, moon, and clouds — fell in line with this movement. The end result is a painting that was elevated by the addition of flowing forms, and quite literally contains a line of action.

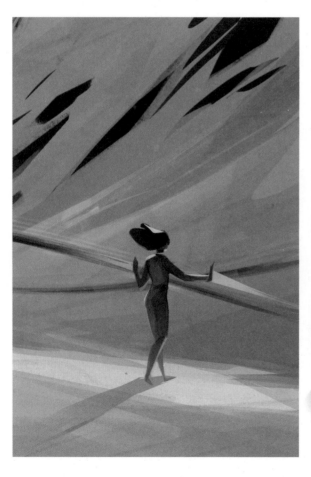

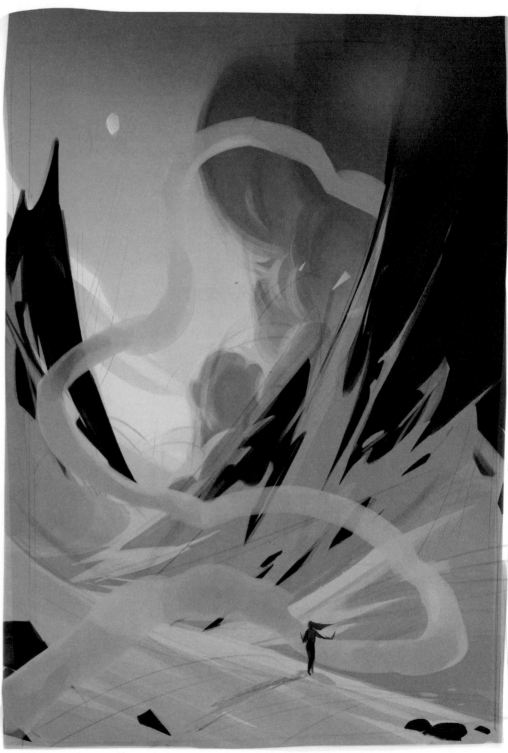

A blobby, semi-translucent approach to the magic concept that didn't make it to the final cut because it lacks movement and flow

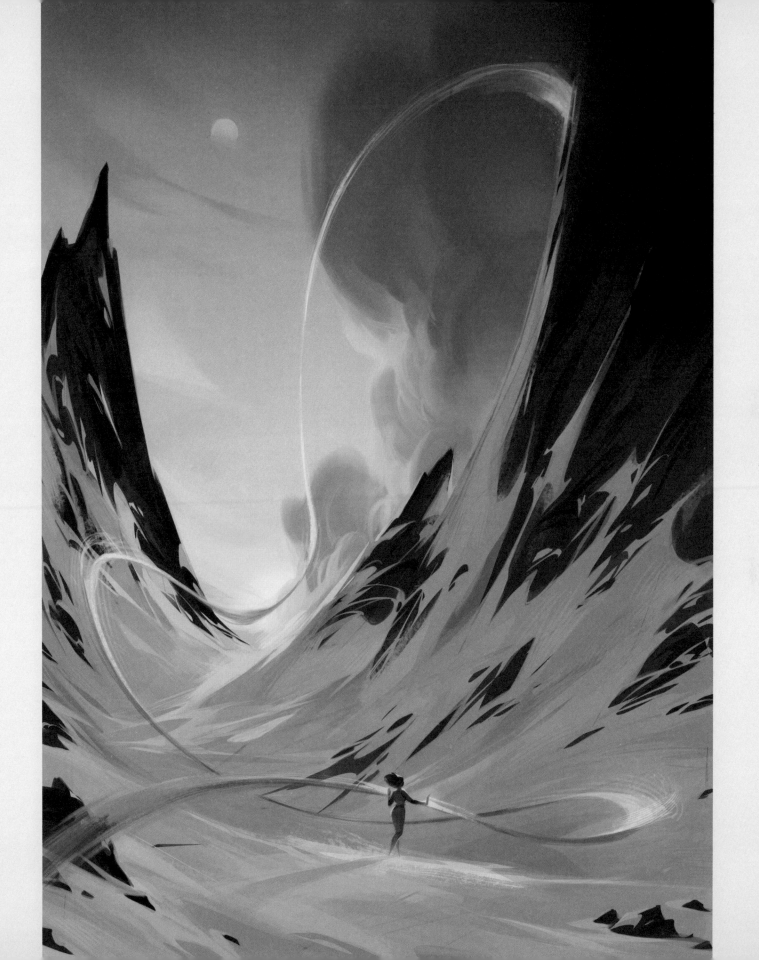

exercise // capturing the movement

Portraying movement and energy in your art is not just about the way you draw, but also which tool you use, and whether it works with your way of drawing. For this exercise, pick three to five different tools, such as ink, crayon, or pencil. If you're working digitally, you can try a few different brushes. It's a speed sketching exercise, so try to draw as quickly as you can and don't sweat the details too much!

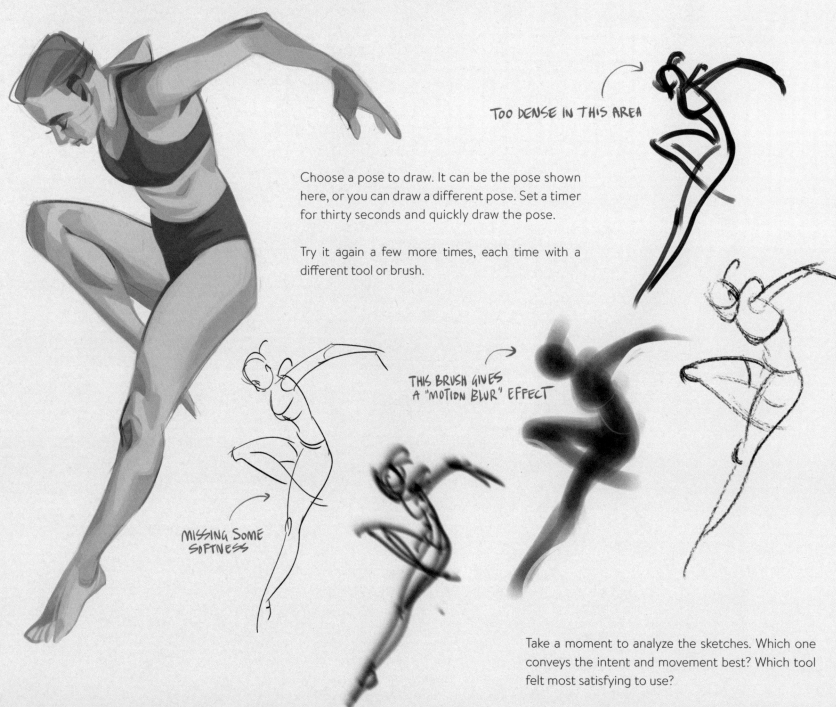

Choose a pose to draw. It can be the pose shown here, or you can draw a different pose. Set a timer for thirty seconds and quickly draw the pose.

Try it again a few more times, each time with a different tool or brush.

TOO DENSE IN THIS AREA

THIS BRUSH GIVES A "MOTION BLUR" EFFECT

MISSING SOME SOFTNESS

Take a moment to analyze the sketches. Which one conveys the intent and movement best? Which tool felt most satisfying to use?

Select the sketch that works best for you and introduce some additional decorative elements to it to push the movement even further.

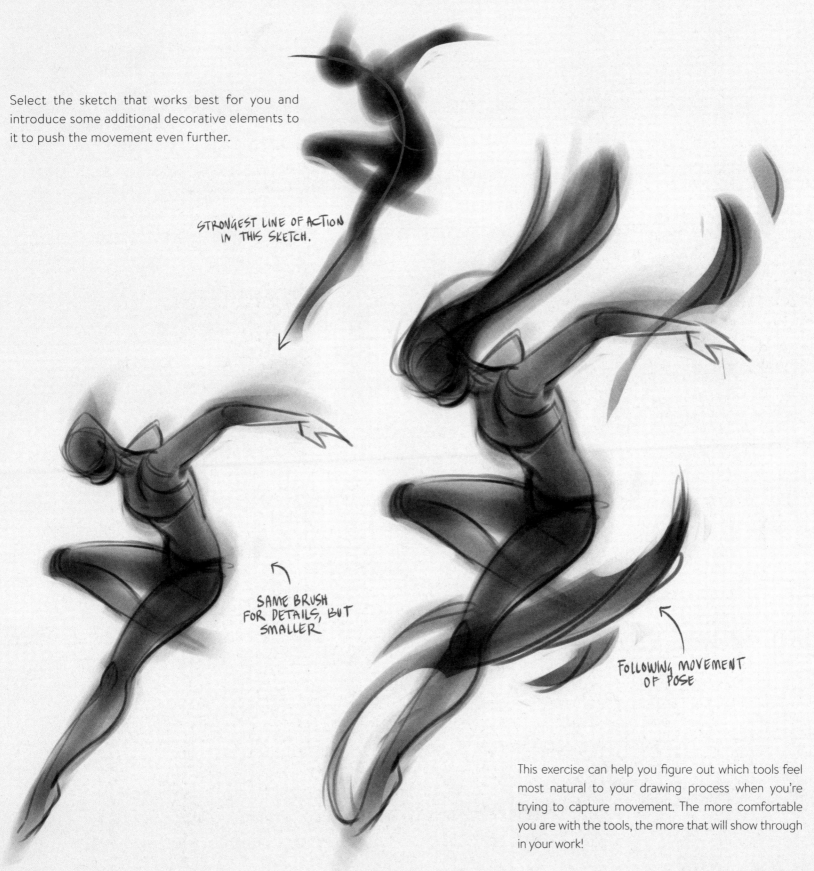

STRONGEST LINE OF ACTION IN THIS SKETCH.

SAME BRUSH FOR DETAILS, BUT SMALLER

FOLLOWING MOVEMENT OF POSE

This exercise can help you figure out which tools feel most natural to your drawing process when you're trying to capture movement. The more comfortable you are with the tools, the more that will show through in your work!

· emotional subjects ·

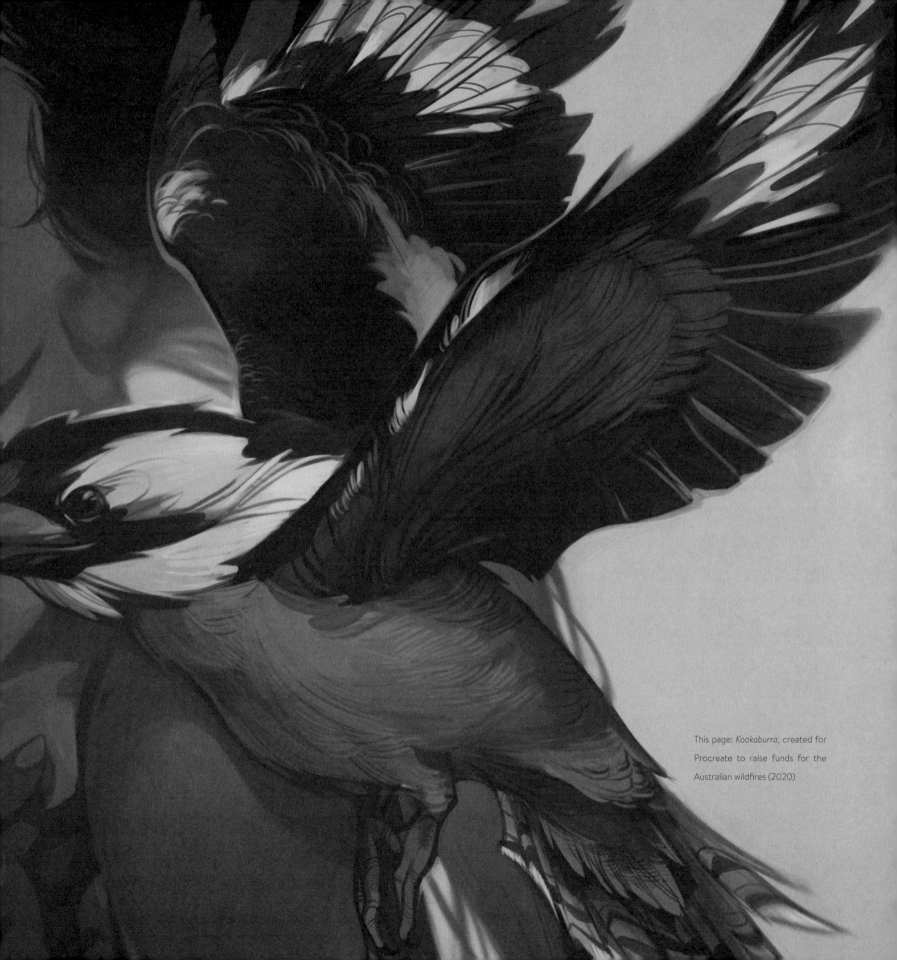

This page: *Kookaburra*, created for Procreate to raise funds for the Australian wildfires (2020)

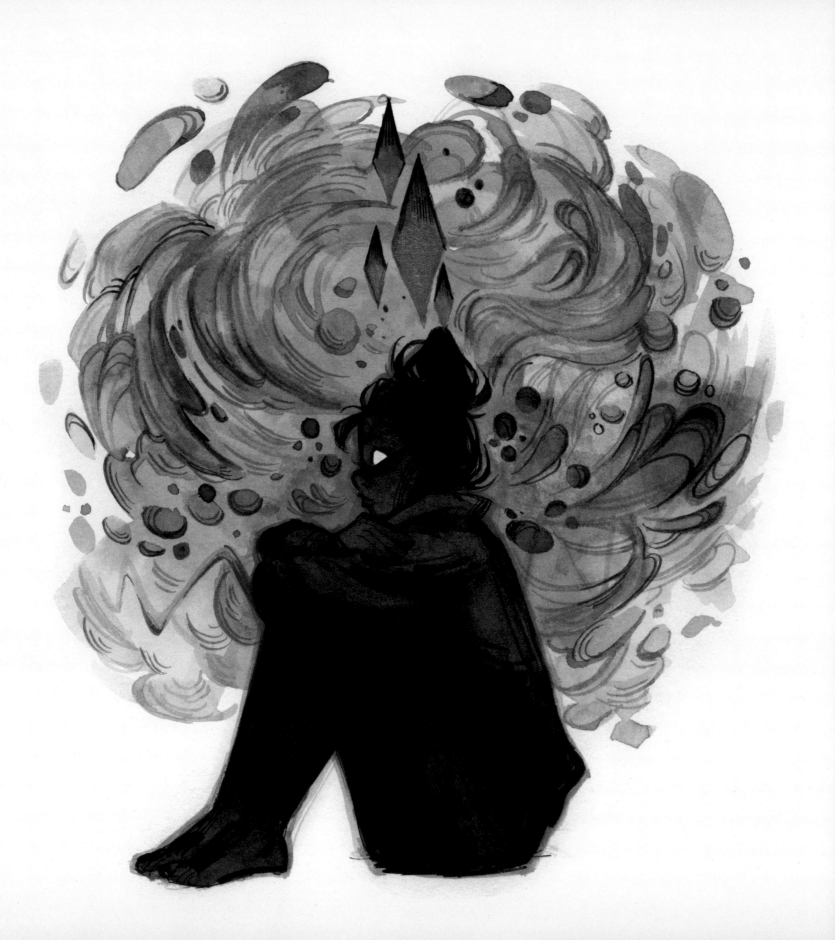

It could be argued that an artistic style is purely defined by its visual characteristics. However, underneath these visual cues is the motivation to convey something — a message, story, or theme. This deeper level is what gives form to the creative decisions that come after. I learned this in art school, where I was surrounded by other artists for the first time in my life, each searching for their own voice. Some of them were incredibly detail-oriented, creating elaborate art and stories that were intricate and dense with visual information. Others loved to tell stories and wrote extensive narratives containing an entire cast of original characters. There were also those who were very technical, always seeking out the limits of their artistic ability and continually experimenting with new techniques and tools.

As inspiring as these fellow art students were, I was not equally passionate about those same things. I didn't really know what I wanted to convey with my art just yet, but seeing so many different artistic goals around me helped me realize that there is not one right way to do it. Everyone had a different way of seeing the world, and thus a different way of expressing themselves through their art.

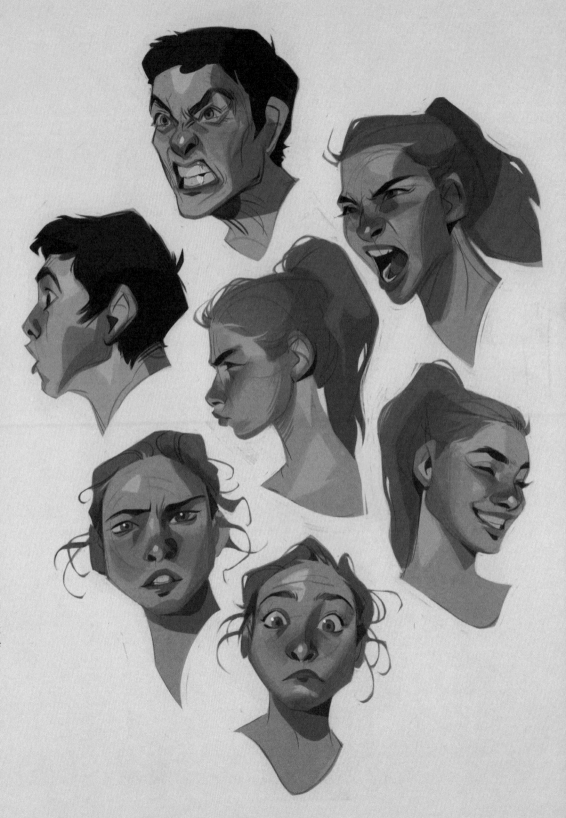

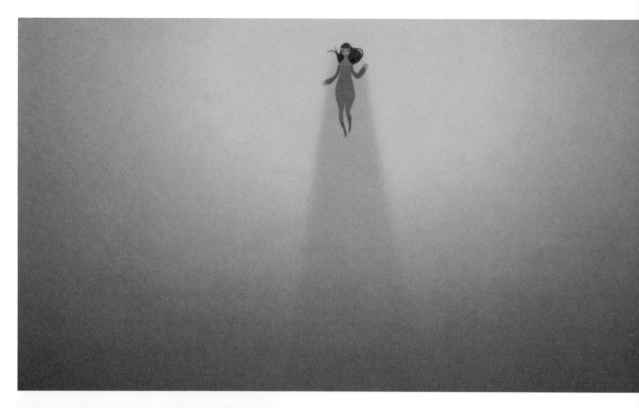

"I experience the world in terms of emotions, and they are the filter through which I make sense of my life"

I searched for my own artistic voice throughout my art school years and finished my studies with a graduation film about a blank character that stumbled upon a special kind of fruit which triggered a change in her emotional world. By creating this project, I learned something about myself: I experience the world in terms of emotions, and they are the filter through which I make sense of my life. I started to notice that while I tend to remember the way I felt when something was happening, a different person might focus more on what they were doing, or how something looked. It was liberating to realize that everyone has a different lens through which they see the world, because it means that we all bring something different to the table. It helped me to embrace my own strengths, creative and otherwise. Most importantly, it helped me to understand and contextualize my own style, and embrace the creative choices that naturally flow forth from my desire to convey moods and emotions.

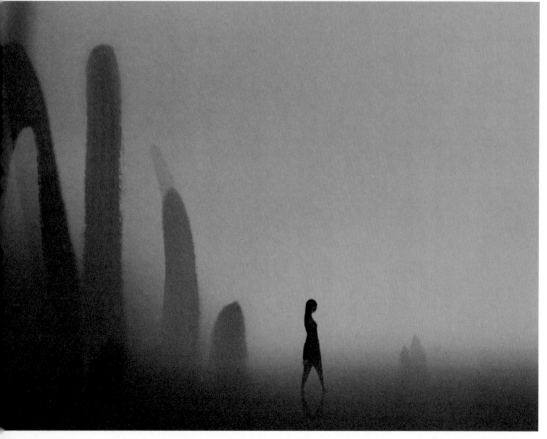

This page: Screenshots taken from my graduation film, *Trichrome Blue* (2009)

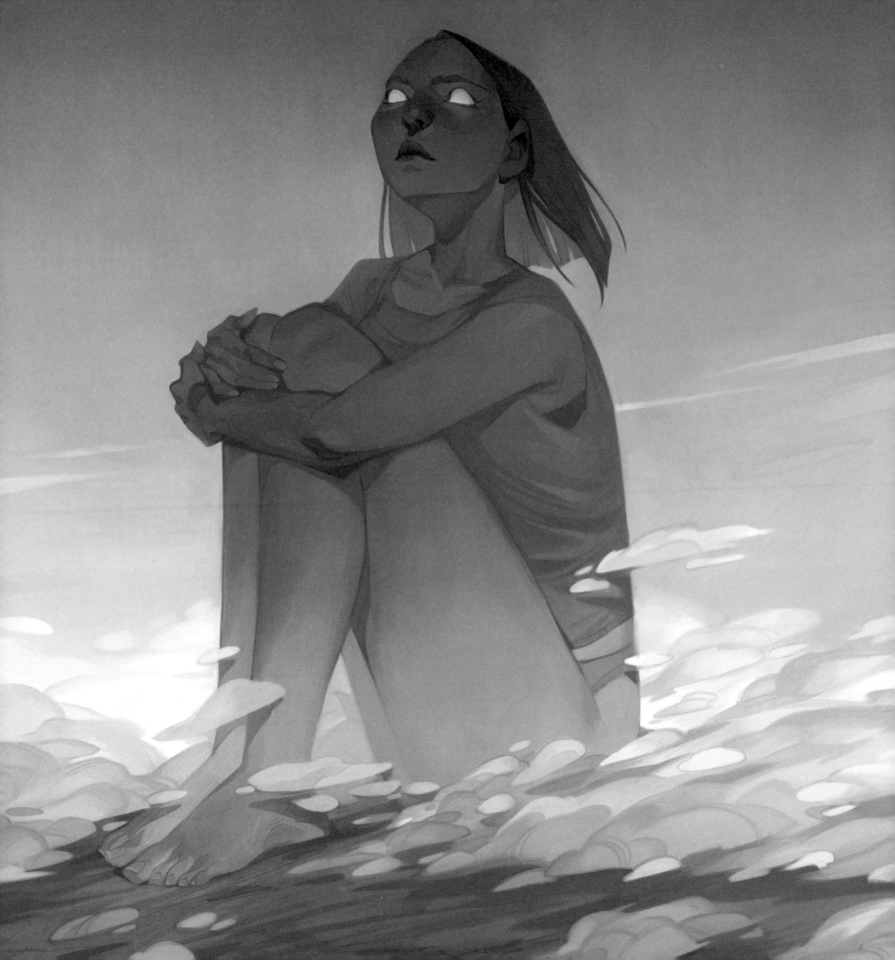

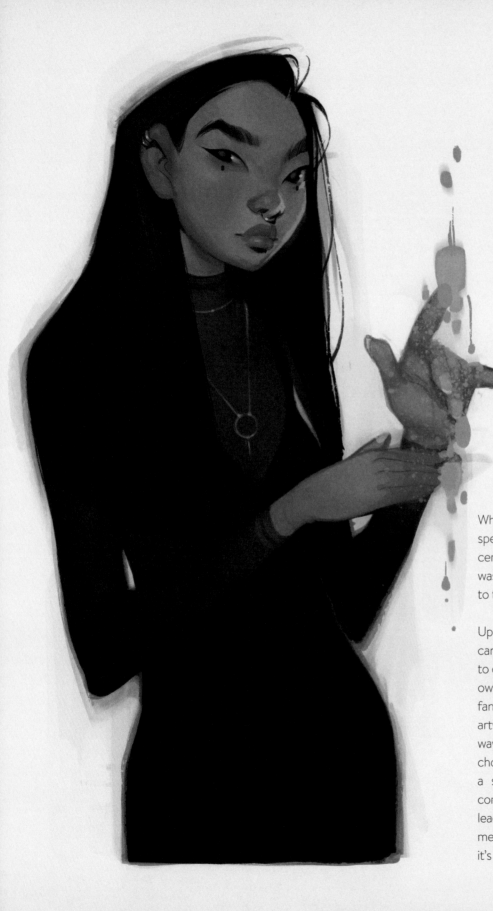

· characters ·

When people talk about "Loish style," they are often referring to the specific way in which I draw female characters, which shows how central they are to my work. I've been drawing them for so long that it was never a conscious choice I made. It was a direct, instinctive reaction to the Disney princesses and art nouveau pinups that inspired me.

Upon analyzing my own work, I realized that a character is essentially a canvas onto which I could project a part of myself. I have always strived to convey a specific type of female character that is comfortable in her own skin, exudes warmth and familiarity, and is in charge of her own fantastical world. This kind of imagery is comforting to me, and creating artwork that conveys this is an expression of my own desire to feel this way, or at least exist in that kind of environment. Many of my stylistic choices are organized around this desire: expressive facial features, a semi-realistic approach that is both familiar and otherworldly, comfortable clothing, magical imagery, and so on. These characters lead the way in my creative process, taking center stage and inspiring me to organize all of my creative decisions around them. Looking back, it's no surprise that I went on to develop a career in character design.

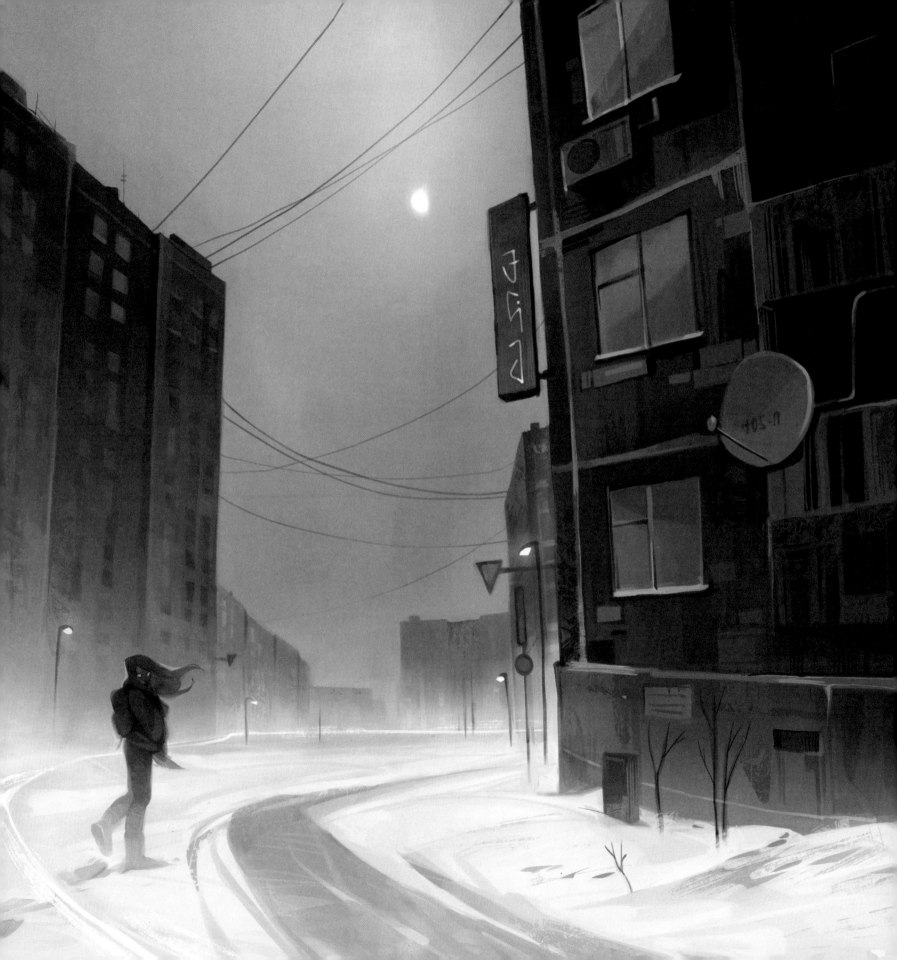

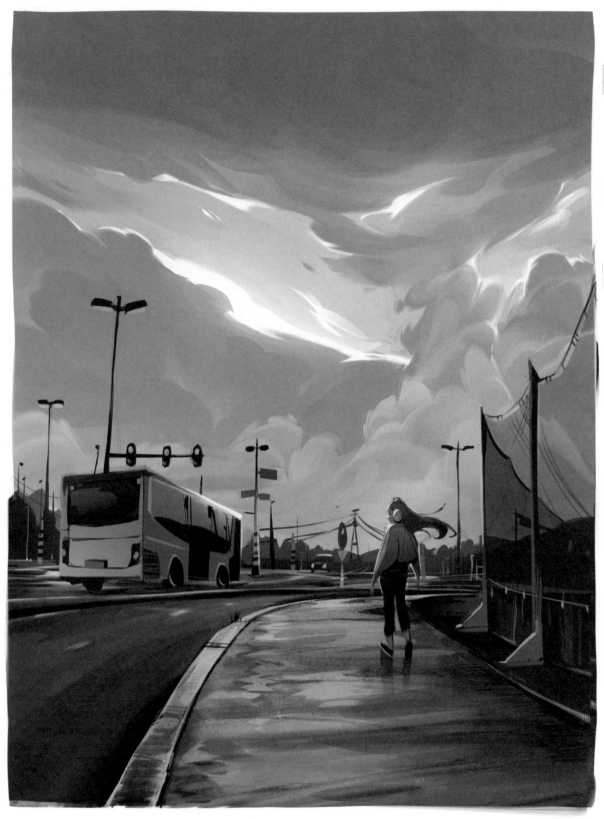

This page: Artwork created with the original photograph opposite as reference

118

· the creative spark ·

My art usually starts with a "creative spark"— a brief moment in which I see something that I like and instantly feel motivated to recreate it in some way. I'm not always drawing, so I usually take a snapshot with my phone or write down some notes to revisit later. These notes are not so much about how that beautiful flower, sunset, or inspiring scene looked, but rather how I felt when I saw it. The resulting artwork may not resemble the initial thing that inspired me at all, but that's not a problem to me. The most important thing is that the feeling I experienced is woven into the work, and helped motivate me throughout the creative process. Stylistic choices, such as exaggerating colors, pushing shapes, and adding imaginary visual elements, come naturally when the goal is to channel a feeling, rather than to capture the details correctly.

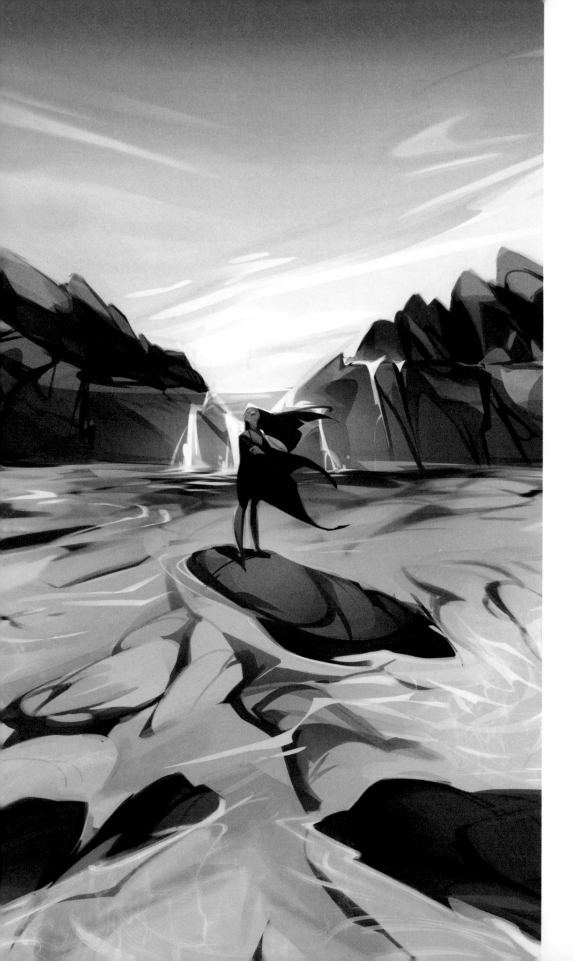

· nature ·

The organic forms, visual richness, and endless complexity of nature never fail to capture my imagination. The poetic beauty can overwhelm me when I'm traveling to faraway places, but a tiny flower growing between concrete tiles can be just as inspiring. In my life, nature is a therapeutic and soothing force that I try to seek out every day, whether that's admiring a houseplant or taking a hike in a nearby forest. This strong emotional impact has influenced my visual style in many ways. I gravitate toward organic shapes and flowing forms, just like the art nouveau artists before me, who were similarly inspired by the aesthetic of nature. Floral and plant-related themes can be found in many of my paintings, and my approaches to color and detail are heavily based on the natural variations and rhythms I see around me in plants, trees, and landscapes. The emotional effect I experience when immersed in nature is a foundational building block of my visual style.

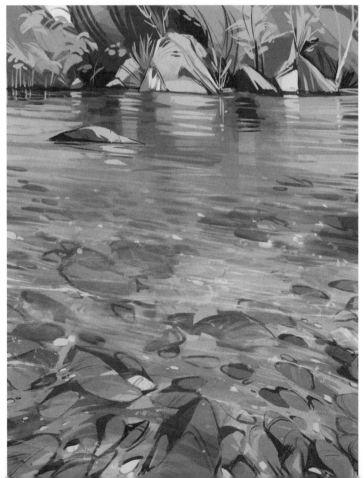

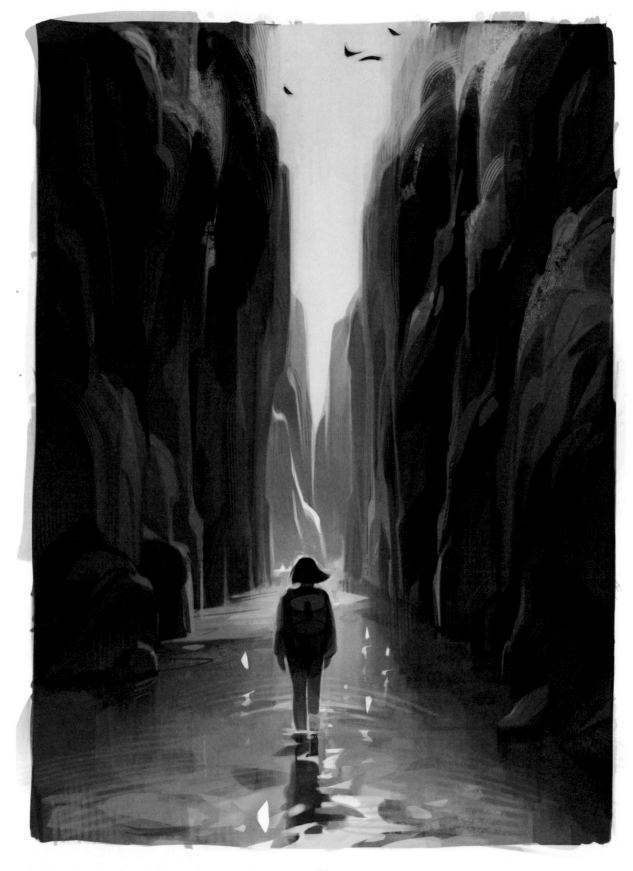

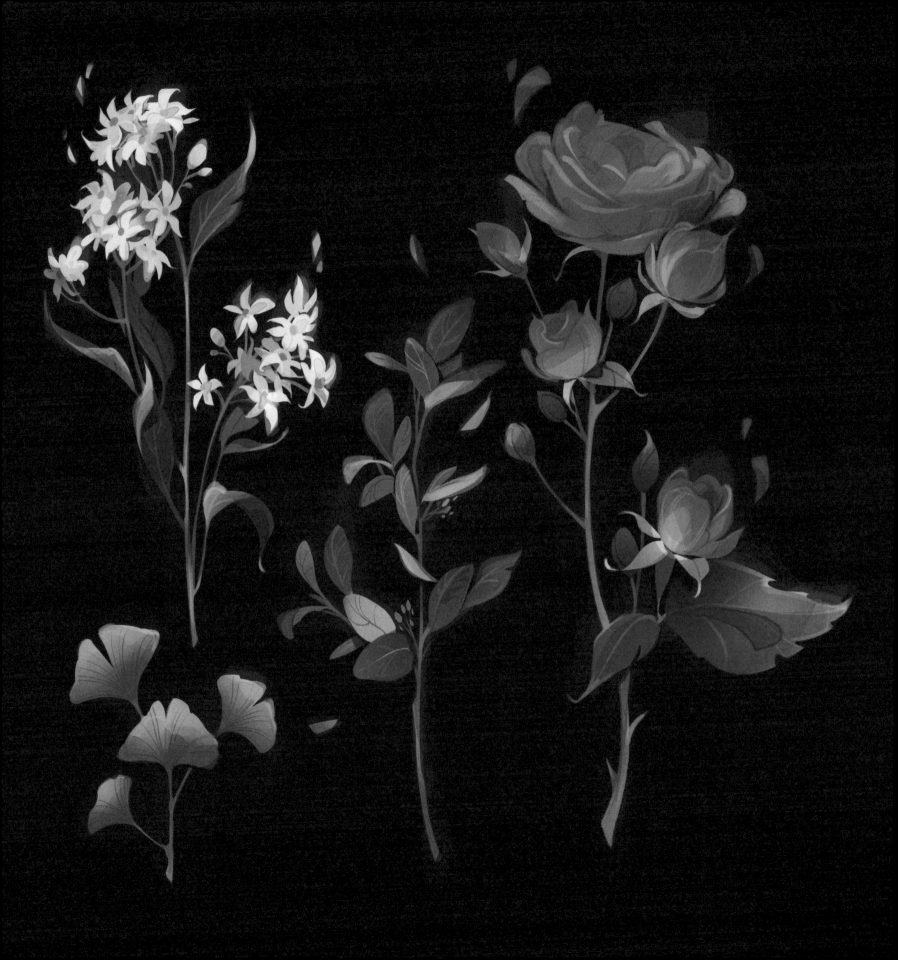

techniques //
generating ideas

keep an inspiration board

The idea that artists are perpetually inspired and constantly creating does not ring true for me. I tend to be more productive when I stick to a steady drawing routine. Inspiration, however, can strike at completely random moments, and it's important to capture it and not let it go to waste. In the moment, I make a note of something that inspires me and return to it later, during drawing hours. Anything goes: a quick photo, a scribble in a notebook, or an elaborate Pinterest board. I use a mix of all three. The most important thing is to remember the emotional response that the single moment of inspiration invoked, so that I can channel it into the subsequent art.

warm in sun,
cold in shadow

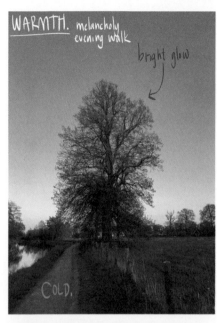

WARMTH. melancholy evening walk

bright glow

COLD.

full

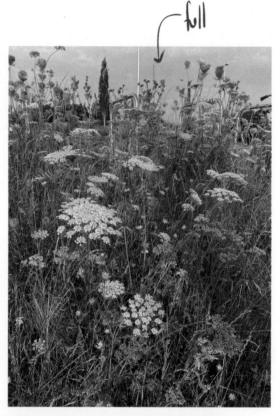

photo is too flat

Seeing the path ahead.

EARLY MORNING. feeling of a new day

Sun very bright/ blinding.

a new place I'd never seen before

falling back on what I know

Art can convey things beyond our imagination, opening up worlds we didn't know existed. However, I connect most deeply to art that is built on the artists' own lived experience in some way. The experience of going through that moment makes the work that much more authentic and believable. When in doubt, I fall back on what I know and try to draw inspiration from my own life and emotional world to come up with new ideas. Much of my art is semi-autobiographical for this reason.

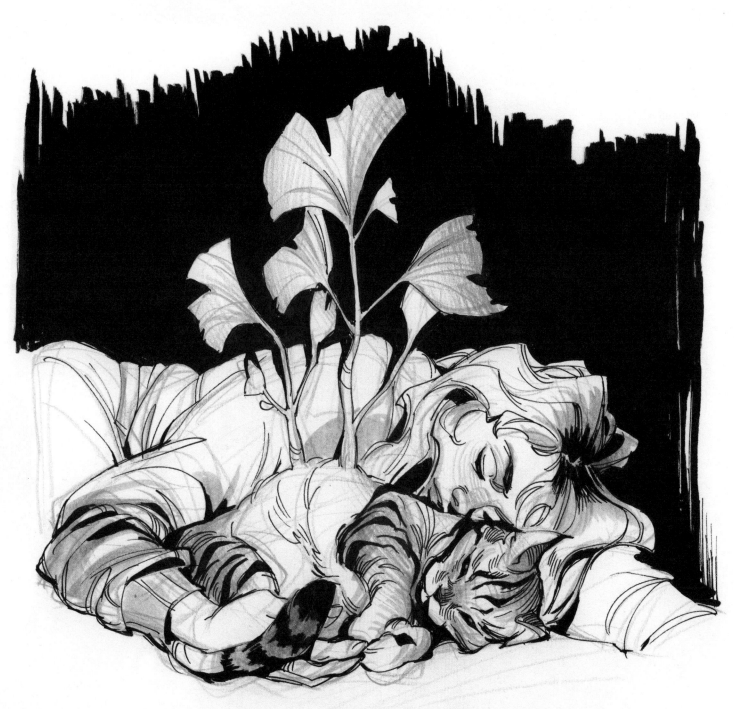

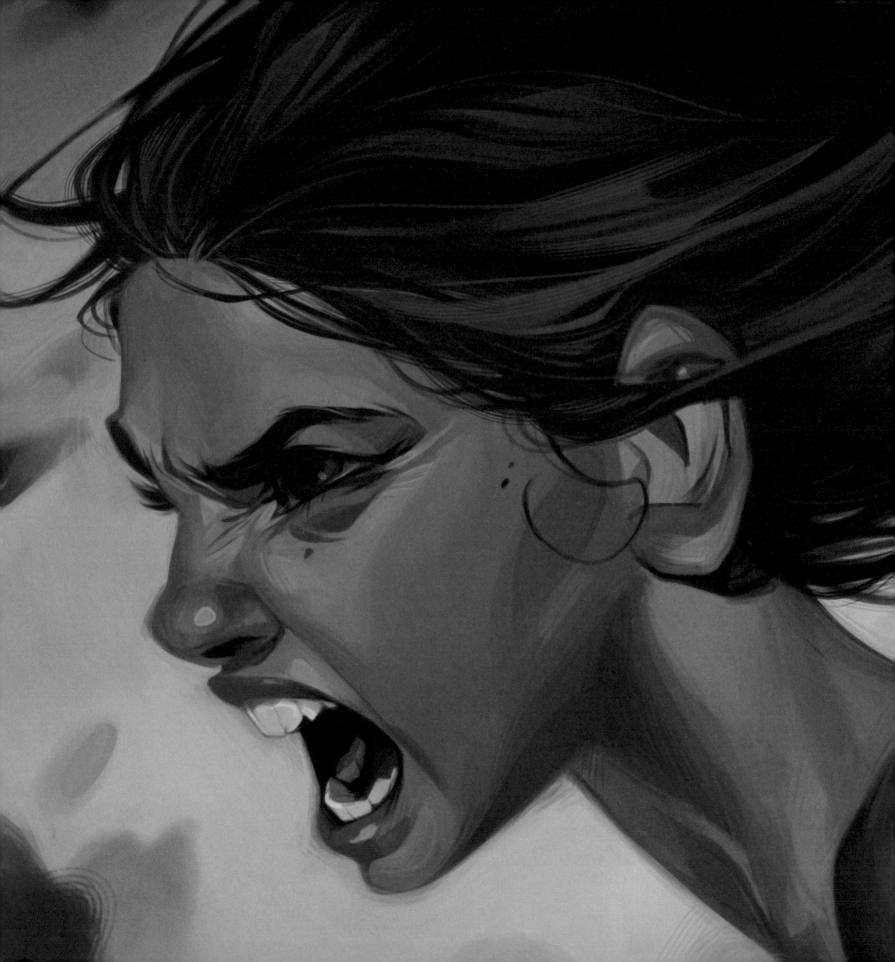

case study //
thunder

This piece has two iterations. The first one was drawn during an ink drawing challenge in 2018. While my work usually conveys a serene mood, this time I wanted to capture the feeling of rage and frustration. To achieve this, it was important to show intensity in the face and also the setting, where stormy clouds were brewing. While the idea had potential, in the end I felt that it missed the mark. It just didn't have the intensity that I was trying to capture.

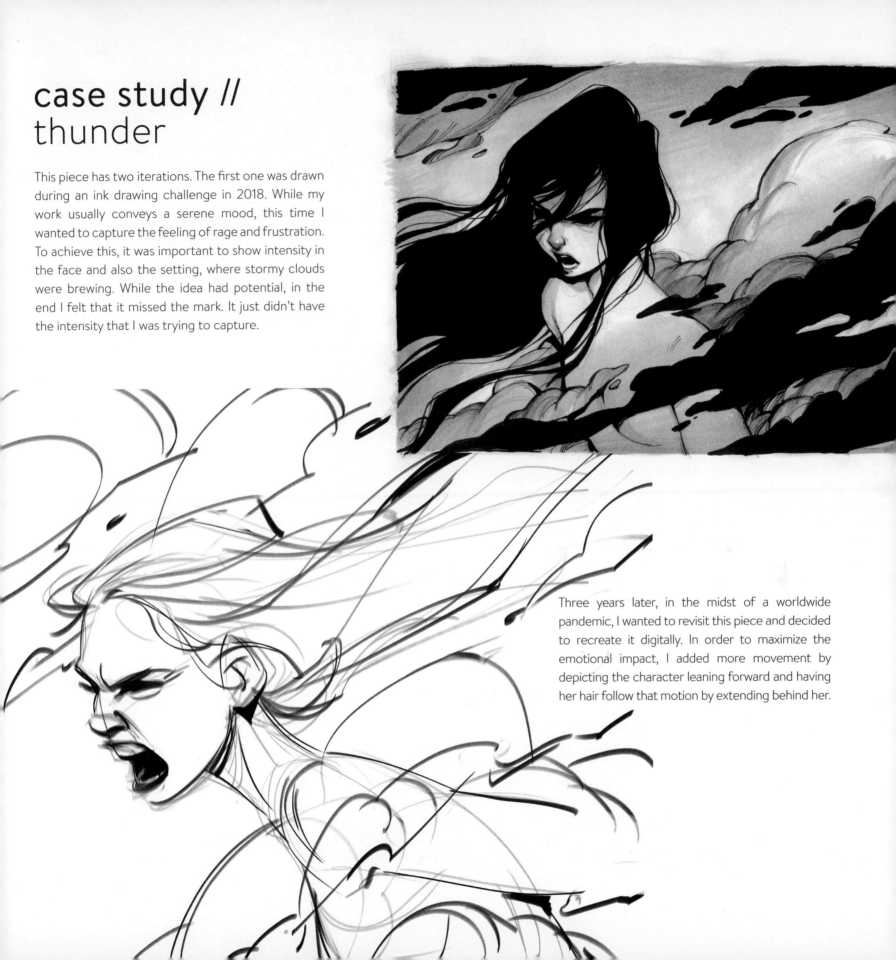

Three years later, in the midst of a worldwide pandemic, I wanted to revisit this piece and decided to recreate it digitally. In order to maximize the emotional impact, I added more movement by depicting the character leaning forward and having her hair follow that motion by extending behind her.

"... it was important to show intensity in the face and also the setting, where stormy clouds were brewing"

I then pushed the enraged expression further with the help of reference images, working to get the small details right so that it felt more intense.

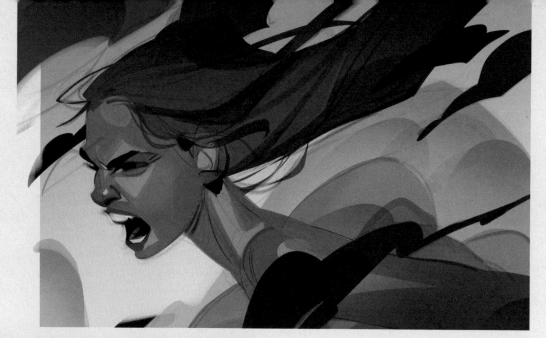

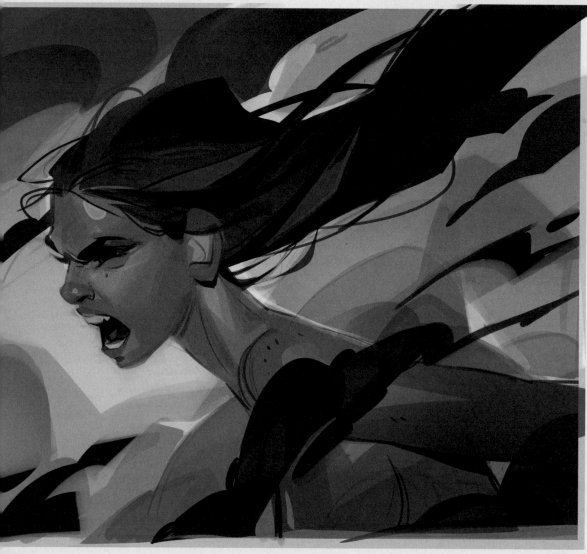

Finally, I changed the composition by having the character fill up the frame more, helping to put her emotion front and center.

This process is a good example of how a concept can resonate emotionally, but still fall flat because the stylistic choices do not sufficiently support the message behind the work. By revisiting it later and making some crucial changes to composition and detail, the impact was closer to what I had originally intended.

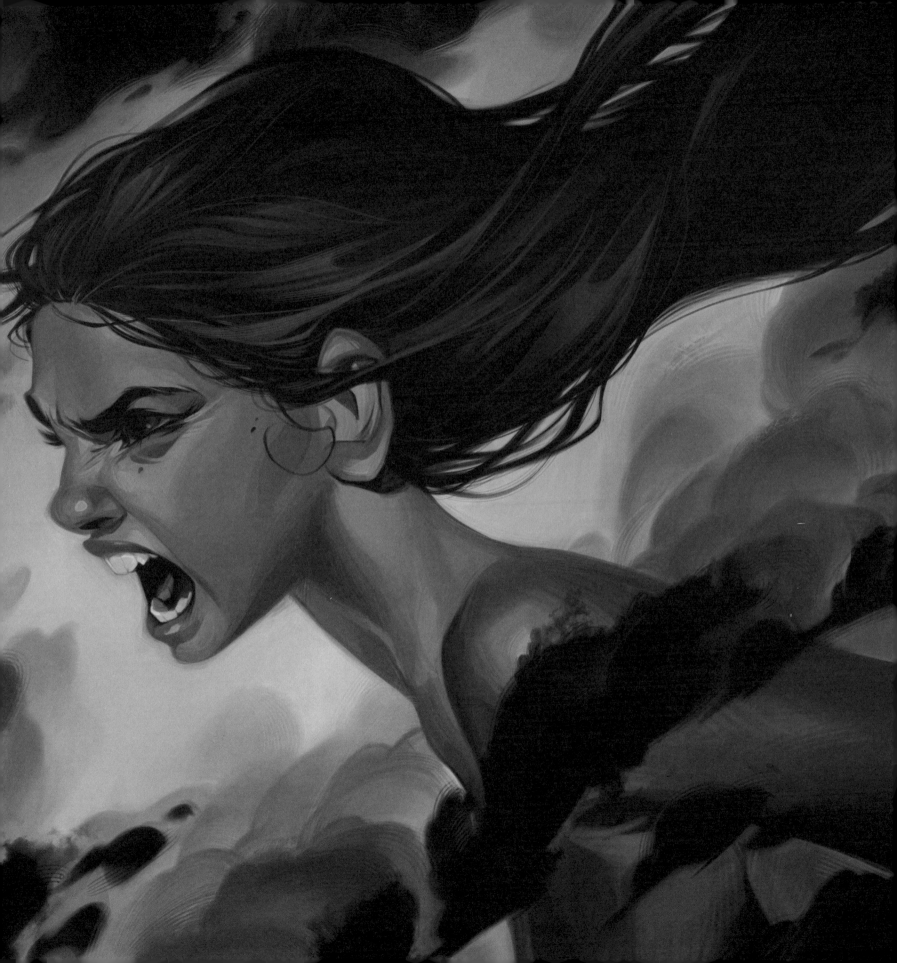

exercise // finding inspiration in daily life

In order to channel inspiration from daily life, it's important to not only pick a specific moment, but also to be aware of how you are feeling while you experience it. This is much easier said than done — I'm usually too caught up in my daily chores or routine to think about that! However, for this exercise, try to observe your own emotional world a little more closely when you see something that appeals to you.

For a few days, take snapshots of things that stand out to you or evoke an emotional response.

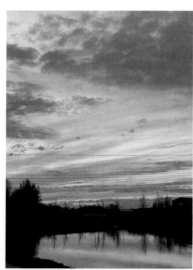

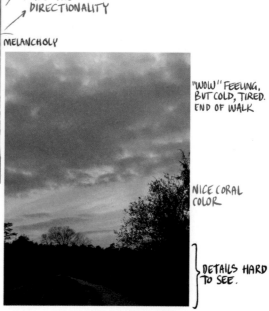

I LIKE THE DIRECTIONALITY

MELANCHOLY

"WOW" FEELING, BUT COLD, TIRED. END OF WALK

THIS ONE HAS MOVEMENT TOO

NICE CORAL COLOR

I LIKE THE REFLECTION.

DETAILS HARD TO SEE.

WAS ALMOST 9PM WHEN I TOOK THIS. AMAZED BY THE LIGHT // FEELING LIKE I SURVIVED THE WINTER

FIRST SKETCH:

ROUGH VERSION:

Select one of the photos and use it as a reference for a drawing. It can be a simple sketch or an elaborate painting — whatever you feel fits with your idea! Force yourself to deviate from your reference photo. What can you change to push it away from reality, and toward the feeling you had at that moment?

FEELS A BIT EMPTY, COLD.

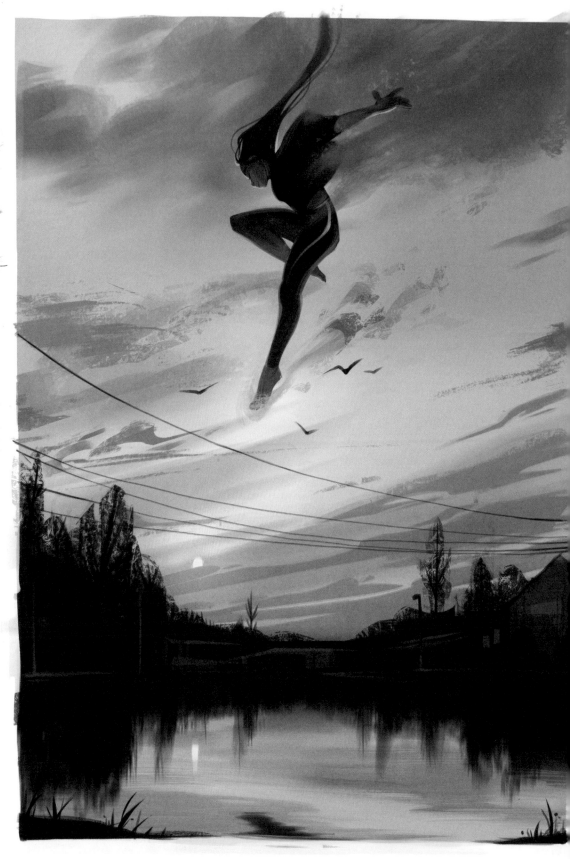

ADDING CHARACTER: GIVES ENERGY

CATCHING THE
WARM LIGHT

You can also add some elements from your
imagination, or combine multiple photos you took.

By doing this exercise, you're training yourself to
better understand the lens through which you see
the world. Such a lens is not good or bad, it's just who
you are and how you see things. The more your art is
a reflection of your vision, the more it will be unique
to you as an artist.

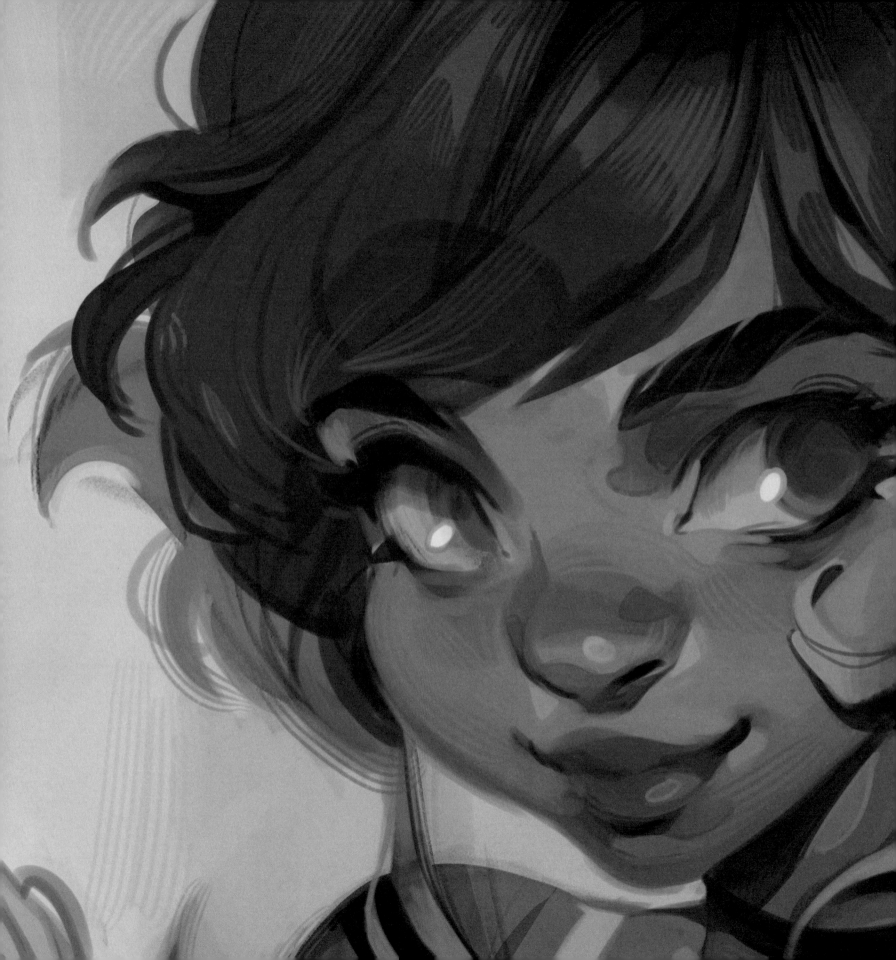

· tutorial ·

· intuitive digital workflow ·

In the previous chapters, I discuss the motivations behind various aspects of my style. While these creative goals are an important driving force behind the choices I make, my workflow and techniques are an equally significant part of that story. When I was first learning how to use digital media, the process sometimes became complex and convoluted. This would knock me out of my creative flow, making the experience of finishing my artwork laborious and frustrating. Over time, I discovered ways to simplify my workflow and use the tools intuitively, which paved the way for the creation of my own style and artistic voice.

I now refer to this as my "intuitive digital workflow." Intuition is an incredibly important tool for artists. It allows us to use our gut feeling as a guide for our creative decisions, and gives us the possibility to lean into what feels right, thus maximizing the potential to develop a unique voice. With this tutorial, I invite you to not only try out this technique, but to make the time to reflect on your intuitive response to it.

There are also some variations at the end that you can try, depending on your personal preferences. I used Photoshop for this drawing, but most drawing apps and software will work fine too. I hope this tutorial will offer a handful of interesting techniques, but more importantly, I hope you feel motivated to adapt them and make them your own!

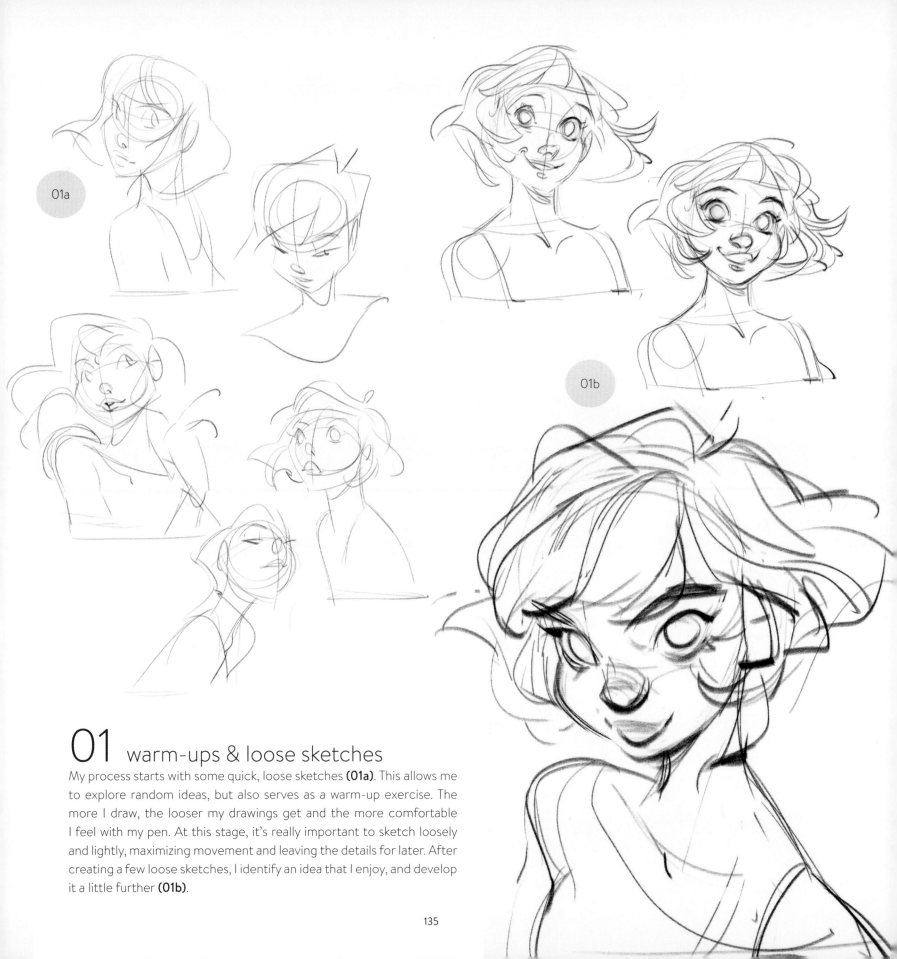

01 warm-ups & loose sketches

My process starts with some quick, loose sketches **(01a)**. This allows me to explore random ideas, but also serves as a warm-up exercise. The more I draw, the looser my drawings get and the more comfortable I feel with my pen. At this stage, it's really important to sketch loosely and lightly, maximizing movement and leaving the details for later. After creating a few loose sketches, I identify an idea that I enjoy, and develop it a little further **(01b)**.

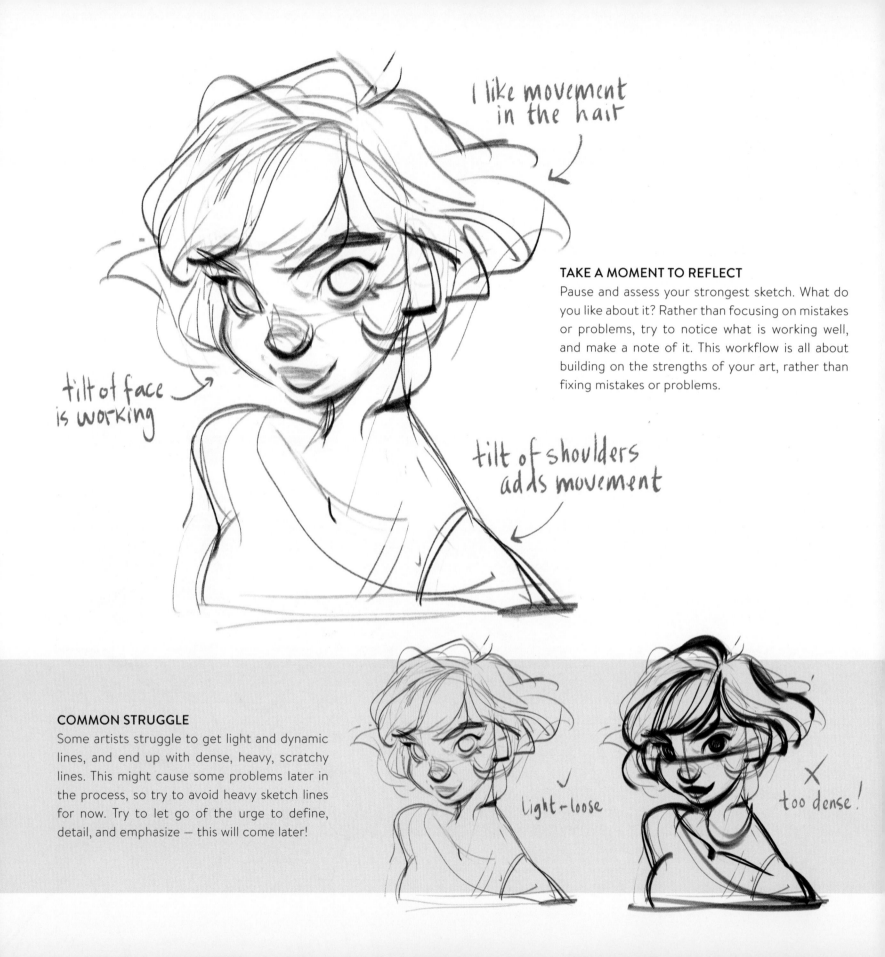

I like movement in the hair

tilt of face is working

tilt of shoulders adds movement

TAKE A MOMENT TO REFLECT

Pause and assess your strongest sketch. What do you like about it? Rather than focusing on mistakes or problems, try to notice what is working well, and make a note of it. This workflow is all about building on the strengths of your art, rather than fixing mistakes or problems.

COMMON STRUGGLE

Some artists struggle to get light and dynamic lines, and end up with dense, heavy, scratchy lines. This might cause some problems later in the process, so try to avoid heavy sketch lines for now. Try to let go of the urge to define, detail, and emphasize — this will come later!

light + loose ✓

too dense! ✗

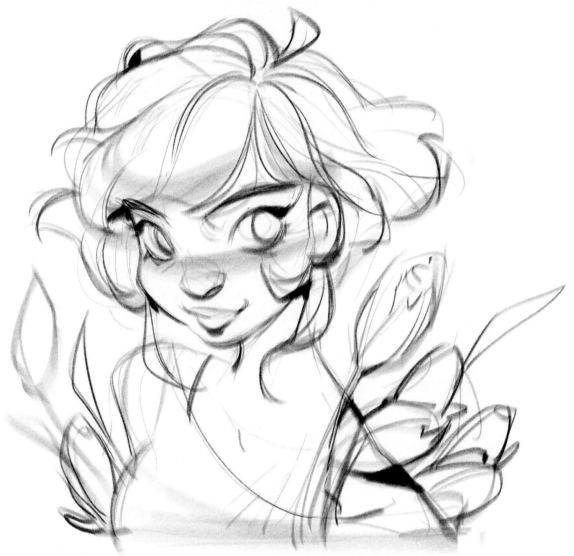

Compare your defined sketch to your rough sketch by clicking the layer on and off. Are you preserving parts of your initial sketch that you like? If not, take the time to adjust your defined sketch. Remember that it's OK if your drawing changes and evolves throughout the process, as long as you are keeping the stronger parts of your drawing intact as you progress.

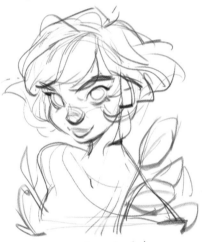

rough sketch

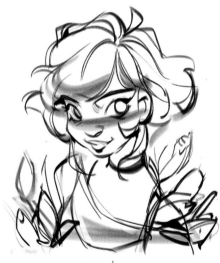

line layer

02 finalizing the sketch

Once I've settled on a sketch that I like, I add a new layer on top of my rough sketch, and create a more defined sketch. I avoid simply tracing over the existing lines; that would weigh down the sketch too much. Instead, I only work on the areas that would benefit from extra definition. When combined, they form a strong mix of dynamic lines and clear definition.

COMMON STRUGGLE

At this stage, it's tempting to start focusing on the tiny details. However, this is meant to be a quick sketching phase. Even though we are defining the sketch, try to focus only on what's absolutely necessary to understand what goes where. The details will come later!

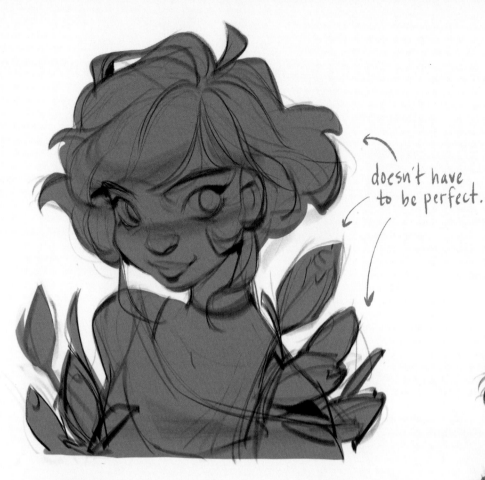

doesn't have to be perfect.

04 choosing the first color

This is where my intuitive process for choosing colors begins. It involves starting with one color and moving gradually out from there, adding new colors one by one. To start, I adjust the base color by opening the Hue/Saturation slider. I move the sliders around until I like what I see. Here I gravitate toward a blueish color.

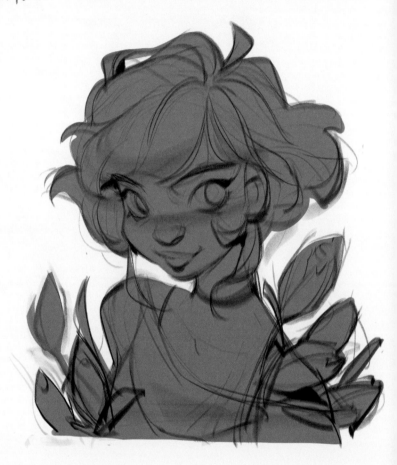

03 base color

Having merged the two sketch layers, on a layer below I block in the silhouette in a random color that I will change later. I like to use the Lasso tool for this, but you can block it in with a brush if you prefer. At this stage, I'm not worried about messy edges, because there will be time to clean the image up later.

TAKE A MOMENT TO REFLECT

Move the color sliders around and observe how this changes the base color. While you're doing this, reflect on the impact that different colors have on you. How does this color make you feel? Do you like it, or do you want to move away from it? Try not to over-analyze, just allow yourself to experience the color. Using this mindset, move toward the color you like most. It doesn't have to make sense, and it can be anything you want!

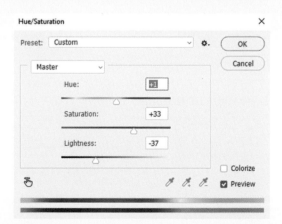

05 creating the color scheme

Once I've chosen my base color, I choose my next color based on how it works with the first. This is something I can only judge once I see the color combination in front of me. There are different ways to test this: I can compare new and current in the color picker window, I can paint on a new color to see how it looks, or I can select certain areas and gradually change the hue of that selection **(05a)**. I opt for the latter, and gradually add darker blues and purple tones to the color scheme. I can also soften the edges of my Lasso tool so that the color transition is less harsh. To finish, I make some tweaks to the overall color scheme using the Color Balance tool, which is also just a matter of moving the sliders around until I like what I see **(05b)**.

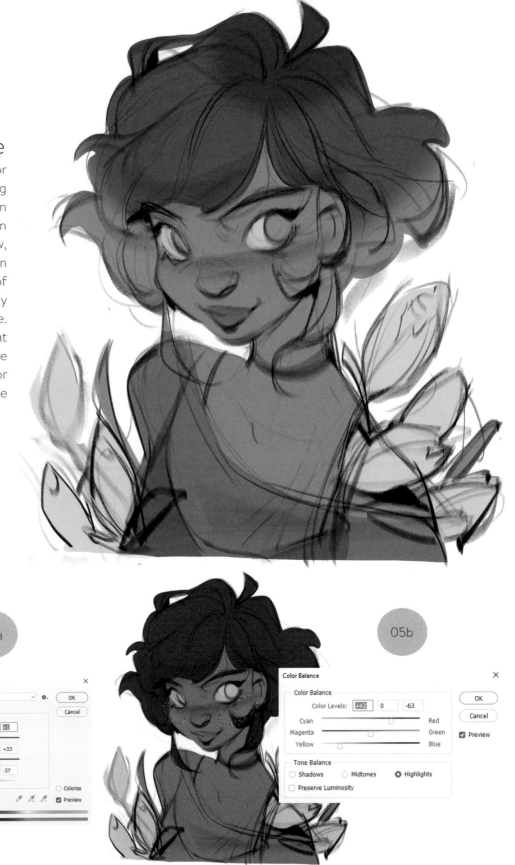

TAKE A MOMENT TO REFLECT

Compare your base color to a few random colors. Which combinations do you like most? Which ones feel right to you, and which do you dislike? Try to use this same gut-feeling response when adding new colors to your color scheme.

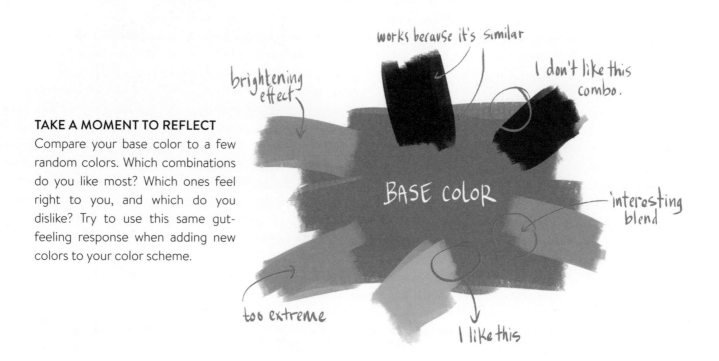

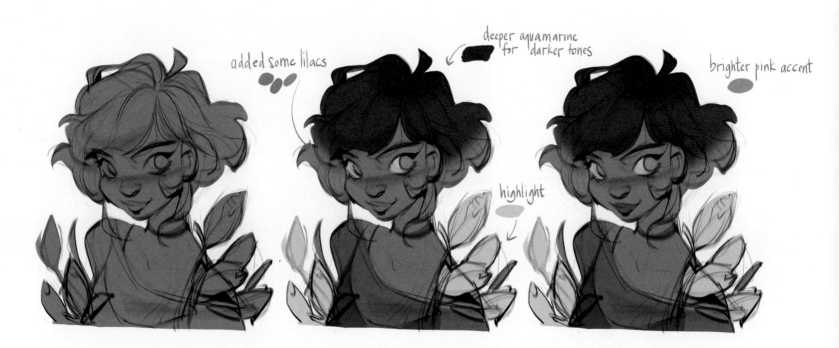

COMMON STRUGGLE

When there are a lot of colors on the canvas, it's hard to get them to work together. They might compete for attention or clash when placed next to each other. This is why I recommend building up your color scheme one color at a time. It's much easier to get a harmonious color scheme when you have a strong starting point!

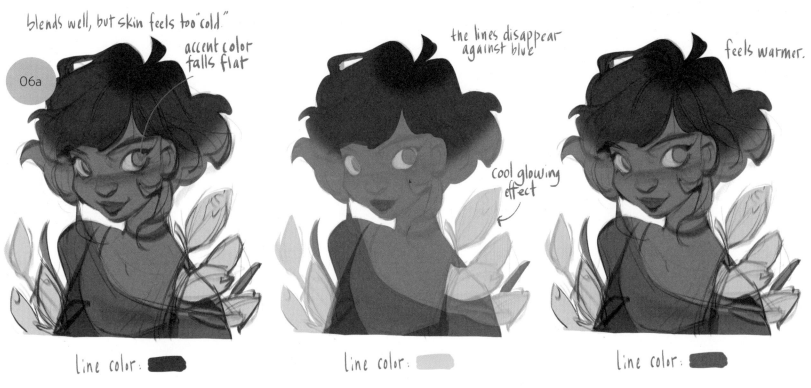

blends well, but skin feels too "cold."

accent color falls flat

06a

line color: ▬

the lines disappear against blue

cool glowing effect

line color: ▬

feels warmer.

line color: ▬

06 changing the line color

For this step, the most important thing is making sure that the sketch layer is set to Multiply. Once that is done, I use the Hue/Saturation slider to modify the color of the sketch, making sure that the "Colorize" box is ticked. I move the sliders around and experiment with different hues **(06a)**. Finally, I land on a color that I like: bright pink. For me, this is when the image comes to life. The color scheme feels more vibrant and unified, and the blend of linework with the base color creates a whole range of new colors to paint with **(06b)**. When choosing your line color, try to use your intuition to decide which one you like most!

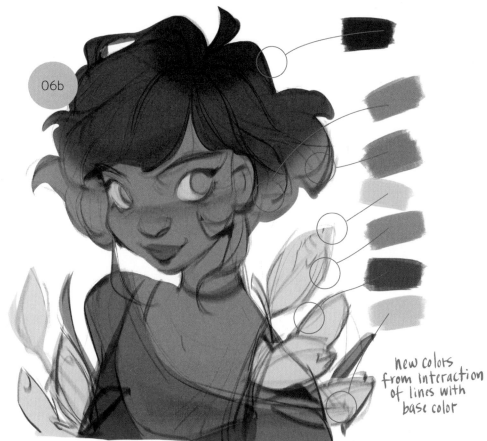

06b

new colors from interaction of lines with base color

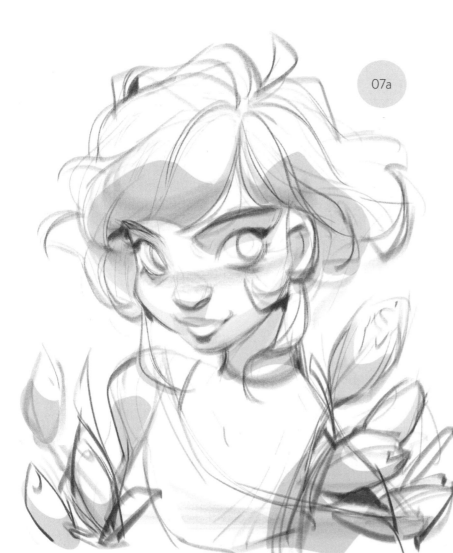

07a

07b

07 adding depth

On a new layer set to Multiply, I quickly block in some shadows **(07a)**. They are not very detailed, but just enough to give a little more depth to this sketch. As always, I use the Hue/Saturation slider to tweak the color until it blends nicely with the base colors. After that, I merge my sketch, base, and shadow layers together, so that all of my art is on one layer **(07b)**.

COMMON STRUGGLE

If you're used to working neatly, you may find it stressful to merge everything together at this stage, especially when there are still some rough edges and messy sketch lines in the drawing. Try to let that go and trust that you can always fix it later! If you are nervous about losing your separated layers, you can always duplicate the layers and keep a backup of them hidden underneath your drawing layer.

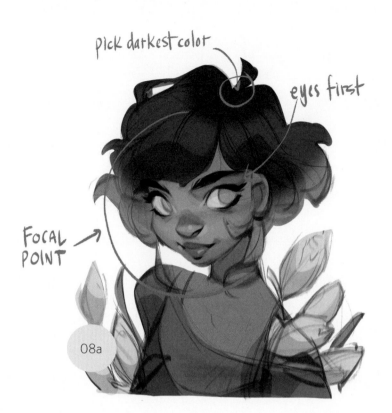

pick darkest color

eyes first

FOCAL POINT →

08a

08 sculpting with color

I like to compare this process to baking a cake. The previous steps were a bit like getting all of my ingredients on the counter. Now that they are all here, it's time to mix them and work towards the finished product. In this case, that means using the colors that are already on the canvas, and gradually adding more depth with them. I start by grabbing the darkest color on the canvas, which is where the sketch lines blend with the top of her hair. I use this color to further define her eyes and facial features **(08a)**. I move out from there, gradually adding highlights and shadows, only using the colors from the canvas **(08b)**.

TAKE A MOMENT TO REFLECT

Before starting the sculpting process, take some time to assess your image and decide on a focal point. Which area do you want people to look at first? Start detailing there, and make sure you give this area the most attention in your painting process. You can leave other areas a bit rougher. This helps emphasize the focal point but most importantly, it saves time.

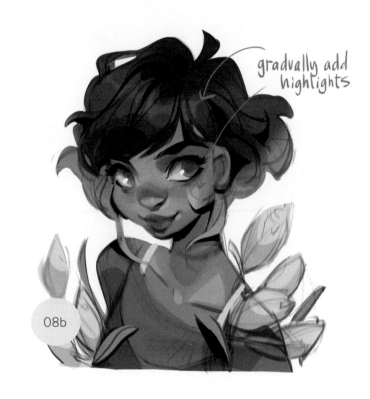

gradually add highlights

08b

COMMON STRUGGLE

When blending the colors together, they can sometimes turn out a bit muddy. This often happens when the highlight and shadow colors are far apart in value, or when the highlights and shadows are simply darker and lighter versions of the base color. To combat this, try to blend colors closer in value, or try using unexpected colors for the shadows and highlights by shifting to a different hue for them. This creates more interesting and vibrant midtones.

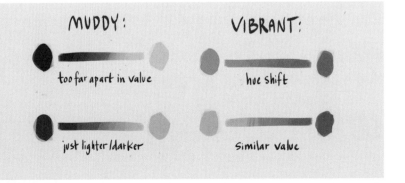

MUDDY:

too far apart in value

just lighter/darker

VIBRANT:

hue shift

similar value

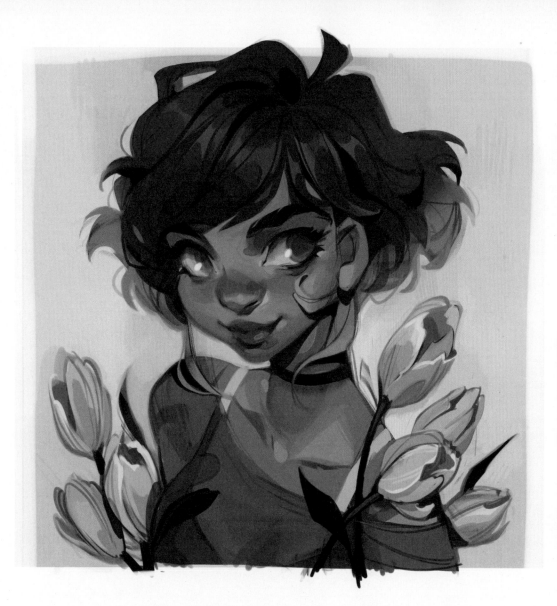

09 rendering the details

As I add more depth, the image looks more and more like a finished piece rather than a sketch. As it continues to evolve, I discover ways that I can add to the piece in order to make it feel more complete. I block in a background color with some pink accents, because I like the way the pink lines stand out against the blue skin tone. I also push the depth further by introducing darker shadows and brighter highlights to the canvas, carefully comparing the new color against the base color to make sure it blends well with the color scheme.

COMMON STRUGGLE

It can feel very satisfying to smooth out the drawing and keep adding details, but it's easy to fall into the trap of over-rendering and lose the charm of the original sketch. I like to pause frequently to compare my painting to previous steps, to check whether it's improving or if I've gone too far. It also helps to keep an eye on a thumbnail view of my painting, to make sure I'm not wasting time on a detail that isn't doing anything for the overall image.

10 finishing touches

To finish the piece, I make final adjustments to the colors to push the blue and pink to a more vibrant level. I paint over the image with a rake brush for some extra texture, and paint some final details on the face **(10a)**. I want to add some finer, sharper detail to the painting to balance out the rougher areas. Once I've done this, I feel like the painting is complete **(10b)**!

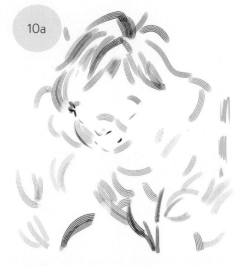

10a

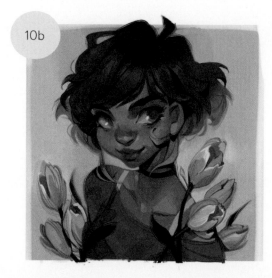

10b

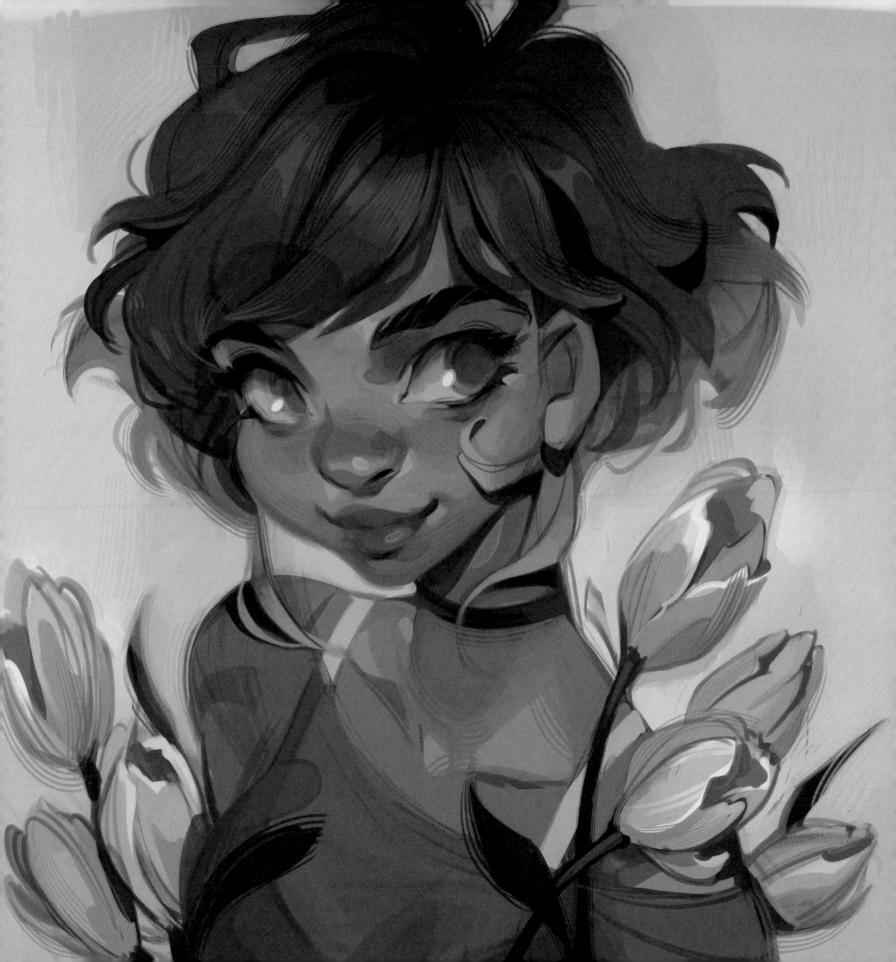

· variations ·

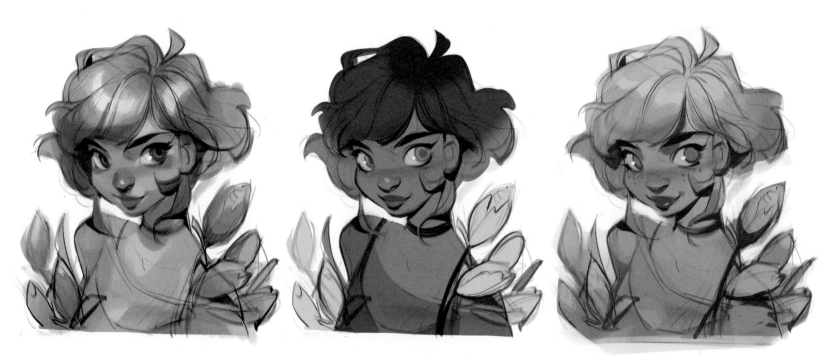

I developed the intuitive digital workflow by cutting out the techniques that didn't work for me. I found drawing clean linework to be tedious and cumbersome, so I stopped doing it. I found working with many layers confusing, so I work on very few layers. In a similar vein, there may be aspects of this workflow that feel tedious and frustrating to you. This can be overcome with practice, but it might also be worthwhile to try variations on the process to see if you can make it more suitable to your own way of working. Here are some variations, but they are just suggestions! Feel free to deviate from the workflow in any way that feels good to you.

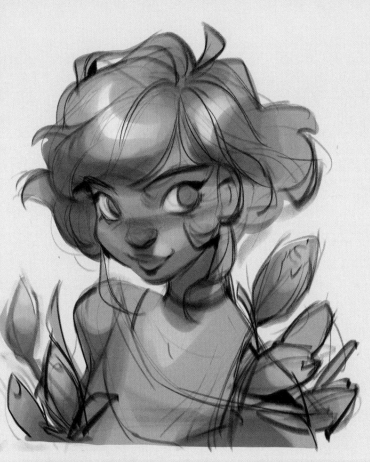

variation 01 // grayscale

This is a variation that might work well for artists who feel less comfortable with the color tools, or simply aren't as interested in using color.

I personally enjoy using this process when I want to focus more on the volumes. This process starts from step 03 of the intuitive digital workflow tutorial, but with a grayscale silhouette rather than a colored one.

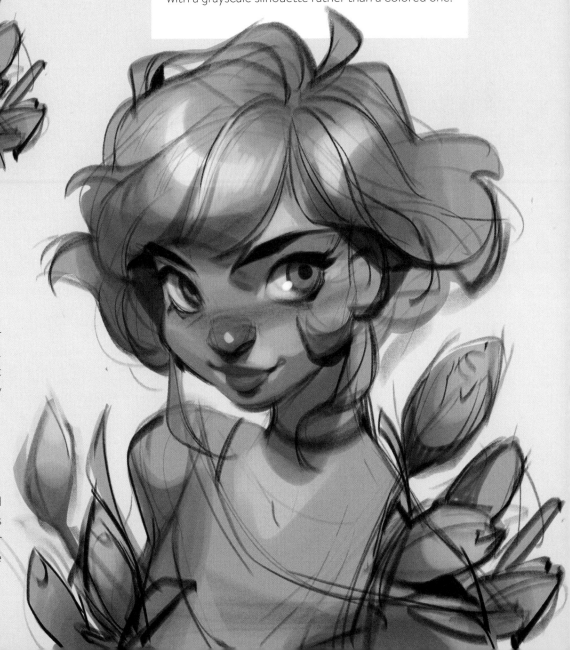

01 add depth

On the grayscale silhouette layer underneath your sketch, paint lighter and darker values to add depth. Don't start with extremely light or dark values, but gradually move out from a medium value and slowly build up the contrast.

02 sculpt with values

Merge the sketch lines with your silhouette layer and start painting over the lines, sculpting the volumes as you go. You can refine the linework and paint over parts of your sketch if you like. Continue pushing the contrast in your focal point.

03 optional: add color

There are different ways to add color to grayscale. I usually make a new layer on top, set it to Overlay, and paint various colors over the sketch **(03a)**. These will blend in with the drawing below. Other layer modes may work well too, so it's definitely worthwhile to experiment with them! Along with this, I also adjust the color of the grayscale painting using Color Balance, moving the sliders around to see how this interacts with the color layer **(03b)**. I keep experimenting with this until I'm happy with the result **(03c)**.

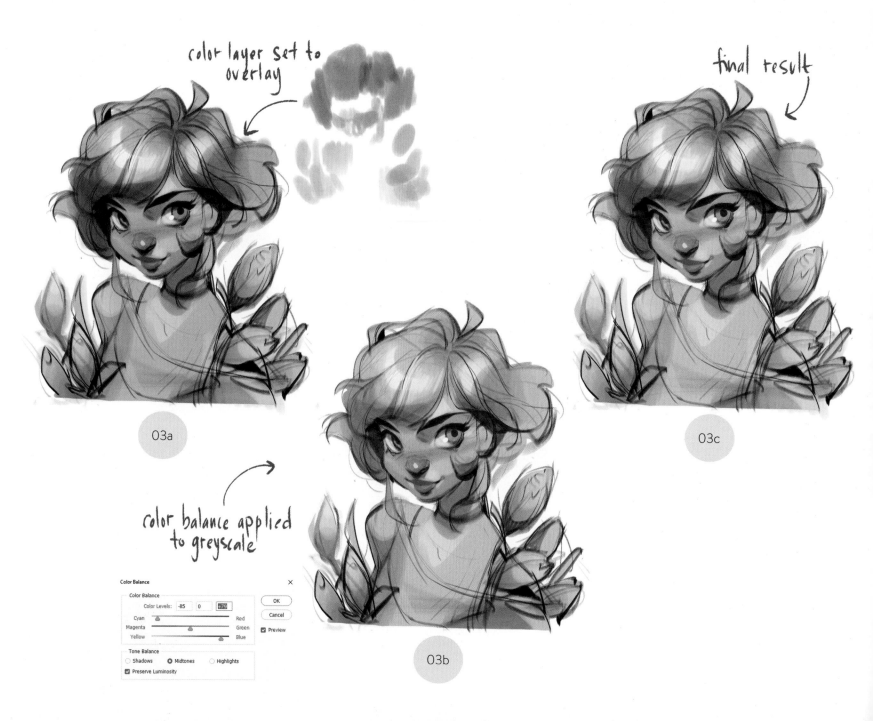

color layer set to overlay

final result

03a

color balance applied to greyscale

03b

03c

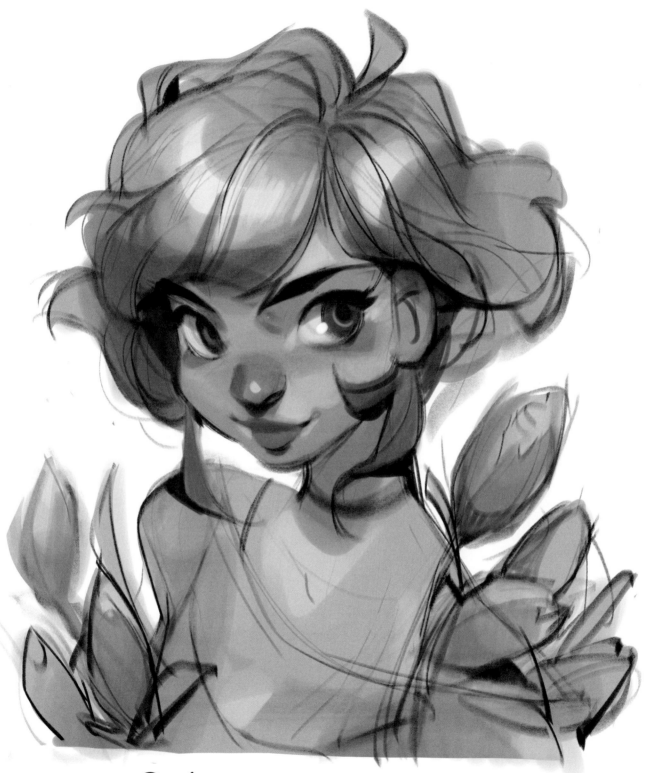

04 render & detail

Once you've landed on a color scheme you like, you can merge it all together and paint from there. As you can see, this can create some interesting results with unexpected and unique color combinations.

variation 02 //
flat color

This variation skips the process of adding depth, and is more suitable for styles that are focused around linework. If you tend to get lost in the painting process with muddy results, this variation might work better for you! It starts from step 06.

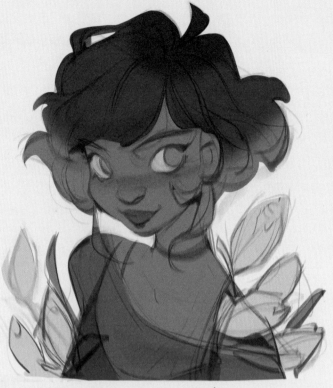

starting point

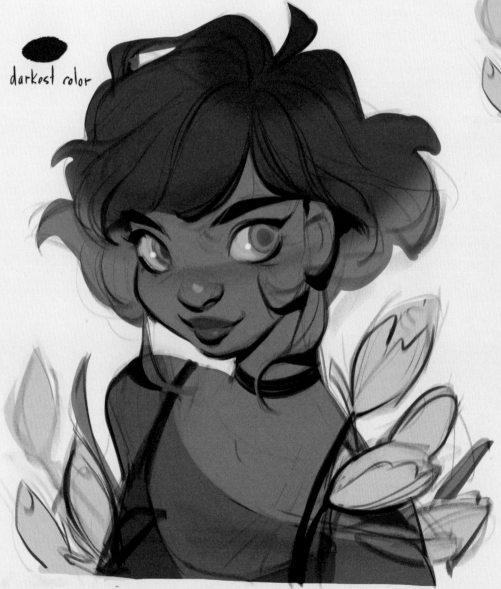

darkest color

01 define darker lines

After changing the color of the linework, some of the contrast may have been lost **(01a)**. Select the darkest color on the canvas and use it to add definition to the lines that would benefit from a little strengthening. Try not to simply trace over your line art, but rather find a balance between defined lines and the loose sketch lines **(01b)**.

02 add details

Introduce a few simple highlights and details. Clean up any messy areas, without polishing away the charm of your rough sketch lines. Just a small pop of extra detail can go a long way with this simpler style.

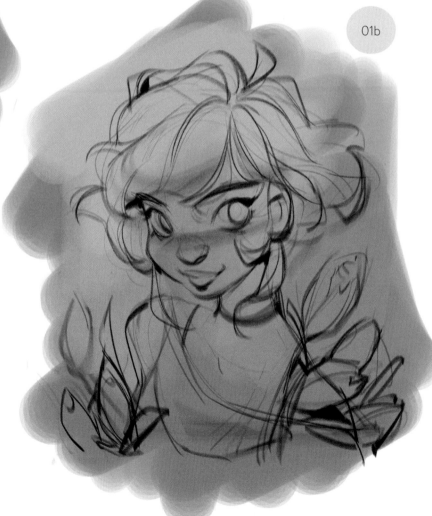

variation 03 //
random base colors

This is a playful variation where I let go of any need to use accurate colors or lighting, and work from random colors to see what comes out of it. It starts from step 02.

01a

01b

01 layer on colors

Rather than block in the silhouette, grab a big brush and layer some random colors underneath the lines. I chose a few bright rainbow hues for mine **(01a)**. Blend them together a bit and see which intermediate hues emerge **(01b)**.

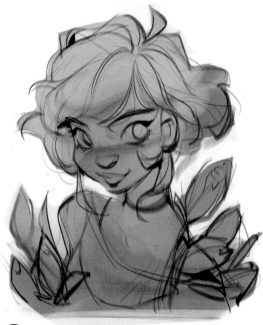

02 trim the edges

With the eraser tool, clean up the edges so that the colors are contained inside the silhouette of the sketch.

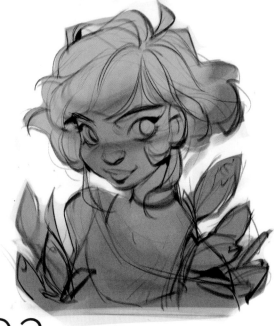

03 adjust the colors

Use simple color editing tools like Color Balance to modify the colors a bit.

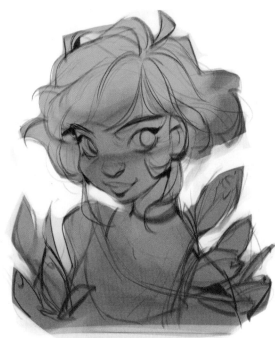

04 change the line color

Next, change the color of your lines: set them to Multiply and use Hue/Saturation to find a color that interacts nicely with the base colors.

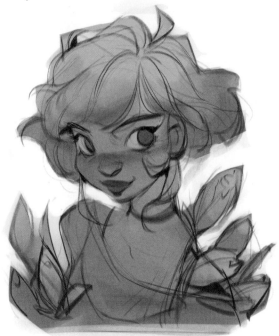

05 paint & sculpt

Try using the colors on your canvas to define your sketch. This might result in some strange color choices, like bright blue for the eye whites, but don't worry too much about accuracy.

06 sculpt with color

Finally, merge everything together and start sculpting with the colors you have, painting over the line art where needed. Try to use the colors already on the canvas to establish highlights and shadows. You will get some interesting results that can turn out much better than you initially expected!

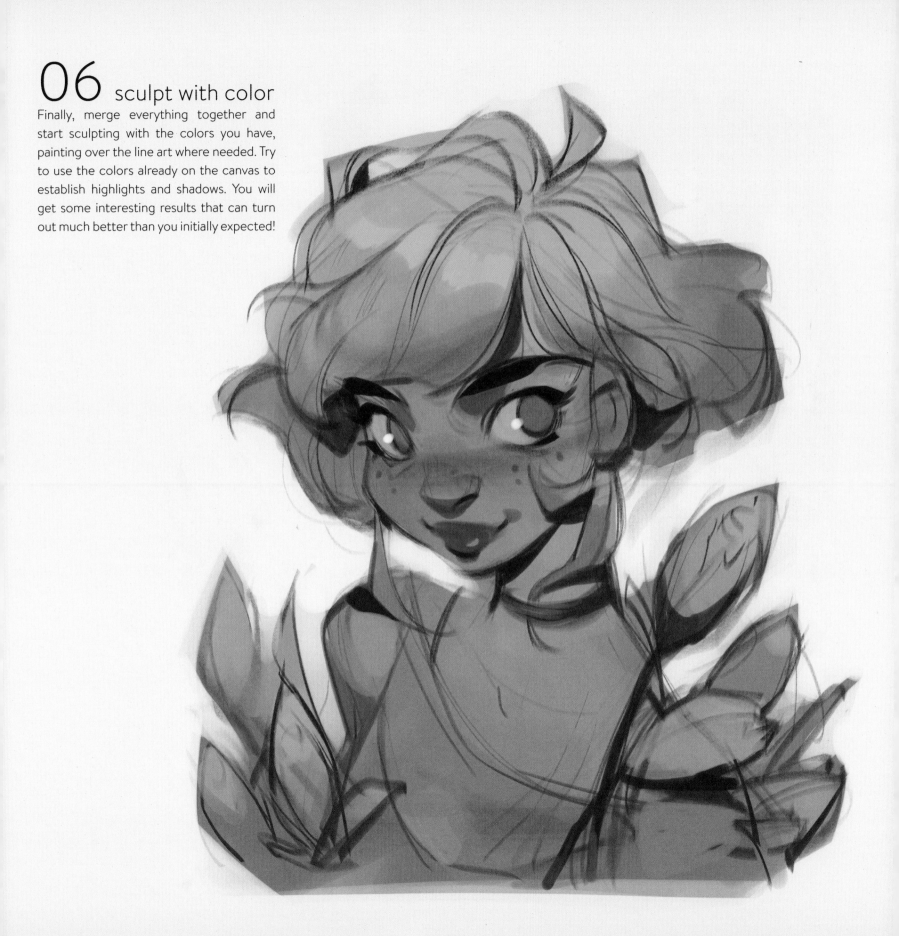

variation 04 //
translating to traditional

As you can see, my intuitive digital workflow depends heavily on digital tools to work. However, I've found a few ways to translate this intuitive process into my traditional work.

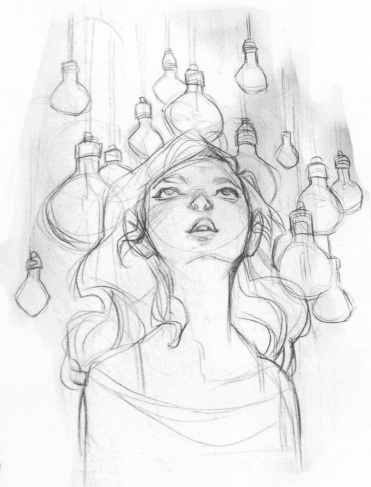

loose sketch

I make a quick and loose sketch before starting, which I keep handy as a reference during my drawing process. This ensures that I don't lose the essence and charm of that sketch in my final work.

colored linework

I draw my initial sketch in a bright color, and then layer more detail on top, mimicking the effect of changing the line color in my digital art. As with my digital work, I also allow these rough sketches to remain visible in the final design because I believe that they add life and personality.

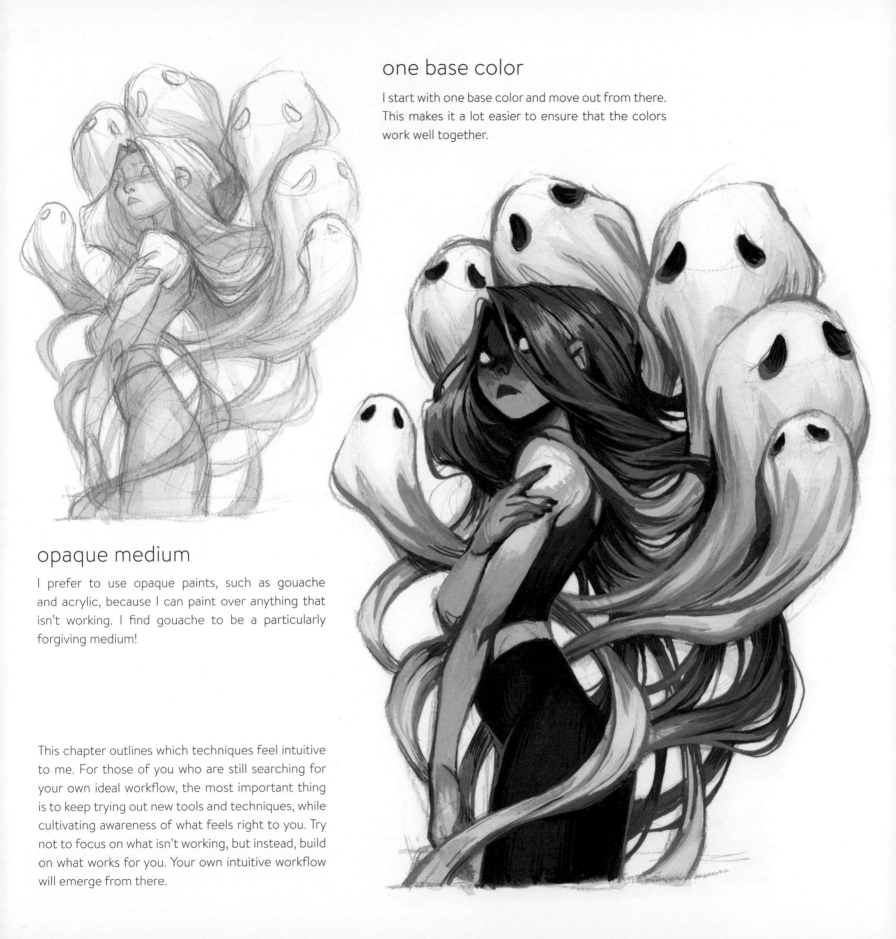

one base color

I start with one base color and move out from there. This makes it a lot easier to ensure that the colors work well together.

opaque medium

I prefer to use opaque paints, such as gouache and acrylic, because I can paint over anything that isn't working. I find gouache to be a particularly forgiving medium!

This chapter outlines which techniques feel intuitive to me. For those of you who are still searching for your own ideal workflow, the most important thing is to keep trying out new tools and techniques, while cultivating awareness of what feels right to you. Try not to focus on what isn't working, but instead, build on what works for you. Your own intuitive workflow will emerge from there.

· quick tips ·

· focused studies ·

When drawing from reference, it's tempting to go into autopilot mode and simply copy what you see. However, if you choose a specific aspect to focus on, you will see greater improvement. Not only that, but by focusing on aspects that you are naturally drawn towards or curious about, you will take steps toward cultivating your own unique style.

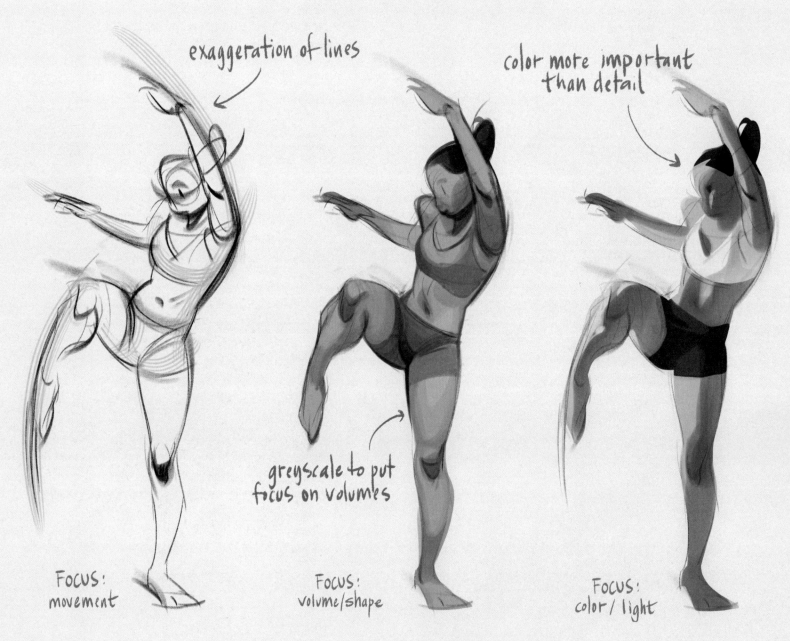

exaggeration of lines

color more important than detail

greyscale to put focus on volumes

FOCUS: movement

FOCUS: volume/shape

FOCUS: color/light

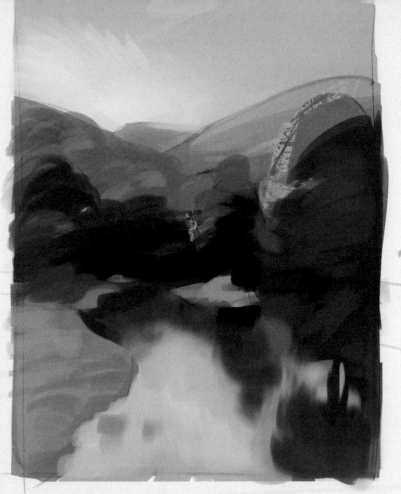

FOCUS:
color

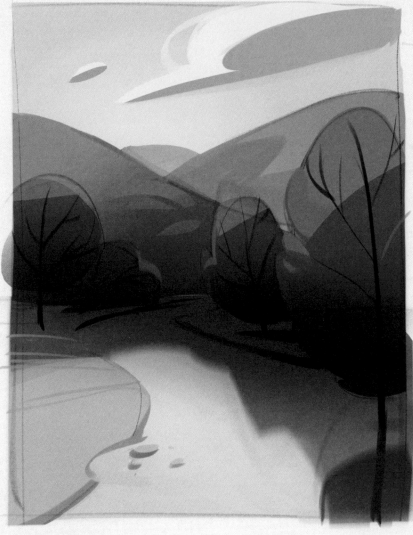

FOCUS:
simplification

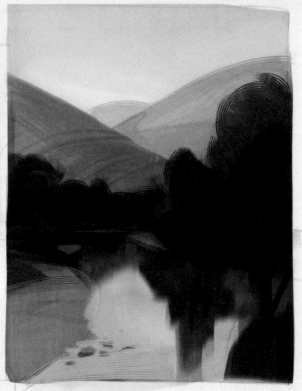

FOCUS:
values

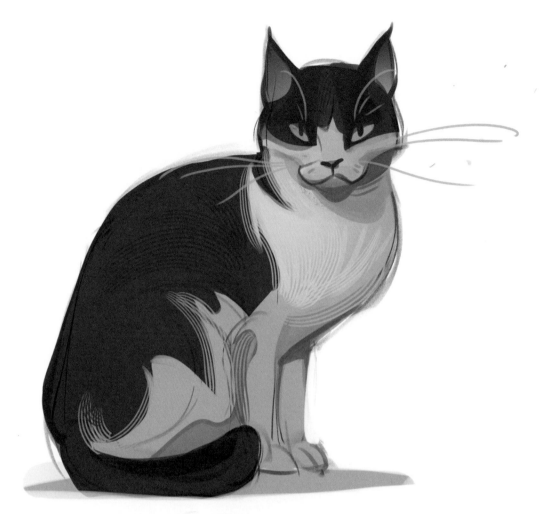

· stylization ·

To stylize literally means to divert from realism. If you're struggling with how to do that, you can use a similar exercise as the previous one to explore different ways to move away from a realistic treatment. Focus on one specific aspect and try to push it further than the rest.

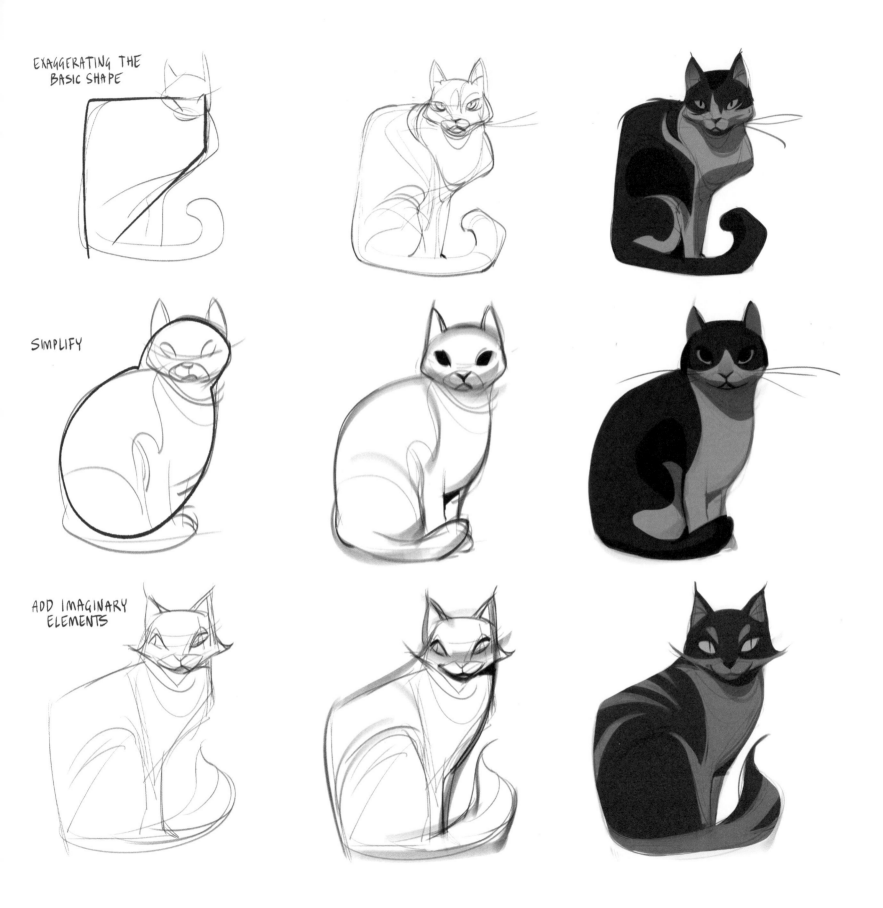

EXAGGERATING THE
BASIC SHAPE

SIMPLIFY

ADD IMAGINARY
ELEMENTS

· multiple styles versus one style ·

I often get asked whether it's OK to have multiple styles, or conversely, whether it's OK to have only one style. Many artists are insecure about their position on this spectrum. The answer is simply: yes, both are perfectly acceptable! Some artists like to explore a wide range of styles, and other artists like to focus on one. It's only a problem if you don't feel comfortable with it.

For artists who have **multiple styles** and want more consistency in their art, you could try the following:

find common themes

Dig up some of your older work and assess your portfolio. You may find some consistent themes or techniques that you didn't realize were there. You could create new artwork that further builds on these consistent elements. From childhood to present day, characters have always been the main focus of my art. Since it's something that's always held my interest, I know I can build on this in the future.

set limitations

Limit your palette or the tools you use, and create a few different drawings within these limitations. Limiting my tools to pencil and ink allowed these pieces to feel consistent, even though they explored different stylistic approaches.

embrace it

Select one specific subject matter and create a series where you convey the same subject in many different styles. With such a series, you could show off your versatility and embrace it as a part of your artistic skillset.

try a new technique

Try something outside of your comfort zone. Your first attempts may not look great, but stick with it and give yourself time to learn. You might discover new techniques that you may not have tried before. I was really uncomfortable with ink at first, but after sticking to a thirty-day drawing challenge, I felt much more comfortable with it and even implemented some aspects of this workflow into my other artwork.

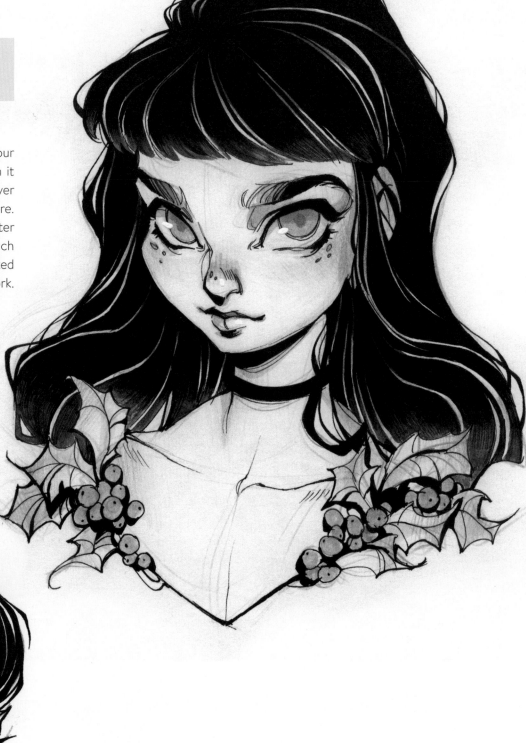

This page: When I drew the same subject matter on the first day of an inking challenge and again on the last day, I could see that I had become more comfortable with these new tools over time

style studies

Make studies of styles different from your own. You could even take it a step further by mixing and matching different styles, which will force you to think critically about which aspects of someone's style you can try out.

expand the boundaries

With your style, you're creating a visual world. How can you expand this world and implement more into it? If you draw a lot of portraits, bring some animals and environments into it. It may feel awkward at first, but your skills will improve if you take on subjects that are outside of your comfort zone.

Whatever you decide to do, just remember that your style will find you with practice, time, and patience!

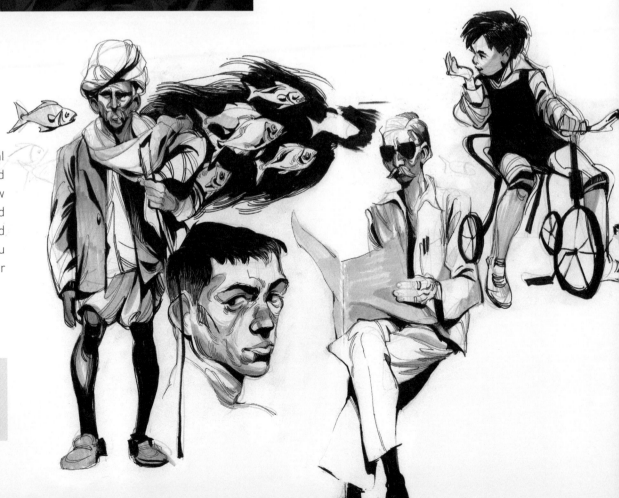

· thank you ·

Thanks so much to everyone who backed this book on Kickstarter and made it a reality! Your enthusiasm and kindness mean so much to me. Thanks to my patrons, whose support allows me to be self-directed in the art that I create, and made much of the art inside this book possible. A big thanks to those who support my work in other ways, whether that's by buying my prints or just following my art on social media. Not only does your support allow me to live off of my art, but your questions and feedback serve as a guide and a source of ideas for my creative work and the resources that I make. I would not be where I am today without you!

Thanks to my publisher for collaborating with me on this book, and always being open to my ideas and suggestions! Your feedback was invaluable in creating it, and I must give full credit to Simon for coming up with this book's title.

Thanks to the generous AdorkaStock for making inspiring stock photos available to artists everywhere, and being the starting point for many of my drawings and studies, including a few in this book!

Thanks to my friends who helped me finalize the idea for this book and who gave me thoughtful feedback and tips. Thanks to my family for always cheering me on. And finally, thanks to my partner, Arjen, who helped me every step of the way, from listening to me read chapters out loud during our evening walks, to filming me next to a busy street for my Kickstarter video. Thank you for always being there for me!

· about the artist ·

Lois van Baarle, better known by her online alias Loish, is a digital artist and character designer currently based in Utrecht, the Netherlands. She was born in the Netherlands but lived all over the world throughout her childhood, returning in 2005 to study animation at the Utrecht School of the Arts.

Lois has worked as a freelance artist and animator since 2009, creating concept art and character designs for animation, games, and toys. She divides her time between client work, creating tutorials and other resources for artists, being active on social media, and making personal art.

website: loish.net | patreon: patreon.com/loish
instagram: loisvb | facebook: loish.fans | twitter: loishh

· about 3dtotal Publishing ·

3dtotal Publishing is a trailblazing, creative publisher specializing in inspirational and educational resources for artists.

Our titles feature top industry professionals from around the globe who share their experience in skillfully written step-by-step tutorials and fascinating, detailed guides. Illustrated throughout with stunning artwork, these best-selling publications offer creative insight, expert advice, and essential motivation. Fans of digital art will enjoy our comprehensive volumes covering Adobe Photoshop, Procreate, and Blender, as well as our superb titles based around character design, including *Fundamentals of Character Design and Creating Characters for the Entertainment Industry*. The dedicated, high-quality blend of instruction and inspiration also extends to traditional art. Titles covering a range of techniques, genres, and abilities allow your creativity to flourish while building essential skills.

Well-established within the industry, we now offer over 100 titles and counting, many of which have been translated into multiple languages around the world. With something for every artist, we are proud to say that our books offer the 3dtotal package:

LEARN | CREATE | SHARE

Visit us at 3dtotalpublishing.com

3dtotal Publishing is part of 3dtotal.com, a leading website for CG artists founded by Tom Greenway in 1999.